*exploring*

# DIGITAL VIDEO

*exploring*

# DIGITAL
# VIDEO

## Lisa Rysinger

**THOMSON**

**DELMAR LEARNING** ™

Australia Canada Mexico Singapore Spain United Kingdom United States

**THOMSON**
™
**DELMAR LEARNING**

**Exploring Digital Video**
Lisa Rysinger

**Vice President, Technology and Trades SBU:**
Alar Elken

**Editorial Director:**
Sandy Clark

**Senior Acquisitions Editor:**
James Gish

**Development Editor:**
Jaimie Wetzel

**Editorial Assistant:**
Marissa Maiella

**Marketing Director:**
Dave Garza

**Channel Manager:**
William Lawrensen

**Marketing Coordinator:**
Mark Pierro

**Production Director:**
Mary Ellen Black

**Production Manager:**
Larry Main

**Production Editor:**
Thomas Stover

**Art/Design Coordinator:**
Rachel Baker

**Technology Project Manager:**
Kevin Smith

**Cover Design:**
Steven Brower

**Cover Production:**
David Arsenault

COPYRIGHT © 2005 by Thomson/Delmar Learning, a division of Thomson Learning, Inc. Thomson Learning™ is a trademark used herein under license.

Printed in the USA.
2 3 4 5 XXX 08 07 06 05 04

For more information contact Thomson Delmar Learning Executive Woods
5 Maxwell Drive, PO Box 8007, Clifton Park, NY 12065-8007
Or find us on the World Wide Web
at www.delmarlearning.com

Library of Congress Cataloging-in-Publication Data

Rysinger, Lisa.
Exploring digital video / Lisa Rysinger.
p. cm.
Includes index.
ISBN 1-4018-4299-2
I. Title.
TK6680.5.R96 2004
006.6'96--dc22
2004004933

*Star Wars:* Episode II *Attack of the Clones* © 2002 Lucasfilm LTD
™All rights reserved.
Used under authorization.
Unauthorized duplication is
a violation of applicable law.

**NOTICE TO THE READER**

# *table of contents*

**Preface**

**Introduction**

1. **Understanding Digital Video Technology**     1

   An overview of digital video technology, including its history, evolution, and how it is used today, as well as necessary terms, concepts, principles, and conventions governing digital video technology.

2. **Digital Video Cameras and Tape Formats**     20

   An examination of the current video tape formats for both analog and digital video, and an explanation of the parts and functions of a digital video camera.

3. **Configuring a Digital Video Computer Editing System**     40

   A discussion of the computer technology required to edit digital video and how to research and budget for an editing system.

4. **Digital Video Preproduction**     60

   An overview of the stages of preproduction, including styles of script writing for video, television, and film; storyboarding; and production schedules. The importance of obtaining legal permission to shoot video is also discussed.

5. **Digital Video Production**     84

   The fundamental techniques of video production—working the video camera, framing shots, basic lighting, basic audio, and shooting for bluescreen and greenscreen.

# *table of contents*

6. **Preparing Photographs for Digital Video**     112

An explanation of how to properly incorporate photographs into digital video, and a step-by–step look at how to acquire and crop photographs without distorting them.

7. **Incorporating Titles, Graphics, and Audio**     136

A discussion of how to prepare titles, graphics, and audio for digital video.

8. **Connecting Equipment and Capturing Digital Video**     156

How to connect equipment and capture digital video, including how to properly cable and connect digital video cameras, video decks, and monitors to a computer editing station. The steps to capturing digital video and audio are also addressed.

9. **Editing Digital Video**     176

A discussion of the basic editing techniques, including transitions, motion, transparency, filters, the importance of a project file, and how to preview a frame.

10. **Rendering and Outputting Digital Video**     198

An examination of how to render digital video efficiently and outputting digital video to tape.

**Appendix A: Digital Video Resource Guide**     222

**Appendix B: Digital Video Troubleshooting Guide**     226

**Appendix C: Digital Video Product Guide**     230

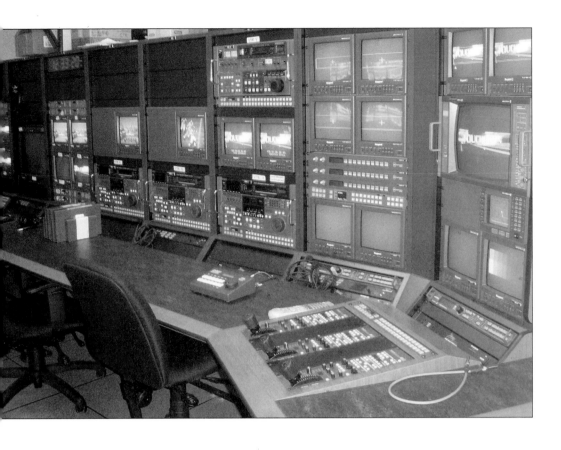

**Appendix D: ILM's Fred Meyers**    236

**Appendix E: ILM's Ben Snow**    244

**Glossary**    254

**Index**    266

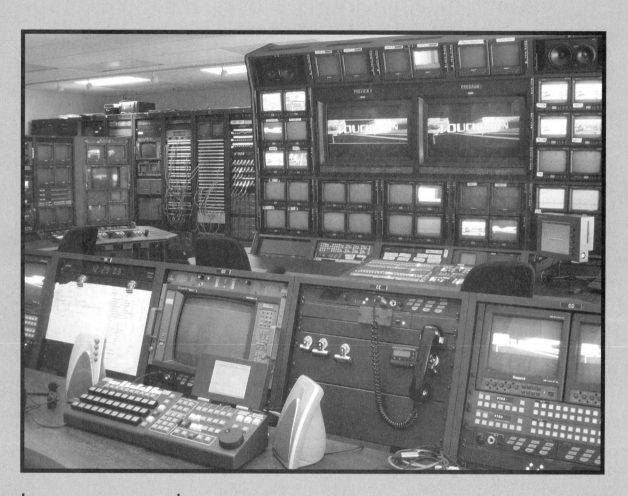

exploring digital video

# *preface*

## INTENDED AUDIENCE

While there are many books written about specific digital video editing software programs, there is no one book that is a comprehensive and practical guide, written specifically for the digital video novice . . . that is until now. Designed specifically as a valuable resource for students training for a career in digital video, this informative and readable text will also appeal to amateur digital video editors and hobbyists. Written by an industry professional who has also taught digital video in the college classroom, *Exploring Digital Video* is the perfect blend of real-world experience and practical, informative instruction.

## BACKGROUND OF THIS TEXT

Digital video is a relatively new and emerging field that is finally now coming into its own. While it is both creative and artistic, digital video requires a certain level of technical expertise to master. Many people are fascinated by this technology, but are reluctant to develop the technical skills it requires. I believe those technical skills, daunting as they may be, can be learned by anyone with a true desire to try. I was inspired to write this book by my students, who believed others could benefit from my knowledge and experience in digital video. When I first became interested in the field in the early 1990s, there wasn't any one place I could go to for information. As a result, I had to learn the hard way—trial and error. I would like to share the information I have amassed over the years with others who have a passion for this technology. While some prior computer and video experience is helpful, this book was designed to introduce digital video technology to anyone with the desire to learn more.

# TEXTBOOK ORGANIZATION

*Exploring Digital Video* differs from other books that place a heavy emphasis on production techniques or specific software programs. Instead of covering material that is already available in other books, this book addresses the technology of digital video. It does not focus on a particular software program, nor does it elaborate on video production techniques, but rather it focuses on digital postproduction, which is the technology behind digital video. *Exploring Digital Video* is not intended to replace software-specific or traditional production books, but rather to work in conjunction with them, providing a solid overview of digital video technology for someone who is new to the field.

### Chapter 1—Understanding Digital Video Technology

Chapter 1 provides a solid overview of digital video technology. It briefly discusses its history and evolution, as well as how it is currently used today in the field. It also delves into the fundamentals of traditional video, which must first be understood before digital video can be fully grasped. Chapter 1 explains the necessary terms, concepts, principles, and conventions governing digital video technology.

### Chapter 2—Digital Video Cameras and Tape Formats

Chapter 2 will clearly explain the current videotape formats for both analog and digital video in the consumer, prosumer, and professional arenas. It will also explain the parts and functions of the digital video camera. This chapter will help readers understand and evaluate which type of digital video equipment is required to create digital video at any level.

### Chapter 3—Configuring a Digital Video Computer Editing System

Chapter 3 will explain how to configure a digital video computer editing system. It will examine all of the relevant computer technology required to edit digital video at any level—consumer, prosumer, or professional. It will also discuss how to research an editing system, as well as address various budget considerations.

### Chapter 4—Digital Video Preproduction

Chapter 4 will discuss the various stages of preproduction. It will examine the different styles of script writing for video, television, and film. It will also talk about how to create storyboards and production schedules. The importance of obtaining legal permission in writing to shoot video will also be emphasized.

### Chapter 5—Digital Video Production

Chapter 5 will discuss the fundamental techniques of video production. Working with the video camera, framing shots, and basic lighting and basic audio will be covered. Shooting for bluescreen and greenscreen will also be addressed.

### Chapter 6—Preparing Photographs for Digital Video

Chapter 6 will explain how to properly incorporate photographs into digital video without distorting them. Acquiring photographs and cropping them while maintaining image quality and resolution will be examined step by step.

### Chapter 7—Incorporating Titles, Graphics, and Audio

Chapter 7 will discuss how to prepare titles, graphics, and audio for digital video. Digital video is rarely comprised of video alone, and this chapter will examine how to successfully incorporate these additional elements into a digital video production.

### Chapter 8—Connecting Equipment and Capturing Digital Video

Chapter 8 will discuss how to connect equipment and capture digital video. It will examine how to properly cable and connect digital video cameras, video decks, and monitors to a computer editing station. It will also address the steps to capture digital video and audio.

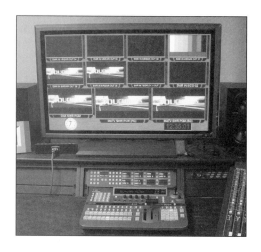

### Chapter 9—Editing Digital Video

Chapter 9 will discuss the basic editing techniques found in most digital video editing software programs. It will also address transitions, motion, transparency, and filters. It will discuss the importance of the project file and demonstrate how to preview a frame of video.

### Chapter 10—Rendering and Outputting Digital Video

Chapter 10 will examine how to render digital video. Rendering is an important stage of the digital video process and can be quite costly, time wise, if it is not done correctly. This chapter explores how to render a project in stages so the rendering process can be done efficiently. Chapter 10 will also explain how to output digital video to tape. Standards for CDs, DVDs, and video for the Internet will also be addressed.

### Appendix A—Digital Video Resource Guide

This appendix will be a valuable resource, providing information about digital video-related books, magazines, Web sites, mailing lists, groups and organizations, hardware and software developers, educational classes, seminars, and workshops.

### Appendix B—Digital Video Troubleshooting Guide

This appendix will address common problems that occur in digital video and how to solve them.

### Appendix C—Digital Video Product Guide

This appendix will help readers evaluate digital video hardware and software at the consumer, prosumer, and professional levels.

### Appendix D—ILM's Fred Meyers

See excerpts from an exclusive interview with digital cinema expert and HD Supervisor Fred Meyers of Industrial Light & Magic.

### Appendix E—ILM's Ben Snow

See excerpts from an exclusive interview with Academy Award-nominated Visual Effects Supervisor Ben Snow of Industrial Light & Magic.

### *Glossary*

A comprehensive glossary of terminology, which includes traditional video, computer, and digital video terms.

### *Color Insert*

A special color insert features *Star Wars*: Episode II *Attack of the Clones*. Learn how the *Star Wars* saga has impacted the field of digital video. Go behind the scenes with exclusive interviews of top Industrial Light & Magic personnel.

### *Back of Book DVD*

A DVD, which includes digital video tutorials, software, vendor and product information, and much more, including a unique behind-the-scenes look at how the Philadelphia Eagles football franchise is using state-of-the-art digital video technology.

# FEATURES

The following list provides some of the salient features of the text:

- Profiles of successful digital video professionals offer important industry advice and inspiration.
- Articles by leading professionals in the field give valuable insight into the creative process.
- A color insert showcases how *Star Wars*: Episode II *Attack of the Clones* used cutting-edge digital video technology to create its special effects.
- Objectives clearly state the learning goals of each chapter.
- Photographs and illustrations supplement the text throughout.
- Review questions reinforce the material presented in each chapter.
- A resource guide provides contact information for groups, organizations, Web sites, training, and more.
- A troubleshooting guide addresses common digital video problems.
- A product guide features current digital video hardware and software.
- A glossary clearly defines both computer and video terminology.
- A DVD includes software, tutorials, product information, and more, including a behind-the-scenes look at how the Philadelphia Eagles use digital video.

# HOW TO USE
# THIS TEXT

The following features can be found
throughout this book:

## ▶ Objectives

Learning Objectives start off
each chapter. They describe the
competencies the readers should
achieve upon understanding
the chapter material.

## ▶ Notes and Tips

Notes and Tips provide special hints,
practical techniques, and information
to the reader.

## ▶ Sidebars

Sidebars appear
throughout the text,
offering additional
valuable information
on specific topics.

## Review Questions and Exercises

Review Questions and Exercises are located at the end of each chapter and allow the reader to assess their understanding of the text. Exercises are intended to reinforce chapter material through practical application.

## The DV Profile

These career profiles are interspersed throughout the text. Each features a successful animator in the field.

## Get Creative

The creative process is important for anyone in an artistic field to understand. These articles are included to help the reader understand how to tap into their creativity and get their creative juices flowing.

*about the author*

## ABOUT THE AUTHOR

Lisa Rysinger is the owner of VIDE Productions, Inc., a digital video production company that produces everything from corporate training videos to television commercials, as well as multimedia and DVDs. Her clients include Campbell's Soup and Keystone Mercy Health Plan. Ms. Rysinger has taught digital video at the college level for over five years. She has a bachelor's degree in Radio, Television, & Film and a master's degree in Writing from Rowan University where she graduated with honors. Ms. Rysinger has also trained with Avid Technology in California and the International Film and Television Workshops in Maine. She is a charter member of the Digital Video Professionals Association and an active member of the Chamber of Commerce of Southern New Jersey. Her other affiliations include the Philadelphia Final Cut Pro Users Group, the Macintosh Users Group of Southern New Jersey, and the South Jersey Apple Users Group. In addition to being an author, with *Exploring Digital Video* being the first of several planned books, Ms. Rysinger also conducts group lectures and seminars. Ms. Rysinger herself has been featured in numerous interviews, including recent articles in the *New York Times* and the *Philadelphia Inquirer*.

# THE LEARNING PACKAGE

## E-Resource

This instructor's CD was developed to assist instructors in planning and implementing their instructional programs. It includes PowerPoint presentation slides, answers to the questions in the text, course syllabi, exams, and more.

ISBN: 1401815065

# ACKNOWLEDGMENTS

I'd like to thank the following people at Delmar Learning for their continued support and expertise: Jim Gish, my Acquisitions Editor, for believing in me and my vision for this book—your encouragement was invaluable, your faith was inspiring, and your motivation continues to challenge me; Jaimie Wetzel, my Development Editor, for always being in my corner—your patience is limitless, your professionalism is unsurpassed, and I feel truly fortunate to have had the privilege of working with you; Tom Stover, my Production Editor, for making my entrance into the technical end of publishing so easy—your skill and attention to detail were a constant reassurance; Marissa Maiella, my Editorial Assistant, for keeping me apprised of everything—I never worried because you were just a phone call away; Mardelle Kunz for her keen eye as my copyeditor, and Liz Kingslien for doing a top-notch job with the page layout—I couldn't have asked for a better person to work with; Kevin Smith, Technology Project Manager; John Cacchione, Quality Assurance Manager; Louise Baier, Account Manager at Cycle Software Services; and everyone else at Delmar in production, marketing, and sales for all your hard work behind the scenes to help make my book a success. I truly do appreciate all of your efforts.

I want to extend a special thank you to the following individuals for all of their help with creating the color insert:  Christopher Holm, Business Affairs, Lucasfilm Ltd.—for making the inclusion of the *Star Wars*: Episode II *Attack of the Clones* segment possible in the first place—it became all that I envisioned and more; Suzy Starke, ILM Publicity—for all your hard work arranging the interviews and providing the background research material; Ben Snow, Visual Effects Supervisor,—for making the time to do a fantastic interview and providing a unique and inspiring glimpse into the world of visual effects; Fred Meyers, HD Supervisor, ILM—also for making the time to do an excellent interview and providing expert insight into the exciting new field of digital cinema; and finally, George Lucas, Writer and Director, Lucasfilm, Ltd.—for creating the *Star Wars* saga and enriching my childhood—and that of countless others—with creativity and enjoyment, for inspiring my passion for movies, and for pioneering the field of digital video technology.

I also want to extend special thanks to the following individuals for their efforts and enthusiasm for the DV profile and the DVD: Robert Alberino, Director of Broadcasting and Executive Producer, Eagles Television Network, ETN—for welcoming me and providing me with full accessibility and great material; and Dana Heberling and Ron Schindlinger, Editors, ETN—for their time, their patience, and their expertise.

I'd also like to thank the following professionals for taking the time out of their hectic schedules to participate in the career profiles; your insight and experience were great additions to the book and will serve as inspiration to others: Sharon Pinkenson, Executive Director of the Greater Philadelphia Film Office; Professor Ned Eckhardt, Chair of the Radio/Television/Film Department at Rowan University; Tommy Rosa, Director of Photography and Senior Editor of Tommy Productions; and Rod Harlan, Executive Director of the Digital Video Professional Association (DVPA).

I'd like to thank the following students for lending your images to this book and for your enthusiasm: Michelle Canning, Steve Hume, Derek Lindeman, and Tommy Avallone. I'd also like to thank Professor Phyllis Owens of Camden County College for introducing me to the world of teaching. A special thank you goes to my first class, whose avid passion for digital video made me decide to continue to teach. I'd like to single out the following students who have gone out of their way to personally express their appreciation to me; students like you are the reason I teach—thank you (in no particular order) Chris Smith, Pam Mazzarella, Steve Lombardo, Sylwia Majewski, Sharon Davis, John Neil, Lauren Destefano, Tom Audio, Linda Hurd, Phil Miller, Ray Weisman, Amy Quering, Hassan Meghani, Mara Toe, Venise Grossman, Tara Angelastro, Andrew Lueddeke, Kevin Croft, Michelle Canning, Rick Gray, John Bryan, and all of my other students who were an inspiration over the years. You know who you are!

I want to thank the following teachers at Rowan University for providing me with a top-notch education and inspiring me to succeed: Professor Diane Penrod, Professor Ned Eckhardt, Professor Carl Hausman, Professor Julia MacDonnell Chang, Professor Joe Bierman, Professor Richard Grupenhoff, and all of my other teachers at Rowan.

I'd also like to thank my family and friends for your motivation and support: my husband, Tom, for never once doubting my abilities; my mother, Grace, for helping with the illustrations, proofreading, and more importantly instilling in me the desire to learn and achieve; my brother, Rob, for sharing my love of computers and helping me develop my technical skills; my sister-in-law, Terri, who is a role model for successful women in business; all of my friends who understood why I've been so busy lately; the members of MUGSNJ and SJAUG for being my computer family; and finally, my late father, Frank, who couldn't be here to witness my first book, but would have been proud—thank you for buying me my first computer, sharing with me your love of film, and teaching me to work hard, to be organized, to stay determined, and to reach for my dreams.

Delmar Learning and the author would also like to thank the following reviewers for their valuable suggestions and expertise:

**JAMES HUDSON**
Video Production/Digital Media Production Department
Art Institute of Pittsburgh
Pittsburgh, Pennsylvania

**DANIEL KIER**
Visual Arts Technology Department
Washtenaw Community College
Ann Arbor, Michigan

**KELLEN MAICHER**
Computer Graphics Technology Department
Purdue University
West Lafayette, Indiana

**EDWARD NOLAN**
Media Department
Naugatuck Valley Community College
Waterbury, Connecticut

**PIYUSH PATEL**
Multimedia & Digital Communications Department
Northern Oklahoma College
Tonkawa, Oklahoma

**JOHN G. PEREZ**
Visual Communications Department
Ivy Tech State
Indianapolis, Indiana

**AMY PHILLIPS**
Digital Media Production Department
Art Institute of Fort Lauderdale
Fort Lauderdale, Florida

**BILL SLATER**
Digital Media Production Department
Art Institute of Phoenix
Phoenix, Arizona

*Lisa Rysinger 2004*

## QUESTIONS AND FEEDBACK

Delmar Learning and the author welcome your questions and feedback. If you have suggestions that you think others would benefit from, please let us know and we will try to include them in the next edition.

To send us your questions and/or feedback, you can contact the publisher at:

Delmar Learning
Executive Woods
5 Maxwell Drive
Clifton Park, NY 12065
Attn: Graphic Arts Team
800-998-7498

Or the author at:
exploringdv@vide.com

# *introduction*

Movies. Television. Computers. The Internet. Cell Phones. DVDs. We live in an exciting time. Digital technology is shaping every aspect of our lives. Innovations have made possible what once seemed impossible. We can stay connected without being confined. There are new worlds for us to explore. We can now create what we once only imagined.

Perhaps you have an idea that you would like to bring to life? A story to tell? A message to convey? A memory to preserve? You can do it. Join me as we embark on a journey of exploration into the world of digital video.

# *dedication*

This book is dedicated to each of my former students. Thank you for encouraging me, for challenging me, and for inspiring me. May your passion and enthusiasm for this technology be an inspiration to others, and may you never lose sight of your individual goals, hopes, and dreams.

DV

understanding digital video technology

# objectives

Learn how digital video differs from analog video

Understand the principle of random access

Find out how digital video has influenced television, filmmaking, multimedia, and the Internet

Discover what factors influence file size in digital video

Learn the conventions used to create digital video for broadcast, multimedia, and the Internet

# introduction

This chapter provides an overview of digital video technology. It discusses the evolution of digital video and its influence on television, filmmaking, multimedia, and the Internet. It is important to understand how digital video differs from traditional analog video. While digital video can be considered a creative profession, it is also a technical one. To succeed in this field, it is vital to understand all of the principles and conventions that govern digital video technology.

UNDERSTANDING DIGITAL VIDEO TECHNOLOGY

# THE DIGITAL AGE

We live in a digital age. Computers are part of our everyday lives. Technology surrounds us. We surf the Net. We talk on cell phones. We watch digital cable, or use cable modems. We have satellite dishes attached to our homes, which beam signals into outer space when we want to change a television channel. We pause live TV to stop and answer the door, and then push a button to pick up watching right where we left off. We even go to the movies and watch films with virtual actors. The world as we know it is changing. It's going digital.

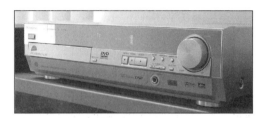

figure 1-1

DVD players are one of the most popular consumer electronics products of all time.

Today, you can walk into Blockbuster Video and rent a movie on DVD. **DVD**, or **digital video disc** (sometimes called digital versatile disc), is a new storage medium that will hold gigabytes of information on a single disc. It has enough space to include an entire feature-length film with superior picture quality and sound, not to mention lots of extra footage!

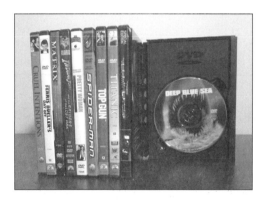

figure 1-2

Many movies, both old and new, are now available on DVD.

figure 1-3

The DVD, or digital video disk, will eventually replace VHS videotape technology.

DVDs are the latest in a series of advances in digital video technology. They also mark the dawn of a new era, one in which video will change forever. Like the demise of 8-track tapes and LPs in the audio world, video will also evolve to take advantage of new technologies. Someday DVDs will replace VHS tapes, and someday is coming sooner than you might think.

# DIGITAL VIDEO, DV

Digital video technology is hot right now. In addition to the DVD craze, everybody wants to learn how to connect their new digital camcorder to their computer and edit video. But not so long ago, this concept was a revolutionary one. Video and computers used to be two very distinct technologies. When the television and the computer were each created, no one anticipated they would one day merge. But that's in fact what did happen. Slowly each field began to overlap a little more. Now you can surf the Internet on your TV, or use a computerized **DVR**, or **digital video recorder**, to record hours and hours of programming without videotape. Video has evolved into **digital video**, or **DV**. But in order to truly grasp digital video, we must first understand traditional video technology.

So just how is a video image actually recorded? Video cameras use **CCDs**, or **charge-coupled devices**, which are computer chips that convert the optical images into electrical impulses. Traditional video uses an **analog** signal, which is an electrical signal that fluctuates exactly like the original signal it is mimicking. Digital video converts the analog signal into binary form, which is represented by a series of zeros and ones.

figure | 1-4 |

The Matrox RTMac converts analog video into digital video.

Think of the analog video signal as a language, like English, and the digital video signal as Spanish. Traditionally, video cameras were only analog, and therefore only spoke English. In order to be able to communicate with the computer, which only spoke Spanish, a video card had to be used to convert the analog signal into a digital signal, or English into Spanish.

| TIP |

Don't confuse a **video card**, which converts analog video signals into digital video signals, with a **graphics card**, which is used to support the video display of a computer monitor.

# HISTORY OF DIGITAL VIDEO

Digital video technology exploded in the 1990s and is now in full swing, but it really began its metamorphosis much earlier. In the 1970s, frames of analog video were converted into digital form and altered for special effects. These **digital video effects systems**, or **DVEs**, were pass-through devices and the frames were not actually stored in memory. In the early 1980s, **digital still store devices** (**DSSs**) were capable of storing and recalling individual video frames. In the mid-1980s, **digital disc recorders** (**DDRs**) were able to both play back and record images at the same time. All of these older technologies contributed to the evolution of digital video.

figure |1-5|

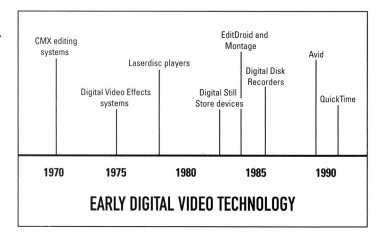

**EARLY DIGITAL VIDEO TECHNOLOGY**

# NONLINEAR EDITING

Digital video was revolutionized on the Macintosh computer platform with the advent of **QuickTime,** a type of software compression that shrinks the size of digital video files. Avid Technology was the company that pioneered the digital video, or nonlinear editing system, and it still has a strong presence in the digital video industry today. This new style of editing video on the computer was called **nonlinear editing** in the professional arena. When it originated in the consumer realm, it was known as **desktop video.** As computer technology continued to evolve, the gap between nonlinear editing and desktop video began to decrease. The term digital video was coined. Today, professional editing systems have become quite affordable, and many freelancers have entered the digital video market.

figure |1-6|

QuickTime is Apple Computer's video compression technology that paved the way for video editing on the computer.

# LINEAR EDITING

Traditional video editing is called **linear editing.** In linear editing, the video program is edited consecutively from beginning to end. One or more video decks (the source decks) play the original videotape from the video camera, and a second video deck (the record deck) records the selected shots onto the master, or edited, videotape. Nonlinear editing, on the other hand, is nonconsecutive in nature. The differences between linear editing and nonlinear editing can be clearly illustrated by using the analogy of an audio cassette tape and an audio compact disc, or CD.

An audio cassette tape is linear. To get to the fifth song on an audio cassette tape, you have to fast-forward through songs one through four. An audio CD is nonlinear. Theoretically, it takes the same amount of time to get to the fifth song as it does to the first, the second, the third, or the tenth.

## BUZZ WORDS

Are digital video, nonlinear editing, and desktop video the same thing? Yes and no. Like digital video technology, the terminology has also evolved over the years. *Nonlinear editing* originally began as a term that represented a style of editing which is nonconsecutive in nature. Technically, film editing is a form of nonlinear editing. However, with the rise of digital video, the term nonlinear is now often used synonymously with professional quality digital video. *Desktop video* is a term that was popular in the 1990s; it was used to refer to consumer digital video editing on the computer. As the gap between consumer digital video technology (desktop video) and professional video technology (nonlinear editing) began to close, the term desktop video was abandoned in favor of digital video. Today, the term *digital video* encompasses many things. Technically, it is a video signal that has been converted into binary form. Digital video can refer to video cameras and decks that record the video signal digitally. It can also refer to digital nonlinear editing or desktop video. In a broader sense, the term can encompass all digital video technology, including digital video recorders (DVRs), digital video disks (DVDs), digital cable and satellite service, as well as digital video cameras and digital video editing.

## RANDOM ACCESS

The founding principle of digital video technology is called **random access** (not to be confused with **RAM, random-access memory**). The principle of random access states that it takes the same amount of time to get to any one point. In linear editing, shot A is followed by shot B, which is followed by shot C, etc. Any changes to the consecutive order of the edited shots are time consuming and difficult to make. However, in nonlinear editing, because of the principle of random access, shots A, B, and C can be rearranged quickly and easily with the click of a mouse.

| NOTE |

RAM is an integrated circuit memory chip that allows data to be stored, accessed, and retrieved in any order. RAM is a computer chip, while *random access* is a digital video principle.

## ADVANTAGES OF DIGITAL VIDEO

Nonlinear editing, or digital video as it is commonly called today, has several distinct advantages over linear editing. Nonlinear editing is faster. Changes are easier to make. Therefore, editors have more creative freedom in arranging their shots. They can easily change the editing order of their shots to see which arrangement they like best.

Another advantage of nonlinear editing is that it does not suffer from generation loss because the video signal is digital. **Generation loss** is the degradation of image quality caused by the duplication of an analog videotape.

If you take a VHS tape and make a copy of it and then make a copy of your copy, the third generation tape has an inferior picture quality when compared to the first generation tape. Conversely, with digital video you can copy a digital video file over and over again, and the last image will be identical to the first one.

Analog videotape is also prone to drop out. **Drop out** occurs when video information is missing on the tape, which in turn, causes a white streak to appear. While digital video still records a digital signal onto tape, the digital format is more durable.

## Advantages of Digital Video

* Editing is faster
* Changes are easier to make
* Allows more creative freedom
* Doesn't suffer generation loss
* Less prone to drop out

# FIREWIRE (IEEE 1394)

Digital video technology really started to take off when Apple Computer invented **FireWire**, or **IEEE 1394**, a protocol that allows digital video cameras and computers to transmit digital video signals back and forth. FireWire replaced the need for the traditional video card to digitize video, or convert the analog signal into binary form.

figure | 1-7 |

This FireWire (IEEE 1394) cable can be used to connect a digital video camera to a computer.

Because digital video cameras already record the video signal in digital form, there is no need to translate it from "English" into "Spanish." The digital signal is then transferred from the digital video camera into the computer via FireWire. All the major electronics manufacturers,

like Sony and Panasonic, adopted FireWire technology. Today, FireWire comes standard with every model of Macintosh computer and is an option on many PCs. A variety of third-party hardware manufacturers also make affordable FireWire expansion cards for PCs.

## MAC VERSUS PC

You are probably aware that there are "Mac" people and there are "PC" people. Each computer platform has its own advantages and disadvantages. Business people tend to prefer PCs, and artists tend to prefer Macs. Digital video was pioneered on the Macintosh. Apple invented QuickTime and FireWire, two technologies that have paved the way for digital video. However, PCs caught up quickly, and just about everything you can do on a Mac involving digital video, you can also do on a PC. Also, PCs tend to be more affordable because there are many manufacturers from which to choose. However, having multiple hardware manufacturers also makes it much more difficult to troubleshoot digital video on the PC. Because digital video is still a cutting-edge technology, which pushes even the newest computer to its limit, there will be the need to troubleshoot on any system from time to time. Because there are so many third-party developers for the PC, it is more prone to conflicts. If you are trying to decide whether to buy a Mac or a PC to edit digital video, you need to take these factors into consideration. For example, how technically proficient are you? Will you be able to troubleshoot a more involved system? Do you have more experience on either platform? Do you need to be on the cutting edge of digital video technology? And perhaps most importantly, will this computer be used for other things besides editing digital video? You should thoroughly weigh all the pros and cons before investing a significant amount of time, money, and effort into any system.

## THE VIDEO SIGNAL

To edit digital video successfully, it is important to understand the technical aspects of video. The video signal itself is broken down into two parts: chrominance and luminance. **Chrominance** is the color portion of the video signal. Red, green, and blue, or **RGB**, are the three additive primary colors used to construct a video image. All the other colors are created from these three. Print media, on the other hand, uses **CMYK**: cyan, magenta, yellow, and black.

**Luminance** is the black-and-white portion of the video signal, or its lightness and darkness values. **Hue** refers to the actual shade of the color being displayed, while **saturation** refers to the intensity of the color.

A **component** video signal is a broadcast-quality signal, in which the red, green, blue, and luminance portions are kept separate. An **S-video** signal separates the chrominance and luminance portions. In a **composite** video signal, the chrominance and luminance portions are blended together.

| THE VIDEO SIGNAL | | | table 1-1 |
|---|---|---|---|
| **Consumer** | **Prosumer** | **Professional** | |
| Composite | S-Video | Component | |
| 1 cable | 1 cable | 4 cables | |
| Chrominance and luminance are blended | Chrominance and luminance kept separate | Chrominance (3) Red Green Blue Luminance (1) | |

| TIP |

**Prosumer** is a cross between professional and consumer. Some high-end consumer camcorders would be considered prosumer because they offer more features than typical consumer cameras, but not as many features as professional cameras.

A component video signal is the highest quality video signal because it has the least amount of interference. It is used professionally. However, digital television sets, DVD players, and DVRs are now bringing the component video signal to high-end consumers.

S-video is used at the prosumer level. Most satellite dishes and some high-end VCRs and television sets offer S-video.

The composite video signal is the lowest quality video signal because it has the most interference. Most consumer TVs, VCRs, and video cameras only have a composite signal.

## THE NTSC VIDEO STANDARD

When a video signal is broadcast in the United States, it must adhere to a set of standards that was set forth by the **NTSC**, the **National Television Standards Committee**. While the NTSC video standard is prevalent in North America, it is not the only video standard used worldwide. Other countries throughout the world use **PAL** (**Phase Alternate Line**) or **SECAM** (**Systeme Electronique Pour Couleur Avec Memoire**). PAL is used in the United Kingdom, Western Europe, and Africa. SECAM is used in France, Russia, and Eastern Europe.

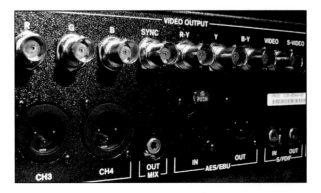

figure 1-8

Professional video equipment is required to transmit the component video signal used in broadcast television.

The NTSC video standard requires that the video signal be broadcast at 525 horizontal lines of resolution and at 30 (29.97) **frames per second**, or **fps**. Video, like motion picture film, is really a set of still images, recorded and played back in rapid succession. In video, there are 30 frames, or still images, in one second. Motion picture film runs at 24 fps.

The NTSC video standard has 525 horizontal lines of resolution. The video image is reproduced on the TV screen by scanning these lines of resolution in two separate passes. Each pass is referred to as a **field**. The odd lines are scanned first, and the even lines are scanned second. These two fields combine to form one frame of video. The method of combining two fields to form a frame is called **interlaced** video. Hence, the television set is interlaced. The computer monitor, on the other hand, is **noninterlaced**, or **progressive**. The computer monitor draws all its lines of resolution in a single pass. Then it goes blank for a fraction of a second before it draws the next frame.

A computer monitor uses **pixels**, or a series of small blocks, to draw a video image. A standard analog video image is 640 pixels wide by 480 pixels high. This length to width proportion of the video frame is called an **aspect ratio**. The current NTSC video standard has a 4:3 aspect ratio. Think of the television set as a rectangle that is four units wide and three units high. It doesn't matter if it's a 13-inch TV or a 27-inch TV, the aspect ratio is still 4:3.

# HIGH-DEFINITION TELEVISION, HDTV

figure | 1-9 |

The aspect ratio for **high-definition television, HDTV**, is 16:9. Because of the increased aspect ratio, HDTV has a superior picture quality, emulating motion picture film. HDTV is quickly gaining in popularity. Many television stations, including the major networks, are broadcasting portions of their prime time programming in HDTV. CBS was the first network to begin broadcasting a daytime soap opera, *The Young and the Restless*, in HDTV. Home Box Office, HBO, now offers a high-definition HBO channel, which airs the same programming twenty-four hours a day as regular HBO. Other premium channels are following suit. Recently, HDTV sets have dropped substantially in price and are becoming more and more affordable.

## ASPECT RATIO

Standard Television 4:3
(4 units wide)

High-Definition Television 16:9
(16 units wide)

**Digital television**, **DTV**, also has the support of lawmakers. The **Federal Communications Commission, FCC,** is the government body responsible for making the laws regarding television broadcasts. They have mandated that the analog video signal will be completely phased out by 2006 and replaced with the digital video signal. Broadcasting digital signals bodes well for proponents of HDTV. It will be interesting to see if and when HDTV is universally adopted.

figure | 1-10 |

Consumers are buying high-definition television (HDTV) sets because of their superior picture quality.

## DIGITAL FILMMAKING

Another new venue that can be attributed to the recent advances in digital video technology is **digital filmmaking**. Many budding filmmakers are turning to digital video to make their film aspirations a reality. While digital video doesn't rival the quality of film—nothing can surpass film in terms of resolution and depth of field—it has become a cost-effective alternative to those with a story to tell.

Filmmakers shoot digital video, edit it on the computer, and then pay to have their movies transferred to either 16 mm or 35 mm film. New models of digital video cameras, which shoot at *either* 30 fps or 24 fps, are aimed specifically at digital filmmakers. Digital video cameras are much more affordable to shoot with, compared to the high costs of shooting, developing, and editing film.

On the more expensive end of the spectrum, shooting with an HDTV camera and editing on the Macintosh with Apple's Final Cut Pro and the Targa CineWave card has recently emerged as another exciting option. Shooting on HDTV, editing it on the computer, and later transferring it to film is currently the best way to rival film's quality. And, as the technology continues to evolve, it will become even more affordable.

figure | 1-11 |

Digital video cameras, like Panasonic's AG-DVX100, give independent filmmakers an inexpensive alternative to shooting on film.

# DV PROFILE

## Sharon Pinkenson

## Biography

**Name:** Sharon Pinkenson

**Job title:** Executive Director

**Organization:** Greater Philadelphia Film Office

**Number of years in current position:** Twelve

**Number of years in field:** Twenty

**Past work experience:** Dental Hygienist; Owner, *Plage Tahiti* (fashion boutique); Fashion Designer, *Plage Tahiti*; Wardrobe Stylist, television commercials; Costume Designer/Supervisor, feature films.

**Degrees/certifications:** Temple University, RDH, BSEd

**Career highlights/accomplishments:** Television series: *Philly* (ABC), *Hack* (CBS); *The Real World—Philadelphia* (MYV); Feature films: *Philadelphia, Two Bits, 12 Monkeys, Up Close & Personal, Maximum Risk, Fallen, Beloved, The Sixth Sense, Jesus' Son, Unbreakable, Signs, Jersey Girl, National Treasure, The Village, In Her Shoes.*

**Professional affiliations:** Board of Directors, Temple University, School of Communications and Theater, Drexel University, College of Media Arts and Design, and African American

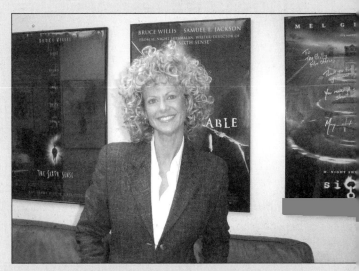

Sharon Pinkenson, Executive Director of the Greater Philadelphia Film Office, stands in front of posters of three M. Night Shyamalan films shot on location in the Philadelphia area.

Museum of Philadelphia; Vice President of the Board, Prince Music Theater; Founding Director of Film, Prince Music Theater; and Secretary, Film US.

**Web site:** www.film.org

## Questions & Answers

**Q. What is the primary role of the Greater Philadelphia Film Office?**

**A.** We're an economic development office with a three-part mission. First, we serve to attract film and video production of every kind to the region, including everything from feature films to TV commercials to music videos and industrial films. Second, we provide the producer free assistance with parking, permits, hotels, labor, and locations, and generally act as liaison between the production and the local community,

## DV PROFILE
*continued*

*Sharon Pinkenson*

cutting red tape as we go. Finally, we serve to grow the local film and video industry in every way possible, recognizing its huge economic impact in job creation and its unparalleled public relations effects for the region.

**Q. Quite a few feature films and television shows have been shot in the Philadelphia area in recent years. What can you tell us about upcoming projects?**

**A.** We are currently in our second season of the CBS television series *Hack*, starring David Morse and Andre Braugher, and we hope that the series will continue for several more years. It is the only network television show to film entirely outside of Los Angeles or New York, and the first television series to shoot entirely in Philadelphia. We are currently working with two different cable stations on new shows for them and for Philadelphia; plus several new feature films, both independent and studio backed productions. But this information is confidential until it is officially "green lit."

**Q. What types of local job opportunities does filmmaking bring to the area?**

**A.** Local residents are regularly hired in every type of film and video production and postproduction job. Starting with location scouts, and production assistants, actors, and crew in each and every production department, from editors to storyboard artists, local residents are working in production, and also in companies that support production indirectly, such as hotels, costume shops, personal service professionals, and so on.

**Q. As the executive director, how has the recent growth of digital technology impacted your job? Are there more digital filmmakers seeking the resources your office provides?**

**A.** The rapid growth in digital filmmaking has vastly changed the model for film production. First of all, digital filmmaking has opened the door for young and old to explore a field that had been closed to them in the past, because previously the technology for filmmaking was so cumbersome and expensive. On the other hand, digital film technology is accessible to almost everyone with a desire to use it. Mastery of digital filmmaking is a wide-open terrain, and young people are particularly well suited to excel in it and break new ground. On the postproduction side, digital technology has quickly overtaken linear technology as the norm, and a local post house is doing the digital dailies for the CBS TV series *Hack*. That's the first time a television series has ever had digital dailies that didn't come out of L.A. or New York.

**Q. What are your thoughts on how digital technology is influencing filmmaking?**

**A.** Just a few years ago, filmmakers were afraid of the techniques and the quality of the end product in the digital film world. They even thought that their films would be taken far less seriously if they decided to go the digital route.

Now more and more filmmakers are going digital, and the industry is finally recognizing that the quality of the films can be phenomenal, both in the creative and the technical side.

*Q. What are some of the challenges you see facing digital filmmakers today?*

*A.* Digital filmmaking is still in its infancy. The techniques and equipment are changing and improving so fast, it may be hard to keep up. The challenge is only in joining the revolution and pushing the envelope.

*Q. What is the Greater Philadelphia Filmmakers Program?*

*A.* Greater Philadelphia Filmmakers serves the third part of our mission: "We serve to grow the local film and video industry in every way possible, recognizing its huge economic impact in job creation and its unparalleled public relations effects for the region." Within the Filmmaker program, we strive to meet the needs of local media artists and technicians with seminars, business training, and technical training to improve the skills of professionals and launch beginners, provide networking opportunities, a jobs and information hotline, internship programs, health insurance, community outreach, technology updates, screenings, and more. In short, Filmmakers conducts an ongoing dialogue to survey and meet the needs of the local film and video community. We even sponsor the "Set in Philadelphia" Screenwriting Competition!

*Q. Can you tell us about the job hotline?*

*A.* The Hotline is the most popular resource that we provide. Once a week all the jobs that are available to be filled in our regional film and video industry are recorded on (215) 686-3663. And each and every day all job opportunities are updated on our Web site www.film.org. Just go from the home page to the Greater Philadelphia Filmmakers section and click on Hotline. There you'll find job opportunities listed by Cast, Crew, Staff Positions, and Internships. No wonder we're getting over 400,000 hits per week.

*Q. What are some of the resources your Web site provides?*

*A.* In addition to the Filmmakers section and the Hotline, visitors to www.film.org can find out about the local companies that serve the film industry in the Professional Listings section, as well as research the crew and their credits. There are listings for everything that a production might need, including equipment, plus sections with location photographs, contact information for film office personnel, sunrise/sunset and weather charts, a filmography for the region, a film and video events calendar, links to local companies and organizations, and the Production Planner with everything a producer might want to know about filming in the region, including government incentives for filmmaking and permit information. You can even get your own listing, or buy an official crew hat, T-shirt, or other cool crew gear right online.

*Q. What advice can you offer to aspiring digital filmmakers?*

*A.* Be creative, daring, and shoot as much as possible. And always remember that it's still all about telling a good story.

# FILE SIZE IN DIGITAL VIDEO

Every pixel in a frame of digital video contains information. In a standard 640 x 480 frame, there are over 300,000 pixels. Keep in mind that there are 30 (29.97) frames in a single second of video. It is easy to understand why the file sizes in digital video are so huge, running hundreds of megabytes, even gigabytes, depending upon the length and quality of the video clip. Compared to the size of a word processing document, digital video files are enormous. Editing digital video is one of the most taxing things you can do on a computer. Huge amounts of information must be processed, and large files are created and moved regularly.

table | 1-2 |

**FACTORS DETERMINING FILE SIZE IN DV**

1. Resolution (pixels)
2. Frame Rate (fps)
3. Color Depth (bits)

There are three primary factors that determine file size in digital video: resolution, frame rate, and color depth. **Resolution** is the size of the video frame, which is measured in pixels. Frame rate is the amount of frames that are displayed in one second of video, which is measured in frames per second. Finally, **color depth** is the number of colors represented in a video image, which is measured in bits.

| NOTE |

A **render** is the process a computer takes to carry out a particular set of instructions. The term render is commonly used in digital video and 3D animation because significant amounts of time are required to complete regular tasks in both fields.

To edit digital video, you have to understand how to manipulate these factors to control file size. If you were creating digital video for the Internet, you would need to work with very small file sizes. If you were creating digital video content for CD-ROMs, file sizes would be moderate. Likewise, if you were creating digital video for broadcast television, your file sizes would be much larger.

The size of a digital video file directly corresponds with how long it takes to render and move that file. The larger the file, the longer it takes to render and move; the smaller the file, the less time it takes to render and move.

It would be counterproductive to work with digital video files large enough for broadcast television, if you only needed to create digital video for the Internet. There are typical standards used to create digital video for broadcast, multimedia, and the Internet.

# BROADCAST

There are several resolutions used today for broadcast digital video. The resolution for video that was originally shot on an analog video camera is 640 x 480 pixels. The resolution for video that was originally shot on a digital video camera is 720 x 480 pixels. Both resolutions are also referred to as **full-screen video**.

| BROADCAST |
| --- |
| 1. 720 x 480 pixels |
| 2. 30 (29.97) fps |
| 3. 32-bit color |

table 1-3

Furthermore, HDTV can be either one of two resolutions: 1280 x 720 pixels (progressive) or 1920 x 1080 pixels (interlaced). Video is 72 **dpi**, or **dots per inch**, be it for broadcast, multimedia, or the Internet. Images created for the print media are typically a much higher DPI than those created for video.

The frame rate for broadcast digital video is 30 (29.97) frames per second. This is also referred to as **full-motion video**. Video for broadcast television must have a color depth of 32 bits. Waveform monitors and vectorscopes are professional test equipment used to measure the quality of video signals. If you were creating a commercial for television, this equipment would be used to test the video signal before it was broadcast.

Full-screen, full-motion video that is not intended for broadcast is typically 24-bit color. This is often the standard for industrial or prosumer digital video.

Audio is also relevant to the size of a digital video file; however, it is much smaller in comparison to the video portion. Nevertheless, it becomes an issue when smaller file sizes are imperative. Typically, broadcast quality audio is either 48 kHz (digital) or 44 kHz (analog), 16-bit stereo.

| NOTE |

DPI, LPI, or PPI?

DPI (dpi) stands for dots per inch. LPI (lpi) stands for lines per inch. PPI (ppi) stands for pixels per inch. Digital video uses DPI because it is typically used to measure monitor resolution. For a more detailed discussion of the uses of DPI, LPI, and PPI, consult the help guide for Adobe Illustrator or Adobe Photoshop.

| NOTE |

DPI, LPI, or PPI?

A **waveform monitor** measures the luminance portion of the video signal, and a **vectorscope** measures the chrominance portion of the video signal.

# MULTIMEDIA

The conventional standards for multimedia are more flexible than they are for broadcast. It often depends upon the configuration of the computer that will be playing the digital video. Computers with faster processors, faster CD-ROM drives, and a lot of RAM will play larger digital video files more smoothly than slower systems. Typically, digital video to be played on a computer is often quarter screen video. The resolution is usually either 320 x 240 pixels (analog) or 360 x 240 pixels (digital). Again, the dots per inch will be 72 because the computer monitor, like the television set, is only capable of displaying 72 dpi.

table 1-4

**MULTIMEDIA**

1. 360 x 240 pixels
2. 15 fps
3. 16-bit color

The frame rate for multimedia is often 15 frames per second. However, this is one of the factors that may be increased to 30 frames per second if the computer system that is playing the digital video is fast enough. It is less taxing to increase the frame rate to full motion than it is to increase the resolution to full screen. Color depth for multimedia is usually 16 bits, but it can sometimes be increased to 24 bits. Color depth can be adjusted by using the quality slider when compressing digital video. Multimedia audio can be 48 kHz or 32 kHz (digital), or 44 kHz or 22 kHz (analog), 16-bit stereo.

# INTERNET

Because many people still connect to the Internet via phone lines, using large digital video files on the Internet is not a viable option. There are two basic methods for transmitting video over the Internet. First, you can make digital video available as a **downloadable movie**. In this instance, a copy of the entire digital video could be downloaded to the user's computer. This option would take longer to download, but one advantage would be that the user would have a copy of the digital video movie. The movie file would remain on the user's computer until it is deleted.

table 1-5

**INTERNET**

1. 180 x 120 pixels
2. 10 fps
3. 8-bit color

Another, second alternative, is to stream the video over the Internet. **Video streaming** temporarily loads the video into the user's computer, frame by frame, while it plays. This option is faster, but the digital

video file is never actually downloaded onto the user's hard drive. Therefore, the movie cannot be replayed or saved.

The typical resolution standards for the Internet are 160 x 120 pixels (analog) or 180 x 120 pixels (digital). Sometimes these resolutions can even be smaller or larger, as long as they maintain the current aspect ratio. Frame rate is seldom more than 10 fps. Color depth is usually 8-bit color. Audio for the Internet is usually 11 kHz, 8-bit mono, but it could also be 22 kHz (analog) or 32 kHz (digital), 16-bit stereo or higher, if audio quality is a priority.

## DIGITAL VIDEO STANDARDS

Obviously, there are many factors to take into consideration when preparing to edit digital video. First and foremost, you need to be aware of what your end format will be. Will it be for broadcast television? If so, it will need to adhere to professional industry standards. Will it be a training video for a corporation? If so, it needs to be full-screen, full-motion video.

Or perhaps it is for a client who intends to have it distributed on CD-ROM. Will it be played on desktop systems or laptops? What operating system will it be shown on? Can the digital video file be transferred and played off the hard drive? Will it need to be blown up onto a projection screen and shown to a large audience?

Maybe your digital video is created specifically for the Internet. Will it be hosted on a client's Web site and be made available as a downloadable movie? Or, will it be stored on a server that streams video over the Internet? Is it important to have high-quality audio? Does the user need to have a copy of the movie?

## CHAPTER SUMMARY

Many decisions need to be made when editing digital video. Understanding how the factors of resolution, frame rate, and color depth correlate directly to file size, and knowing which digital video conventions are used for broadcast, multimedia, and the Internet, can save you hours of time and effort.

Computer technology has revolutionized the way we edit video. Digital video has made video editing faster, easier, and superior in every way. But more importantly, it has opened the door to a whole new generation of video editors. Virtually anyone can pick up a digital video camera, connect it to a home computer, and start editing video. However, the difference between an amateur digital video editor and a professional one is still distinct; experimenting with the technology is fun, but truly grasping it requires dedication, perseverance, and hard work.

## in review

1. Define digital video.

2. What is the difference between linear editing and nonlinear editing?

3. What is the principle of random access?

4. Name three advantages of digital video editing.

5. What is FireWire (IEEE 1394) and why is it important?

6. Explain the difference between composite and component video signals.

7. What is the NTSC video standard?

8. What is the difference between interlaced and noninterlaced?

9. What three factors influence file size in digital video?

10. What are the conventions for creating digital video for broadcast?
    For multimedia? For the Internet?

## exercises

1. Make flash cards to help yourself learn new terminology. Write any terms you
   are not familiar with on the front of 3 x 5 index cards and their definitions on the
   back. Then quiz yourself until you are familiar with all the terminology. Separate
   any terms that you are having trouble remembering into a pile and spend some
   extra time focusing specifically on those terms.

2. Make two columns on a piece of paper, one for digital video and one for analog
   video. Write down everything you learned from this chapter. Compare and
   contrast their similarities and differences.

3. Make three columns on a piece of paper, one for broadcast, one for
   multimedia, and one for the Internet. Then number one to three under each
   column. Determine the three factors that determine file size in digital video.
   Using these factors, list the conventions for broadcast, multimedia, and the
   Internet. Be specific!

## notes

_____

_____

_____

_____

_____

_____

_____

_____

_____

_____

_____

_____

_____

_____

_____

_____

_____

_____

_____

_____

_____

_____

_____

digital video cameras and tape formats

# *objectives*

Evaluate consumer analog and digital videotape formats

Evaluate prosumer analog and digital videotape formats

Evaluate professional analog and digital videotape formats

Study the primary components of a digital video camera

Learn how to evaluate the features of a digital video camera

# *introduction*

There are three basic classifications of videotape formats: consumer, prosumer, and professional. The quality of the video signal determines which category a videotape format falls into. Keep in mind that video is made up of two parts: chrominance, the color portion, and luminance, the black-and-white portion. The chrominance can be further broken down into the three primary colors of the video signal: red, green, and blue.

## COMPOSITE AND COMPONENT VIDEO

A composite video signal is the lowest quality video signal. Most consumer video products use a composite video signal. In the composite video signal, the chrominance and luminance portions of the video signal are blended together. The next step up in quality is the S-video signal, which would be classified under the prosumer category. In an S-video signal, the chrominance and luminance portions of the video signal are kept separate. The highest quality video signal is the component video signal. In the component video signal, the chrominance and luminance are again kept separate; however, in addition, the chrominance is also separated into the three primary video colors: red, green, and blue.

Another factor in determining the quality of the video signal is the number of horizontal lines of resolution that are displayed. Different video tape formats record and play back different resolutions. They also have different methods of recording the video signal on the tape. Furthermore, different video formats use different size videotapes, typically ranging in size from eight millimeters to one inch in width.

Before you decide which video camera you want to buy, it is important to understand the various videotape formats so you can make an informed decision. Today, most consumers investing in a camcorder should select a digital video camera, as opposed to an analog one. However, it is necessary to understand analog video technology in order to appreciate the higher quality of the digital video signal.

figure | 2-1 |

This S-VHS editing deck adheres to the analog S-VHS videotape standard.

## ANALOG VIDEO

Analog videotape has been around for quite some time, and even though the analog signal is being replaced by the digital signal, you don't want to throw away your VCR just yet. The VHS tape is not going to disappear overnight, despite the fact that DVDs are the fastest growing consumer electronics product of all time. Although the picture quality of VHS is inferior when compared to DVD technology, millions of people have been using the format for years, and it will take some time before VHS is phased out completely.

Likewise, in the professional arena, the industry standard Betacam SP tape format won't go away anytime soon either. Far too many professionals have invested significant amounts of money in Betacam SP technology to throw away their expensive equipment in favor of a digital format. Instead, analog and digital videotape formats will coexist in the professional realm during the transition to digital.

# CONSUMER ANALOG TAPE FORMATS

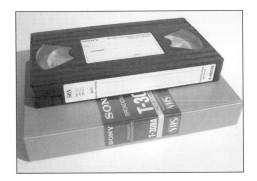

figure |2-2|

VHS videotapes are available in various qualities ranging from consumer to professional grades.

## VHS

While most people know what a VHS tape is, they probably don't know what the acronym really stands for. **VHS**, as it is commonly known, actually stands for **video home system**. The VHS videotape is one half-inch wide and has only 240 horizontal lines of resolution, making it the lowest quality videotape format. VHS video cameras tend to be large, heavy, and awkward.

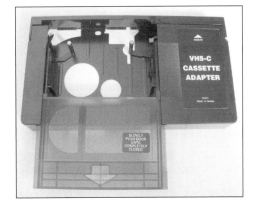

figure |2-3|

An adapter is required for a VHS-C videotape to be played in a VCR.

## VHS-C

A counterpart to the VHS tape is the **VHS-C** video format. It has the same tape size, one half inch, and resolution, 240 lines, as the full-size VHS tape, but it was designed in a smaller, compact form; hence the "C" stands for compact. In order to play the smaller VHS-C videotape format in a regular VHS VCR, the tape must be placed inside of an adapter, which is the size of a standard VHS cassette. VHS-C was created to allow for smaller, lighter video cameras that are easier to handle.

## 8 mm

Although the tape of an **8 mm** videocassette is actually smaller than a VHS tape, it has a slightly higher resolution. However, the primary advantage of 8 mm is really that its small size allows for substantially smaller and lighter video cameras. Its main drawback is that 8 mm tapes cannot be played back directly in a VCR.

figure |2-4|

This is an 8 mm analog videotape.

# PROSUMER ANALOG TAPE FORMATS

## S-VHS

**S-VHS**, or **Super-VHS**, is another videotape format with half-inch-wide tape. However, this prosumer quality video format has 400 horizontal lines of resolution and stereo quality audio. Because the tape is the same size as a regular VHS tape, the video cameras are larger and more cumbersome.

figure | 2-5 |

This S-VHS editing deck can play both standard and Super-VHS videotapes.

| NOTE |

Even though S-VHS tapes are the same size as regular VHS tapes, they cannot be played back in a standard VCR, due to the increased resolution. However, S-VHS decks are capable of playing a regular VHS tape.

## Hi-8

Like the S-VHS tape, the **Hi-8** videotape also has 400 horizontal lines of resolution. However, while it matches the S-VHS tape in video quality, the Hi-8 video format surpasses it in audio quality. It uses high fidelity, Hi-Fi, PCM stereo audio. Like its name suggests, the Hi-8 video format uses a tape that is eight millimeters wide. Therefore, the video cameras are small, light, and easy to handle. Unfortunately, Hi-8 has the same drawback as regular 8 mm: the tapes cannot be played back directly in a VCR.

| NOTE |

Like the S-VHS tape, a Hi-8 videotape cannot be played back on an 8 mm deck or camera, but the reverse is true. A regular 8 mm tape can be played back on Hi-8 video equipment.

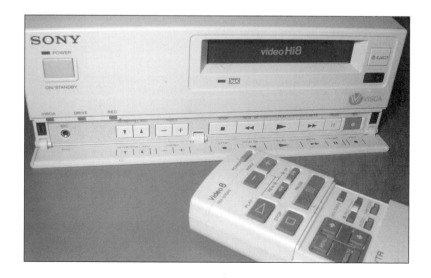

figure | 2-6 |

This computer-controlled Hi-8 editing deck can play both 8 mm and Hi-8 videotapes.

# PROFESSIONAL ANALOG TAPE FORMATS

## Betacam SP

In the professional arena, Betacam SP is the industry standard analog videotape format. **Betacam SP** was developed by Sony and uses half-inch-wide videotape. The "SP" stands for Superior Performance, and its high quality video signal is the analog video format of choice at broadcast television stations, as well as independent video production houses. However, Betacam SP cameras, tapes, and video decks are expensive.

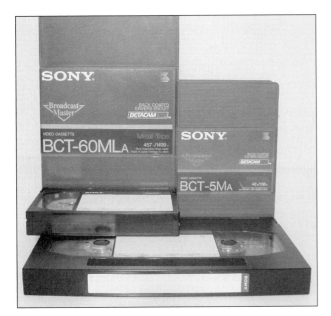

figure 2-7

Betacam SP videotapes are available in large and small formats.

## ANALOG VIDEOTAPE FORMATS

| Consumer | Prosumer | Professional |
|----------|----------|--------------|
| VHS | S-VHS | Betacam SP |
| VHS-C | Hi-8 | |
| 8 mm | | |

table 2-1

This chart depicts the standard analog videotape formats.

# DIGITAL VIDEOTAPE FORMATS

## The Digital Video Standard

Even the inexpensive consumer digital videotape formats rival the picture quality of Betacam SP, so it is no wonder digital video technology is revolutionizing the industry. Originally, a consortium of ten prominent electronics companies came together to develop the digital video standard. Today, there are over sixty companies endorsing the *DV* standard. The original ten companies were: Sony, Panasonic, JVC, Hitachi, Sanyo, Sharp, Mitsubishi, Toshiba, Philips, and Thompson.

They set forth the standard for two types of digital video: SD, Standard Definition, and HD, High Definition (HDTV). The standard DV cassette has 482 horizontal lines of resolution and can record for up to 270 minutes. It uses a digital component signal that is comparable to Betacam SP. Standard DV uses a 5:1 data compression ratio and a type of MPEG 2 video CODEC.

## Compression and Sampling

When the digital video signal is recorded, the video information is sampled and compressed. Again, there are two parts of a video signal: the chrominance, or color portion, and the luminance, or black-and-white portion. The two primary methods for sampling the data are digital component 4:2:2 and digital component 4:1:1.

## Luminance and Color Difference Components (Y, R–Y, B–Y)

The luminance portion of the video signal is designated by the letter "Y." The chrominance portion of the video signal is divided into two parts: the CR component, "R-Y," and the CB component, "B-Y." These sampling methods yield a total bit rate, which is measured in megabits per second, Mb/s. These sampling rates are calculated using the following formula:

**Horizontal Pixels x Horizontal Lines of Resolution x Frames Per Second (FPS) x 8 (Bits of Color Per Pixel)**

table **2-2**

This is the formula for 4:2:2 sampling.

### DIGITAL COMPONENT 4:2:2

**Pixels x Lines x FPS x 8 = Total Bit Rate**

| | |
|---|---|
| Y Luminance: | 720 x 482 x 30 x 8 = 83 Mb/s |
| CR Component: | 360 x 482 x 30 x 8 = 41.5 Mb/s |
| CB Component: | 360 x 482 x 30 x 8 = 41.5 Mb/s |

Total Bit Rate = 124.5 Mb/s

table **2-3**

This is the formula for 4:1:1 sampling.

### DIGITAL COMPONENT 4:1:1

**Pixels x Lines x FPS x 8 = Total Bit Rate**

| | |
|---|---|
| Y Luminance: | 720 x 482 x 30 x 8 = 83 Mb/s |
| CR Component: | 180 x 482 x 30 x 8 = 20.75 Mb/s |
| CB Component: | 180 x 482 x 30 x 8 = 20.75 Mb/s |

Total Bit Rate = 124.5 Mb/s

# CONSUMER DIGITAL TAPE FORMATS

Because the consumer digital video format offers high picture quality at a fraction of the price of similar analog cameras, it is no surprise that the digital video standard has been so widely embraced. Mini-DV and Digital-8 are both consumer digital videotape formats that adhere to the standards set forth by the consortium.

## Mini-DV

**Mini-DV** tapes record on quarter-inch-wide tape for either 30 or 60 minutes and use 4:1:1 sampling. Most leading consumer electronics manufacturers—such as Sony, JVC, Panasonic, and Canon—offer digital video cameras that use the Mini-DV format. Mini-DV videotape records up to 500 horizontal lines of resolution. Audio can be recorded in either two channels at 16-bit 48 kHz, or four channels at 12-bit 32 kHz.

figure | 2-8 |

This a standard Mini-DV consumer videotape.

## Digital-8

Sony also offers digital video cameras that use the **Digital-8** videotape format. The Digital-8 cameras can record on analog Hi-8 or 8 mm videotape. In addition, they are also capable of playing back both Hi-8 and 8 mm tapes. Like the Mini-DV format, the Digital-8 videotape format can record up to 500 horizontal lines of resolution. Digital-8 also records in either 12-bit or 16-bit PCM stereo audio.

# PROSUMER DIGITAL TAPE FORMATS

In the prosumer realm, Sony's DVCAM and Panasonic's DVCPRO are both very popular digital videotape formats. They have superior resolution when compared to consumer digital video. The number and size of the CCDs, charge-coupled devices, directly correlate to image quality. Most

consumer videotape formats have one CCD, or computer chip, that processes the three primary colors of the video signal. Three-CCD, or three-chip, cameras have one chip for the color red, one chip for the color green, and one chip for the color blue. Prosumer and professional cameras usually have three CCDs. The size and type of chips account for the differences in price and quality. The bigger the CCD, the higher the resolution and the more expensive the camera.

## DVCAM

**DVCAM** uses 4:1:1 sampling and quarter-inch-wide videotape format. It records two channels of audio at 16-bit 48 kHz, and four channels of audio at 12-bit 32 kHz. DVCAM is also compatible with standard DV because Sony used a 15-micron-wide track pitch. Therefore, a DVCAM tape can be played back in a standard DV machine and vice versa. However, while in theory it is possible to record DVCAM on a consumer DV tape, Sony advises against it because the consumer DV tape is more prone to drop out. Drop out is the white streaks that occur when video information is missing due to a defect in the videotape. Analog tapes are more prone to drop out than digital tapes. As a rule of thumb, generally the more expensive a videotape format is, the less prone it is to drop out.

figure |2-9|

DVCAM is a prosumer to professional grade videotape.

## DVCPRO

**DVCPRO** also uses quarter-inch-wide videotape format. DVCPRO records at 4:1:1, but will accept and maintain a 4:2:2 signal because it does not resample it, but rather passes it through. Another difference between DVCAM and DVCPRO is that DVCPRO only uses 16-bit 48 kHz audio.

# PROFESSIONAL DIGITAL TAPE FORMATS

The professional digital video cameras use larger and more expensive CCDs to produce upwards of 800 horizontal lines of resolution. Sony's Betacam SX, JVC's Digital-S, and Panasonic's DVCPRO 50 are all professional digital videotape formats. Before the recent advances in digital video technology, older digital formats like D1 and D2 were popular and can still be found in use today.

## Betacam SX

Like its analog predecessor, **Betacam SX** sets the standard for broadcast video professionals. It is the same size as Betacam SP, using half-inch tape format, and it is thus compatible. Betacam SX records 8-bit 4:2:2 component digital video signals. It also supports four channels of 16-bit 48 kHz audio, instead of two like its consumer and prosumer counterparts. Betacam SX offers recording times of up to 124 minutes.

## Digital-S

**Digital-S** also uses a half-inch tape format, 4:2:2 processing, and can record tapes up to 124 minutes on a single tape. It offers either two or four channels of 16-bit 48 kHz audio. However, unlike Betacam SX, Digital-S is capable of playing back S-VHS tapes. While it appears to look like a standard VHS tape on the outside, a special mechanism prevents it from being accidentally loaded into a VCR.

## DVCPRO 50

While **DVCPRO 50** also offers 4:2:2 sampling like Betacam SX and Digital-S, it does so by using two compression chip sets that work in parallel, each using 2:1:1 compression. It uses 16-bit 48 kHz, two-channel PCM audio. Unlike Betacam SX and Digital-S that use a half-inch tape format, DVCPRO 50 uses a quarter-inch-wide tape. Therefore, the cameras are lighter.

### DIGITAL VIDEOTAPE FORMATS

| Consumer | Prosumer | Professional |
|----------|----------|--------------|
| Mini-DV | DVCAM | Betacam SX |
| Digital-8 | DVCPRO | Digital-S |
| | | DVCPRO 50 |

table | 2-4 |

This chart depicts the standard digital videotape formats.

# DIGITAL VIDEO CAMERAS

After determining which tape format best suits your needs, you should evaluate the features and technical specifications of the digital video camera. As in selecting which computer system to buy, it is a good idea to start by identifying a budget. Compare camera models within your target price range with cameras that are one step above your price range and one step below your price range. Doing so will help you to determine if the features are worth the additional cost. The following are elements to consider when buying a digital video camera.

## CCDs

The largest factor separating video camera models in different price ranges is the type of imaging system used. As mentioned previously, CCDs are computer chips that reproduce the video signal by converting an optical image into electronic information. Video cameras have

either one CCD or three CCDs. A one-chip, or one-CCD, camera uses one chip to generate the video image. These are lower in quality and therefore less expensive. A three-chip, or three-CCD, camera uses three different chips to generate the optical image, one for each primary color of the video image: red, green, and blue.

## Viewfinders

Most cameras come with black-and-white viewfinders. The quality of the viewfinder can be determined by how many horizontal lines of resolution it has. Color viewfinders are often available in video cameras that do not have any additional video displays.

## LCD Displays

In addition to the viewfinder, many of today's video cameras offer color LCD displays. Depending on the camcorder model and manufacturer, these displays may fold out and pivot for added convenience, making it easier to see what you are shooting while you are shooting it. They also give the videographer the ability to play back their video on location without having to connect the camera to a television or a portable video monitor. LCD displays usually have independent controls for adjusting the color and brightness of the display, as well as the volume. The display should be evaluated based upon the size of the viewing screen and the resolution.

figure | 2-11 |

The LCD display available on most video cameras provides improved viewing capability.

## Video Inputs and Outputs

In addition to FireWire ports, most digital video cameras also have analog inputs and outputs. These ports should be judged by the quality of their signals. Do they offer composite only, S-video, or component connections?

## Audio Inputs and Outputs

Today, most digital video cameras offer analog stereo inputs and outputs. They usually also have a stereo minijack for connecting headphones. More expensive models offer XLR jacks for professional audio connections.

figure | 2-10 |

S-video, composite, and digital video inputs and outputs are available on this model video camera.

## Microphones

In addition to the audio inputs and outputs, the quality of the camera's built-in microphone should be evaluated. Many cameras offer places to mount and connect additional microphones, and more expensive models can even record multiple channels of audio at controllable frequencies and decibels.

## Timecode

Most digital video cameras can read and write **timecode**, which is an electrical signal that assigns a numerical address to every frame of the videotape. Timecode is measured in and displayed as Hours: Minutes: Seconds: Frames. Higher-end models offer selectable functions that give the users options to control how the timecode is recorded.

## Lenses

Another factor that corresponds directly with the cost of the video camera is the quality of the camera's lens. Also, consider whether the lens can be removed and replaced with a different type, such as a wide-angle lens. There are three basic types of lenses: a normal lens, which has a medium field of view; a wide-angle lens, which has a broader field of view, but distorts the image; and a telephoto lens, which covers a limited field of view, but has the ability to magnify. High-quality lenses that have only one of these capabilities are called **prime lenses**. A **zoom lens** combines all three of the capabilities into a single lens, but sacrifices quality.

No matter which type of lens you buy, it's a good idea to invest in an ultraviolet filter, which can protect the lens from being accidentally scratched and damaged.

Most video cameras will also let you choose between automatic focus and manual focus.

## Zooms

Most digital video cameras come with a zoom lens. As its name suggests, a zoom lens will allow you to move closer to a subject or magnify an area. A 24x zoom will make the subject appear 24 times closer than it actually is in reality. The better the zoom capability, the more expensive the lens. There are two types of zooms: optical zooms and digital zooms. An **optical zoom** is the built-in capability of the lens to magnify, which is determined by the construction of the lens itself. A **digital zoom** is a computer representation of what the image would look like as it is magnified. Digital zooms can dramatically extend a zoom capability of the lens, but the resolution is not as high quality as that of the optical zoom.

figure | 2-12 |

This zoom lens combines normal, wide-angle, and telephoto capabilities into a single lens.

## Exposure Modes

Digital camcorders have automatic exposure modes that are optimized for everything from low light situations to capturing quick actions like those in sports. Exposure regulates the light's intensity over time. Check to see if the camera will allow you to override the automatic settings and adjust your exposure manually.

Exposure is controlled by two factors, aperture and shutter speed. The **aperture** controls the amount of light that is let in by adjusting an opening called the **iris**, which changes sizes to let in more or less light. These sizes are measured in increments known as **f-stops**. The **shutter speed** of the camera controls the rate of exposure of the light. The speed of the shutter is measured in fractions of a second and typically ranges anywhere from 1/4 of a second to 1/10,000 of a second.

## Lighting

There are other features of the video camera besides exposure that relate to light. All light has color, which is called **color temperature**. Daylight is a different color from artificial light. Color temperature is measured in degrees Kelvin (K). Daylight is 5,600 K, while artificial tungsten light is 3,200 K.

### White Balance

The video camera can adjust to the differences in color temperature by resetting its **white balance**. Most cameras will adjust white balance automatically, but higher-end models will allow you to manually control the white balance.

### ND Filter

Another feature that is directly related to lighting is the **neutral density**, or **ND**, **filter**. The ND filter decreases the amount of light to reproduce an image without altering the image's color. ND filters are useful to control overexposure when shooting video outside on a bright, sunny day.

### COLOR TEMPERATURE

| Typical Light Sources (Measured in degrees Klevin) | |
| --- | --- |
| Candle | 1200-1500 K |
| Light Bulb | 2500-3000 K |
| Studio Lights | 3200 K |
| Sunset | 3000-4500 K |
| Sunlight (Noon) | 5400-6500 K |
| HMI Lights | 5600 K |
| Blue Sky | 10,000-15,000 K |

figure 2-13

This camera has built-in neutral density (ND) filter capability.

### Lux

The intensity or brightness of light is measured in **lux**. One lux is the amount of light that falls on a surface area of one square meter when a candle is placed one meter away. Video cameras are rated in lux to identify their ability to shoot in low light conditions. A camera rated to shoot at one lux requires less light to produce an image than a camera rated to shoot at three lux.

## Special Features

Some video cameras offer special features such as image stabilization and night vision. The extra features should also be evaluated to determine if they are worth the additional cost.

### Image Stabilization

Many cameras offer some type of image stabilization to correct the shakiness of handheld camera work. This can be controlled electronically, digitally, or optically. Electronic image stabilization adjusts for shakiness, whereas digital image stabilization prevents the camera from overcompensating when you pan and tilt. Optical image stabilization is more expensive because it uses a set of lenses to adjust for unwanted motion.

### Special Effects

Today's digital video cameras offer a variety of special effects, including fading to and from black, superimposing titles, solarization, and shooting in black and white or sepia tone.

### Night Vision

Some camcorders use infrared technology to shoot up to ten feet away at 0 lux, or no light. The shutter speed is often slowed to allow more infrared light and provide higher contrasting images. Night vision features are usually monochromatic, which means the images are one color.

figure |2-14|

Sony's Memory Stick is one of several removable media formats available on digital video cameras.

### Digital Still Photo Mode

Many digital video cameras offer the additional ability to take still photographs. These resolutions are the same as a single frame of digital video, 720 pixels wide by 480 pixels high at 72 dpi. Photographs can either be recorded to tape or on a removable media like Sony's Memory Stick.

### 16:9 Widescreen Mode

Some higher-end video cameras allow consumers the option of shooting in a 16:9 **widescreen** aspect ratio, as opposed to the standard 4:3 aspect ratio. The widescreen aspect ratio simulates a movie theater perspective by creating an elongated rectangle. Some camera models will also create the letterbox effect by striping black bars across the top and bottom of the video image.

| TIP |

16:9 widescreen mode does not mean the video camera has the high resolution of HDTV. Widescreen mode has the same aspect ratio of HDTV, but not the same resolution. However, you can purchase expensive HDTV video cameras that adhere to the HDTV standard.

### Pass-through

Another useful feature worth searching through the fine print for is the ability to pass an analog video signal through a digital video camera and automatically convert it to FireWire, so a computer can understand the video signal. Without this **pass-through** option, the signal must first be recorded to tape in real-time, and then played back in real-time. For example, a five-minute analog video segment would take ten minutes to convert to FireWire without the pass-through feature—five minutes to record it to tape and another five minutes to play it back.

### Zebra Display

A **zebra display** or indicator is a feature that is available in higher-end digital video cameras. It lets the videographer know if there are parts of the image that exceed the camera's ability to record their brightness by striping zebra-like lines across the specified area.

### 24 FPS

Consumers interested in independent filmmaking can now purchase digital video cameras that shoot 24 frames per second, the frame rate for motion picture film, in addition to shooting at 30 (29.97) frames per second, the frame rate for video. The ability to shoot at 24 fps is important to independent filmmakers because they can have their movies transferred directly from digital form to film at a higher quality than was previously available.

## Other Considerations

In addition to the various features, there are other factors to take into consideration when evaluating which video camera to purchase. A video camera's overall weight and design are also important.

### Weight

Another necessary consideration is the weight of the video camera. How many pounds does the camera weigh, both with and without the battery? The longer you have to hold a video camera, the heavier it feels. If you are planning to shoot more handheld video than video shot with a tripod, you definitely want to take camera weight into account.

### Design

In addition to a camera's weight, the overall design is another factor to consider. Unfortunately, this is difficult to evaluate without actually handling the camera. Even if you decide to buy a video camera at a mail order store, visit a local reseller and try it out. Many people are too intimidated to pick up a camera to see how it handles, but this is really important. For example, is the camera's weight evenly distributed, or is it top heavy? Do you

| TIP |

Be advised that purchasing a video camera that loads the tape from the bottom will mean that you will have to remove the camera from the tripod every time you want to change the tape. This can be a real inconvenience if you frequently use a tripod when shooting video.

like the positions of the viewfinder and LCD display? How does the tape load? Are the zoom controls comfortable and easy to work? It doesn't matter how good the video camera's resolution is if you are not satisfied with its overall design.

### Warranty

Lastly, check to see how long the manufacturer's warranty lasts and exactly what it covers. Be wary of extended warranties. Most often under extended warranties, the video cameras are not actually repaired by the manufacturer, but rather by the manufacturer's authorized reseller, who may or may not have had experience repairing your particular model camera.

## VIDEO CAMERA ACCESSORIES

The following is a list of additional accessories you may want to consider purchasing to get the most of your digital video camera.

- Extra Batteries and Battery Charger
- Carrying Case or Bag
- Fluid Head Tripod
- Ultraviolet Filter
- Extra Cables and Adapters
- Additional Video Tapes
- Mountable Light
- Lighting Kit
- Microphones, Shot Gun and Wireless
- Headphones
- Grounded Indoor/Outdoor Extension Cord
- Video Monitor
- Video Editing Deck

The following is a list of video equipment manufacturers and resellers. Please visit their Web sites to see their complete product lines.

# VIDEO EQUIPMENT

## Digital Video Cameras/Decks

- Sony (www.sony.com)
- Panasonic (www.panasonic.com)
- Canon (www.canon.com)
- JVC (www.jvc-vhs.com)

## Video Monitors

- Sony (www.sony.com)
- Panasonic (www.panasonic.com)
- JVC (www.jvc-vhs.com)

## Tripods and Supports

- Glidecam (www.glidecam.com)
- Steadicam (www.steadicam.com)
- Bogen (www.bogenphoto.com)
- Kaidan (www.kaidan.com)
- Miller (www.miller.com.au)
- Sachtler (www.sachtler.com)
- Vinten (www.vinten.com)
- Cartoni (www.cartoni.com)

## Lights

- Lowel (www.lowel.com)
- NRG (www.nrgresearch.com)
- Frezzi (www.frezzi.com)
- Cool-Lux (www.cool-lux.com)

## Batteries

- Bescor (www.bescor.com)
- Anton/Bauer (www.antonbauer.com)
- PAG (www.pag.co.uk)
- NRG (www.nrgresearch.com)

## Microphones

- Shure (www.shure.com)
- Electro-Voice (www.electrovoice.com)
- Audio-Technica (www.audiotechnica.com)
- Sony (www.sony.com)
- Gitzo (www.gitzo.com)
- Sennheiser (www.sennheiser.com)

# VIDEO RESELLERS

- B & H Photo and Video (www.bhphotovideo.com)
- Markertek (www.markertek.com)

# CHAPTER SUMMARY

Understanding all of the digital videotape formats is an important part of the technology. Regardless of which digital video camera you use, you need to understand the differences in resolution for consumer, prosumer, and professional digital video. It is also important to learn how to evaluate the features of a digital video camera. Selecting the right equipment is one of the most significant steps in creating great digital video.

## in review

1. Compare the analog and digital video standard.

2. What are the commonly used consumer analog and digital videotape formats?

3. What are the commonly used prosumer analog and digital videotape formats?

4. What are the commonly used professional analog and digital videotape formats?

5. What are the two methods for sampling digital video data?

6. What types of video and audio inputs and outputs are available?

7. Which video camera features relate to lighting?

8. What are the three basic types of lenses available for digital video cameras?

9. What kind of special features are available on most digital video cameras?

10. What other types of video equipment are typically used?

## exercises

1. Practice researching video cameras on the Internet. Visit the Web site of a manufacturer like Sony or Panasonic and study the technical specifications of three camera models: one model in your price range, one model below your price range, and one model above your price range. Compare the various features and their costs.

2. Visit an electronics store and examine the video cameras on display. Pick up and try focusing with various camera models to compare their design. Note their weight and how they handle.

3. Compare the resolutions of analog and digital tape formats. Look at the picture quality of a VHS tape and compare it to the picture quality of a DVD.

**notes**

configuring a digital video computer editing system

# *objectives*

Understand the importance of researching a computer purchase

Learn the role of the processor in digital video editing

Understand which digital video elements need to be rendered

Learn the role of the hard drive in digital video editing

Understand the role of FireWire and the video card in digital video editing

Compare the different options for backing up digital video files

# *introduction*

There are many factors to consider when choosing what type of computer to buy to edit digital video. Before you commit to a system, you should determine exactly what your needs are and spend a little time researching the market. Buying a computer, for any purpose, is an important undertaking. Making the wrong decisions can cost you time and money, not to mention countless hours of aggravation.

CONFIGURING A DIGITAL VIDEO COMPUTER EDITING SYSTEM

figure |3-1|

Mail order companies are popular alternatives to local computer stores.

table |3-1|

These are some criteria to consider when evaluating vendors.

### VENDOR CHECKLIST

- ☑ Reputation
- ☑ Warranty
- ☑ Customer Support
- ☑ Return Policy
- ☑ Payment Methods
- ❏ Sales Tax
- ❏ Shipping Charges
- ❏ Installation Charges
- ❏ Location
- ❏ Price Matching

table |3-2|

These are some points to consider when upgrading an existing computer system.

### UPGRADE CHECKLIST

- ☑ Hardware Compatibility
- ☑ Software Compatibility
- ☑ Known Conflicts
- ☑ Money Invested
- ❏ Anticipated Costs
- ❏ Life Expectancy
- ❏ Future Upgrades
- ❏ Overall Value

# DOING YOUR HOMEWORK

Before you decide what kind of computer you want to buy, you should think about where you want to buy it. Today, there are more choices than ever before. You can drive to a local computer store and buy a system; many people still do. However, mail order companies are also very popular, as is the Internet. If you are not in a hurry to buy, area computer shows can offer some great deals.

No matter where you choose to buy your computer, you should make sure your vendor is reputable. What kind of customer support do they offer? What are their return policies? What forms of payment do they accept? You should also shop around because you will save money if you compare prices. Be sure to watch out for hidden costs like sales tax, shipping, and installation charges.

A savvy shopper knows the market. It's always a good idea to read up on the latest industry trends. Sometimes it pays to wait. Timing can be very important, especially if a new product or model is about to be released.

Research is an important step to buying a computer that many people tend to overlook. The Internet is an excellent resource. Most companies have information sheets with technical specifications about their products, as well as information about features and pricing that can be easily downloaded. Major computer magazines have online databases that archive reviews of popular hardware and software. In addition to reading the reviews about a product you are interested in purchasing, it might be prudent to visit the technical support page of that company's Web site to see what problems, if any, other users have had with that product.

# DETERMINING A BUDGET

Once you have familiarized yourself with the products that are available, you can begin to evaluate which type of computer system will work best for you and estimate how much it will cost. Do you want to edit digital video professionally, or as a hobby? Someone who wants to make a career out of editing digital video will need to invest significantly more money in a system than someone who just wants to edit their home movies. The good news is that it is much more affordable to buy an entry-level digital video editing system today than it was before the creation of FireWire.

Hobbyists usually plan to use their computer to do other things in addition to editing digital video, so those factors must be taken into account when upgrading or buying a new computer. Will you still be

able to use your existing hardware and software, or are there potential conflicts? If you have already invested a significant amount of money in your existing computer, you will want to be certain that you will be able to integrate the older technology with the newer technology before making any additional purchases.

Digital video hobbyists can usually begin editing their home movies with a moderately priced system. They usually require a computer with adequate speed and hard drive space, FireWire or a video card, a compatible video camera, and an entry-level video editing software program. Ideally, hobbyists should also have a method for backing up their work, such as a recordable CD-ROM drive.

On the other hand, professionals usually purchase a fast, high-end system with the primary purpose of editing digital video. Because higher-quality video images have larger file sizes, digital video professionals usually require large, fast hard drives. Consequently, recordable CD-ROMs are not sufficient to back up these large files; recordable DVDs are the preferred option. In addition to using a 17-inch computer monitor or larger, editors also purchase a second video monitor to view their work. They purchase expensive video cameras, video cards, and professional digital video editing software programs.

However, regardless of which route you choose to go, there are some basic things to consider when buying a digital video editing computer system, or for that matter, any computer in general.

First and foremost, you need to determine how much money you are willing and able to spend. Once you have a realistic budget, it will dictate what your options are. Begin by pricing systems within your price range. Then look at a system one level higher than your budget and a system one level below your budget. Researching equipment above and below your price range will help you compare features and evaluate whether they are worth the additional cost. Could these features be upgraded or added at a later time?

Having the ability to expand and upgrade a system is very important, especially in the field of digital video, which is always exploiting cutting-edge technology. There used to be an adage that after five years, a top of the line computer system will be obsolete. With the rapid rate at which technology is evolving today, that gap seems closer to three years and continues to decrease. It's usually more practical to focus your budget on buying a fast computer now, that is expandable, and make additional upgrades later, as you can afford them.

table | 3-3 |

These are some of the typical components of an entry-level editing system.

### ENTRY-LEVEL SYSTEM

- ☑ Fast Processor
- ☑ Large Hard Drive
- ☑ FireWire/Video Card
- ☑ Digital Video Camera
- ❏ Video Editing Software
- ❏ Photo Editing Software
- ❏ CD-R/ CD-RW

table | 3-4 |

These are some of the typical components of a high-end digital video editing system.

### HIGH-END SYSTEM

- ☑ Dual Processors
- ☑ RAID
- ☑ Accelerator Card
- ☑ FireWire (IEEE 1394)
- ☑ Digital Video Camera
- ☑ Video Card
- ❏ Video Editing Software
- ❏ Photo Editing Software
- ❏ DVD-R/Authoring
- ❏ 17-inch Monitor
- ❏ NTSC Monitor

| TIP |

You may want to focus your budget on processor speed, as opposed to RAM or hard drive space, which can always be added later. The processor is arguably the most important part of the computer.

| TIP |

Digital video editors usually purchase computers with dual processors to help reduce long rendering times.

If your budget is very small, you may want to consider purchasing a used computer system, rather than a new one. In addition to buying directly from a private individual, many computer companies sell used and refurbished systems with limited warranties. You may also be able to trade in an older computer and apply it toward the cost of a newer one. The Internet and computer user groups are good places to look for privately sold used equipment.

However, whether you need a professional editing system or you just want to upgrade your existing computer to edit home movies, there are several important factors to take into consideration when configuring a computer to edit digital video.

# THE NEED FOR SPEED

If you want to edit digital video, you need a fast computer—the faster, the better. There are several ways to measure the speed of a computer system. The most significant factor is the speed of the processor, or CPU.

## The Processor

The **central processing unit**, **CPU**, is the chip that performs most of the information processing in the computer. Think of the CPU as the computer's brain. The processor's speed is typically measured in *megahertz*, MHz; the higher the megahertz, the faster the computer. Processors are also available in *gigahertz*, GHz, which is 1,000 MHz.

A common misconception regarding processors is that a 500-MHz PC and a 500-MHz Macintosh run at the same speed. However, comparing MHz between Macs and PCs is like comparing apples and oranges. The architecture of the chip design of a Macintosh processor is different from that of a PC. Consequently, a 500-MHz Macintosh is actually faster than a 500-MHz PC.

You can also buy a computer with dual processors, or even multiple processors. With a multiple processor system, the instructions are divided among the processors, which then share the workload and speed up the completion of tasks. The speed of the CPU will determine how quickly your computer will be able to render digital video.

## Rendering

Render is the process the CPU takes to carry out a particular set of instructions or tasks. The term render is commonly used to refer to the high-end calculations required to edit digital video or

create 3D animation. Typically, in digital video editing, special effects like transitions, filters, motion, and transparency require time to render.

A **transition** is a special effect, such as a dissolve or wipe, which appears while you are transitioning from one video clip to another. A **filter** manipulates the video's individual pixels, usually by altering its color. **Motion** can be applied to a video image, a photograph, a title, or a still image or graphic. Motion can zoom in and out, pan left and right, and rotate. **Transparency** shows several images at the same time by using different techniques to combine multiple layers into a single layer of video. These effects can be programmed in popular video editing software, but they do require additional time to render.

figure | 3-2 |

This transition from Track A to Track B, done in Adobe Premiere, is an effect that needs to be rendered.

## Cache

Another variable that directly correlates to the processor speed of a computer is the computer's cache. **Cache** is typically available in level one, L1, level two, L2, or level three, L3, configurations—the larger the cache, the faster the computer.

Simply put, cache works like an electronic storage area, temporarily holding frequently used data for the CPU so the CPU doesn't have as far to go to retrieve it, and hence, cutting down on retrieval time. Cache helps to streamline the work of the processor, thus making it faster and more efficient.

## Memory

In addition to the speed of the processor, RAM is an important factor in the overall performance of a computer. Random-access memory also stores data for the computer to access quickly. It is an integrated circuit memory chip that allows data to be stored, accessed, and retrieved in any order. All software applications, including the operating system, require

figure | 3-3 |

RAM can be added to increase a computer's performance.

RAM to run. The more RAM that is installed in the computer, the faster the computer's overall performance. There are different types of RAM that have different functions. For example, **V-RAM**, or **video RAM**, is used specifically for graphic display functions, such as supporting the colors on a computer monitor.

# HARD DRIVES

Just as your computer can never be too fast to edit digital video, it can never have a hard drive, or HD, that is too large. Most people who edit digital video end up purchasing additional hard drives. Digital video files are huge. They take up hundreds of megabytes, even gigabytes of space. Not only do you need large hard drives to edit digital video, they also need to be fast.

There are different types of hard drives, such as **ATA** (**Advanced Technology Attachment**), **IDE** (**Integrated Drive Electronics**), **SCSI** (**Small Computer System Interface**), and FireWire. All hard drives are either internal or external. An internal hard drive is housed within the computer itself, while an external hard drive is attached outside of the computer, requiring a separate housing, cooling fan, and power supply.

figure |3-4|

Maxtor manufactures external FireWire hard drives in various configurations.

The size of a hard drive is usually measured in gigabytes, GB. There are three ways to measure its speed: by its RPMs, revolutions per minute; its seek time, which is measured in milliseconds; or its transfer rate, which is measured in megabytes. **RPMs** refer to how fast the hard drive spins—the faster, the better. **Seek time** refers to how quickly the hard drive accesses the information on the disk—the lower the seek time, the faster the hard drive. **Transfer rate** refers to the rate at which the hard drive sends and receives data—the higher the transfer rate, the better.

Choosing the right hard drive depends largely on what kind of computer you have and what your needs will be. Will you need to transport large files back and forth between computers? If so, an external hard drive might be a logical choice. Are you going to edit digital video professionally? If so, speed will be an important factor.

## Optimizing Performance

In professional digital video, the file sizes are much larger because quality cannot be sacrificed for size. Often standard hard drives are not fast enough to capture high-quality digital video

without dropping frames. Therefore, many professional digital video editors purchase SCSI accelerator cards and RAIDs.

## SCSI Accelerator Card

A **SCSI accelerator card** is a card that is added to the computer to provide additional throughput so that large amounts of data can be moved quickly. By widening the data path, more information can pass through that path more quickly. Compare a SCSI accelerator card to adding additional lanes on a highway in order to prevent traffic congestion.

figure |3-5|

Adaptec makes SCSI accelerator cards that fit into a computer's PCI slot.

## RAIDs

A **RAID, redundant array of inexpensive disks,** is two or more hard drives working together simultaneously.

RAIDs, also called arrays, can be configured to divide the data and share the workload, similar to the way a computer system with multiple processors works. This process is known as **striping,** or RAID level 0. Level 0 is nonredundant, or not repeating, and is designed specifically for speed. Anyone editing digital video uses RAID level 0. However, RAIDs can also be formatted, or prepared, to record the data in other ways. Levels 2 through 5 are **redundant,** which means that the data is duplicated, and if one drive fails, the files are not lost.

# Formatting

Formatting is an important step in digital video, no matter what type of hard drive you are using. When you edit digital video, you are continually moving large files around on your hard drive. Over time the disk can become fragmented. **Fragmentation** means that a file is no longer written in one continuous space, but rather is broken up into multiple parts scattered across the hard drive. Fragmentation slows down the overall speed of the hard drive.

In order to prevent fragmentation, and increase the performance of the hard drive for digital video editing by optimizing its speed, the hard drive may be periodically reformatted. There are two types of formatting: low-level formatting and high-level formatting.

### Low-Level Formatting

**Low-level formatting** prepares the hard drive for recording data by numerically marking all its sectors and tracks. This stage takes significantly longer than high-level formatting and is relative to the size of the hard drive—the larger the hard drive, the longer it takes to perform low-level formatting.

| TIP |

Professional digital video editors may perform periodic low-level formatting to improve the speed and performance of hard drives used for high-end editing.

figure | 3-6 |

Software is used to format a computer's hard drive.

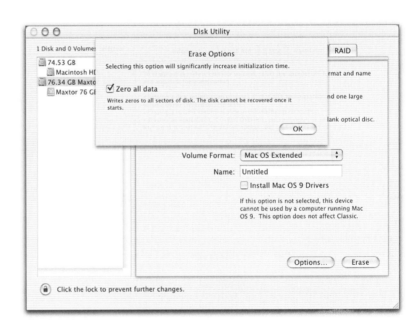

## High-Level Formatting

**High-level formatting** is less intensive. It simply installs a file and directory structure on a hard drive that has already been low-level formatted at least one time. You can high-level format a hard drive to work with a Macintosh or a PC. This is also known as initializing the disk.

When you buy a hard drive directly from the manufacturer, it has already been formatted and is ready to record data. Keep in mind that formatting completely erases all the information on the disk and that information is not recoverable. Therefore, before attempting to format any hard drive, be sure to back up all your software and files correctly.

## Partitioning

**Partitioning** a hard drive is the process of dividing it into sections that are known as volumes. Typically, a hard drive is one volume. However, drives can be partitioned into multiple volumes for different reasons. For example, someone who wants to run more than one version of the operating system on the same computer can partition the drive into multiple segments and then install a different version of the operating system on each volume.

| **NOTE** |

Be sure to back up all of your files before you reformat a hard drive. This information cannot be recovered once the drive has been reformatted, not even with data recovery software.

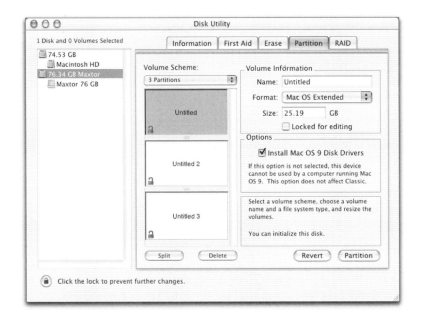

figure | 3-7 |

Hard drives can be formatted into multiple volumes called partitions.

# DV PROFILE

## *Eagles Television Network, ETN*

## Featured on the DVD

The Eagles Television Network, ETN, has set the standard for locally produced broadcast digital video in the mid Atlantic region. Built from the ground up in 1997 by Director of Broadcasting and Executive Producer Rob Alberino, ETN has consistently been a leader in both nominations and victories for private production houses by the National Academy of Television Arts and Sciences, NATA. Some of the programming pro- duced by ETN includes *Inside the Eagles with Andy Reid, Eagles Total Access,* and *The Donovan McNabb Show.* ETN also produces exclusive player features, interviews with the coaches, and game highlights, in addition to covering live events like the Eagles' press conferences, NFL 101, and special events hosted by the team and the Eagles Youth Partnership.

In 2003, ETN traversed over to the live events world and became the production entity in charge of audio and video throughout Lincoln Financial Field, the Eagles's new stadium which opened in July 2003.

64 MID ATLANTIC EMMY NOMINATIONS

13 MID ATLANTIC EMMY VICTORIES

- OUTSTANDING DIRECTOR
- OUTSTANDING EDITOR
- OUTSTANDING LIVE SPORTS COVERAGE SERIES
- OUTSTANDING SPORTS SERIES
- OUTSTANDING CAMERA OPERATOR (nominated)
- OUTSTANDING SPORTS FEATURE
- OUTSTANDING TECHNICAL ACHIEVEMENT
- OUTSTANDING BEST DESIGN
- OUTSTANDING ONE-TIME ONLY SPORTS SPECIAL
- OUTSTANDING COMMERCIAL CAMPAIGN

## Dana Heberling

**Position:** Editor, Eagles Television Network, ETN

**Number of Years in Current Position:** Two

**Number of Years in Field:** Sixteen

**Degree:** Bachelor of Arts, Radio, Television, and Film, Temple University

**Previous Work Experience:** Production Equipment Coordinator, Audio Production, Field Production, On-line Post-production

**Special Skills:** Adobe After Effects, Avid Symphony, Adobe Illustrator, Adobe Photoshop

**Job Note:** Dana has won several Emmys in several categories for his work as a feature editor, as well as back to back Best Editor wins. On game day, he operates the DNF Shot Box, which is the controller that selects all of the digital video segments that appear live on the Daktronics Pro Star Video Displays at either end of the stadium at Lincoln Financial Field. In addition, Dana's duties include editing, designing, and directing.

**Advice to Students:** "To enter this field you need to have a real desire to do so. As much glamour as there seems to be, there are also long, strenuous hours and work involved. This is not a 9 to 5 career. Some of my favorite projects were also the longest and hardest and were usually finished around 2 to 3 in the morning. As grueling as it can be though, I love the creative outlet it provides. I never dread going to work in the morning as many people often do. This is not a job. It is a career. As a career you must also stay on top of changes in technology. If you are standing in place, you are falling behind. As a former analog on-line editor, I found it very important to learn nonlinear editing—After Effects, Photoshop, etc.—to further my career. To wrap this all into a simple thought, stay hungry and you will succeed."

# DV PROFILE
## *continued*

### *Eagles Television Network, ETN*

## Ron Schindlinger

**Position:** Editor, Eagles Television Network, ETN

**Number of Years in Current Position:** Two

**Number of Years in Field:** Ten

**Previous Work Experience:** Sound Designer, Graphics Designer, Avid Editor, and Graphic Artist

**Special Skills:** Avid Symphony, Adobe Creative Suite, Adobe After Effects, Acid 4.0, and Cakewalk Sonar

**Job Note:** Ron edited the Philadelphia Eagles' stadium grand opening video for the unveiling of Lincoln Financial Field, which premiered on Monday Night Football in 2003. His work was recognized by both local and national media as a "Super Bowl caliber event" and "one of the greatest video openings for a building ever." In addition to editing, Ron's duties also include designing and directing.

**Advice to Students:** "Education is important, but I think that it is equally vital to observe the work of others in the field. The inspiration of seeing work that you like can affect your projects greatly. Being a musician, music has always driven my editing and design. I always try to select the music choices first. The flow of the edit is often dictated by the tempo and the mood of the piece. Finally, without a voracious appetite for learning new technologies and programs, you will find yourself falling behind the curve. Being able to always offer your clients something new is invaluable."

# Robert Alberino

**Position:** Director of Broadcasting and Executive Producer, Eagles Television Network, ETN

**Number of Years in Current Position:** Eight

**Number of Years in Field:** Fourteen

**Degree:** Bachelor of Arts in Media Production and Sound Recording Technology (Dual Major) with a Minor in Still Photography, Duquesne University

**Previous Work Experience:** Associate Development Director, National Public Radio Station; Associate Director, ABC Sports Affiliate; Associate Producer, Production House; Producer/Director, College Football Programming; Filmmaker, NFL Films

**Job Note:** My favorite project that I worked on was the initial creation of shows for the Eagles. In 1997, I was asked to create ETN from the ground up—carte blanche—and I was asked by ownership to simply "Make our regional shows look national." This task was daunting, as we did not own a piece of equipment at the time—no camera, no decks, not even a place to edit what we would eventually shoot. As a matter of fact, there was no room for me at Veterans Stadium, so I was given a makeshift office in the mailroom. I created relationships in the city with post and rental houses and rented all of the equipment that I needed to get the startup off the ground, and then I spent eight straight hours at a local diner conceiving the shows. I did not plan on it, but halfway through a grilled cheese sandwich, the ideas came and

when they come, you have to be prepared. I asked the waitress for a pen and started writing and formatting the shows on table napkins, and soon, I had three shows plotted out. Eight hours later the shows were on paper, so to speak. To this day, the formats remain the same, and the project was—and I did not realize this at the time—the Genesis of ETN and the benchmark for the shows we produce and what many other teams produce as well.

**Advice to Students:** "In my estimation, persistence and ambition combined with common sense are the most valuable assets when trying to enter the field of production. I receive resume upon resume from young producers and editors who are hoping to break into our group. I search for the person who is most apt to learn, take risks, take initiative and become valuable through using their instincts and common sense, as opposed to theory that they have been taught. I feel that I can teach anyone to be a great producer, director, camera operator or editor. It is becoming a versatile businessperson and team member that will separate the great from the exceptional."

# FIREWIRE AND VIDEO CARDS

Either FireWire or a video card is required to capture video and output it to tape again.

## FireWire (IEEE 1394)

FireWire is Apple Computer's trade name for the interface IEEE 1394. It is an international standard that allows high-speed connections and transfer rates between a computer and peripherals.

FireWire can be used to connect a digital video camera to a computer. Most major electronics manufacturers have adopted FireWire technology. Sony has its own version called i.LINK, which adheres to the IEEE 1394 standard.

FireWire has revolutionized the digital video industry by allowing digital video cameras to communicate directly with the computer. Digital video hobbyists can purchase a FireWire card for their PCs. FireWire comes built-in on all Macintosh computers, so there is no need to purchase an additional card.

## Video Cards

However, the creation of FireWire did not lead to the extinction of the traditional video card, which translated the analog video signal into digital form, rather it led to its evolution. There is a new generation of video cards that do more than just convert the analog signal into a

figure | 3-8 |

Matrox makes video cards that work with popular digital video editing programs for both PC and Macintosh computers.

digital one. These new video cards, with both analog and digital video support, offer multiple layers of **real-time** video editing. This means that special effects created in popular video editing software programs, such as basic transitions, motion, and transparency, no longer have to be rendered before they can be viewed.

Many of these video cards also support a second computer monitor and an NTSC video monitor for previewing and playing the video. Without a video card, a FireWire camera must be attached while editing in order to view the video in its actual resolution. Many professional digital video editors will purchase one of these new video cards because the added features will save time and money. The next generation of video cards can range in price from $600 to thousands of dollars. Manufacturers of popular video cards include Avid, Pinnacle Systems, Media 100, and Matrox.

## CODECs

Whether you are using FireWire or one of the newer generations of video cards, the digital video files are compressed using a CODEC.

A **CODEC** is a mathematical algorithm used to decrease the file size of a video image. Because digital video files are so large, they need to be compressed to make them more manageable.

Typically, a high-quality, five-minute digital video clip, compressed using the **DV-NTSC** (used by FireWire) CODEC, will occupy over a gigabyte of hard drive space. There are many different types of CODECs; *MPEG* and *Cinepak* are two popular ones. Cinepak is often used for CD-ROMs, while MPEG is used for DVDs. Most CODECs are software-based, meaning they don't require any additional hardware to be viewed.

However, certain video cards require hardware CODECs as well. If you are purchasing a video card, check to see if it requires a hardware CODEC, or if it also has a software CODEC available. If it does not, you will not be able to view digital video files recorded with that model video card's CODEC on any other computer that doesn't have that model video card installed. If the video card has a software CODEC, you can move the digital video files to any computer and view them by installing the software CODEC into the operating system.

| NOTE |

CODEC is short for Compression/ Decompression.

figure |3-9|

In Adobe Premiere, there are various software CODECs from which to choose using QuickTime.

# BACKING UP

Now that you've spent hours and hours editing and have gigabytes of digital video, what do you do with all that information? Capturing and editing digital video is only part of the process. Backing up your data is a critical stage of digital video editing. You'll need to save your work if you want to go back and make changes to it later.

Although there are various alternatives for backing up your digital video files, there are three primary factors to consider: size, cost, and speed. Hard drives and removable hard drives, such as Jaz drives, are not viable alternatives because they are too costly to stack up and leave sitting on a shelf. Digital video editors usually use DAT, recordable CDs, or recordable DVDs to back up their files.

## DAT

**| NOTE |**

There are also other recordable tape formats, such as 8 mm and quarter inch.

**DAT**, **digital audio tape**, was originally introduced as a way to record music digitally. Although DAT is still used in the audio industry today, it has also been adapted to back up data. A DAT drive records digital information onto a small, 4 mm tape. The tape can also be erased and rewritten.

DAT is an economical way to back up large files because it can hold between 40 GB and 80 GB on a cartridge that retails for approximately $50. A DAT drive retails for $700 to $1,500. More expensive DAT drives are capable of backing up over 300 GB of data at one time. However, there is a drawback to backing up on DAT: the speed is relatively slow.

## CD-Rs

**CD-Rs**, recordable compact discs, are a cost-effective way to back up moderately sized files quickly. A CD-R typically holds between 650 MB and 700 MB and costs less than $1 per CD. With the advent of DVDs, CD burners have dropped dramatically in price, now retailing for under $100.

You can also purchase a rewritable CD drive and media, CD-RW. Unlike a regular CD, the data on a CD-RW can be rewritten. CD-RW drives are approximately $100-$150 and CD-RW media is less than $1 per CD.

## DVDs

Today, the best choice for backing up gigabytes of files is DVD. DVDs are fast and moderately priced. Currently, DVDs can store between 4.7 GB and 9.4 GB per disc; however, the next generation of recordable DVDs are estimated to hold 27 GB per disc.

DVDs are available in a variety of formats, only some of which can be played back on both a computer and a standalone DVD player. The formats include DVD-R, DVD-RW, DVD+R, DVD+RW, and DVD-RAM. Each format has significant financial backing from multiple computer and electronics companies, so currently picking a DVD drive is a tricky business. The next generation of DVDs is based on a blue laser light technology. Reportedly, the same standard is endorsed by most of the major manufacturers.

You can also buy certain DVD drives that will record CDs and CD-RWs. DVD drives range in price from $300 to $600; the media ranges from $4 to $20.

table **3-5**

DVD is the preferred option for backing up large digital video files quickly and cost-effectively.

### BACKUP OPTIONS

| Method | Capacity | Cost | Speed |
|--------|----------|------|-------|
| DAT | Large | Inexpensive | Slow |
| CD-R | Moderate | Inexpensive | Fast |
| DVD | Large | Moderate | Fast |

## CHAPTER SUMMARY

Whether you are editing digital video professionally or as a hobby, and whether you are buying a Mac or a PC, you'll need a fast computer, a large hard drive, FireWire or a video card, and a method to back up your files. You'll also need digital video editing software and a compatible video camera.

Also available are related hardware and software, such as scanners and graphic design programs, which are not required, but preferred, for creating digital video.

Configuring your own digital video editing system is a technical process that requires careful planning and research. While you can purchase a preconfigured system with a hefty price tag from a vendor, you need to understand digital video and computer technology to do it well.

Digital video pushes the current computer technology to its limits and will probably continue to do so for years to come. Therefore, in order to be able to troubleshoot your editing system when problems occur—and eventually they will occur—you need to understand how the hardware and software work. Otherwise, you are at the mercy of a technical support person who may or may not be an expert in digital video. Today, most hardware and software vendors charge for technical support after the initial "free support" time period has expired.

When you are ready to buy a digital video editing system, be wary because some sales people will sell you anything. If you arm yourself with technical specifications, reviews, and pricing, and have a fundamental understanding of both computer and digital video technology, you will save yourself time, money, and aggravation. So, do your homework!

## in review

1. What factors should be considered when determining a budget for buying a digital video editing system?

2. What is the role of the processor in digital video editing?

3. What special effects typically need to be rendered in digital video editing?

4. What is cache and how does it contribute to the overall speed of a computer?

5. What is the difference between RAM and V-RAM?

6. What is the role of the hard drive in digital video editing?

7. How can you optimize hard drive performance?

8. What is the role of FireWire and the video card in digital video editing?

9. What is a CODEC and why is it important in digital video editing?

10. What are the different options for backing up digital video files?

## exercises

1. Open up your computer and look inside. DO NOT touch anything. Static electricity can damage the computer. Identify the hard drive, RAM, and the expansion slots.

2. Think about your "dream" computer editing system. Write down all the hardware you would like to have, and price it using mail order catalogs or the Internet.

3. Research hard drives on the Internet. Be sure to look at different types, including RAIDs.

# Screenplay

Plot Point 1
(Pages 25-27)

Plot Point 2
(Pages 85-90)

EXT.            THE WORTHINGTON RESIDENCE            DAY

ESTABLISHING SHOT of an expensive suburban home.  MR. WORTHINGTON,
a well dressed man in his thirties, arrives home early from work.

INT.          FOYER          DAY

# Production

Mr. Worthington takes off his sunglasses and looks at the RINGING telephone.
He removes his overcoat and hangs it in the closet.  The telephone RINGS again.
He sets his briefcase on an endtable and peers into the living room.

# Schedule

            MR. WORTHINGTON
      Charles?  Charles?

There is no reply and the phone continues to RING.  Mr. Worthington grows
annoyed and mutters under his breath.

# Storyboards

# *objectives*

Learn the principles of script writing for film and video

Understand the paradigm of a dramatic structure

Learn how to frame basic camera shots

Learn how to create a storyboard

Learn how to create a production schedule

Understand the importance of obtaining permits and release forms

# *introduction*

It all starts with a great idea, but it takes a lot of planning and preparation to turn that idea into a reality. No matter what your video project is, the more time and effort you invest in preproduction, the better your final result will be. The **preproduction** phase of the video process is all the work that precedes the actual video shoot. It begins by developing your idea in writing, then visualizing it by creating storyboards. Finally, the storyboards are broken down into a production schedule. Then the shooting begins.

**DIGITAL VIDEO PREPRODUCTION**

# SCRIPT WRITING

The first phase of preproduction is to get your great idea down on paper. Depending on the project, this written phase can take many forms: a proposal, a treatment, a screenplay, a television or video script, or a voice-over script.

## Proposals

The **proposal** can be anywhere from one page to well over a dozen. It has no fixed form and can change accordingly with every project. You can write a proposal for a personal video, a television commercial, or even a film. Its purpose is to force you to articulate the vision in your head. This process can be very valuable. By explaining your ideas for the project, potential problems and challenges can be anticipated in advance.

First, begin by summarizing your idea in a sentence or two. This is the theme of your project, and you want to avoid straying from it. Refer to it from time to time to refocus your ideas and help yourself stay on track. Next, determine who will be in your video and describe in detail what their roles will be. Identify the necessary locations and their relevance to your project. Finally, outline the story or the information you need to convey.

figure | 4-1 |

Here are some ideas to help you get started writing.

### GETTING IT DOWN ON PAPER

✍ **Always keep a notebook or journal handy.** Jot down your ideas wherever and whenever you think of them.

✍ **Make a list.** Start by writing down everything you may want to say, then group common themes, discard irrelevent ones, and organize your topics into an outline.

✍ **Just sit down and write.** Write down the first thing that pops into your head, keep writing without stopping and soon your thoughts will begin to sort themselves out on paper. Once you clear the "brain clutter," you will figure out what you want to say.

## Treatments

The film or television **treatment** is much more involved than the proposal. It can be as much as half the length of your finished project. For example, a treatment for a two-hour film can be as long as sixty pages. The treatment is more formal than the proposal. In a treatment, you should fully develop your story and characters. A typical film treatment tells the story and describes the characters, but uses little or no dialogue.

## Screenplays

A **screenplay**, or film script, follows a specific structure. When written within that format, one page of a screenplay is roughly equivalent to one minute of screen time. The screenplay is organized by scenes, or the various locations where filming will take place. It specifies whether the scene will take place inside (interior) or outside (exterior). The approximate time of day is also included. Descriptions and actions run the width of the page, from the left margin to the right. Dialogue is centered on the page underneath the name of the speaker. When a character is first introduced, the character's entire name is capitalized. Sounds are also written in capital letters.

These conventions all have a purpose: to facilitate the film-making. It is important to know the time of day because it impacts the lighting of a scene. Whether a scene takes place indoors or out is of paramount importance because it will dictate what type of film stock is used. (Keep in mind that daylight and artificial light have different color temperatures.) The conventions for screenwriting have been in place for a long time, and if you wish to break into the business, you must take the time to learn them.

There are software programs, like Final Draft, that are available to help with the formatting. There are also many books written about how to write a screenplay. One of the more acclaimed teachers of screenwriting is author and speaker Robert McKee. His book *Story* and his seminars on screenwriting are well respected in the industry.

---

### SAMPLE SCREENPLAY FORMAT

#### *The Butler Did It*

EXT.                THE WORTHINGTON RESIDENCE                DAY

ESTABLISHING SHOT of an expensive suburban home. MR. WORTHINGTON, a well-dressed man in his thirties, arrives home early from work.

INT.            FOYER            DAY

Mr. Worthington takes off his sunglasses and looks at the RINGING telephone. He removes his overcoat and hangs it in the closet. The telephone RINGS again. He sets his briefcase on an end table and peers into the living room.

                    MR. WORTHINGTON
                Charles? Charles?

There is no reply and the phone continues to RING. Mr. Worthington grows annoyed and mutters under his breath.

                    MR. WORTHINGTON
                Where is that butler?

He walks over to the phone and answers it.

                    MR. WORTHINGTON
                Hello? Roger Worthington here.

He removes a handkerchief from his jacket and begins to polish his sunglasses.

                    MR. WORTHINGTON
                Oh hello Maggie. No I finished early today.
                Really? What time was she supposed to
                be at the club? I'm not sure…I just walked
                in the door. Yes, yes, I know how she so
                looks forward to tennis with Swen. Hold
                on, I'll see if she's here.

Mr. Worthington puts down the receiver and starts for the steps.

---

figure | **4-2**

The inspiration behind this short screenplay came from a joke. It is written in conventional film style.

figure | **4-3** and **4-4** |

> MR. WORTHINGTON
> Clarisse?
>
> INT.            HALLWAY            DAY
>
> Mr. Worthington arrives in the hallway to find the master bedroom door ajar. He is about to push it open when he hears VOICES.
>
> MRS. WORTHINGTON
> Charles, dear, take off my dress.
>
> CHARLES
> Yes, madam.
>
> The dress falls in a crumpled pile visible from the partially open door.  CLOSE - UP of a very surprised Mr. Worthington.
>
> MRS.  WORTHINGTON
> Charles, take off my bra.
>
> CHARLES
> Certainly, madam.
>
> The bra falls near the dress.  EXTREME CLOSE-UP of the shocked expression on Mr. Worthington's face.
>
> MRS.  WORTHINGTON
> Now Charles, take off my shoes and stockings.
>
> CHARLES
> Yes madam, if you insist.
>
> One high heeled shoe lands on the dress, the other close by.
>
> MR. WORTHINGTON
> (whispering)
> My God!  Clarisse!
>
> The stockings land on top of the pile.  CLOSE-UP of Mr. Worthington's hand reaching tenatively for the door knob.

> MRS. WORTHINGTON
> Now Charles, take off my---
>
> Having had enough, Mr. Worthington slowly pushes the door open.
>
> INT.            MASTER BEDROOM            DAY
>
> A fully clothed MRS. WORTHINGTON is reprimanding the naked BUTLER.
>
> MRS. WORTHINGTON
> I'm warning you Charles, if you want to keep
> your job, don't let me catch you wearing my
> clothes again!
>
> An embarassed Charles, visible from the waist up, attempts to cover himself as he walks past a dumbfounded Mr. Worthington. Charles exits and the door shuts.

## The Premise

Before you begin writing, you need to be able to summarize the idea of your screenplay in a single sentence. This is called the **premise**. What is your story about? If you read the television listings, the show descriptions would be good examples of premises. Start by creating premises for movies you have already seen. For example, "A young boy befriends an alien who is lost and longing to go home" would be the premise for the movie *ET*. Once you have established the premise, you can use it to stay focused.

## Types of Conflict

All good stories have conflict. The **protagonist**, or hero of the story, is always faced with some kind of challenge that has to be overcome. There are five basic categories for conflict in a dramatic structure.

- Man versus Man
- Man versus Nature
- Man versus Society
- Man versus Himself
- Man versus Machine

Man versus man is a type of conflict as old as storytelling itself. There is a hero and a villain. There is a good guy and a bad guy. The bad guy, the **antagonist**, is the adversary of the protagonist. The movie *Speed* with Keanu Reeves and Dennis Hopper would be an example of man versus man conflict. Keanu Reeves is the protagonist, out to stop mad bomber Dennis Hopper, the antagonist.

The type of conflict man versus nature is easy to discern. The protagonist is faced with battling some force of nature and the perils it may cause. In the movie *The Perfect Storm*, a film based upon actual events, the crew of the fishing boat *Andrea Gale* was faced with the conflict man versus nature when they encountered a terrible storm at sea.

In man versus society, the protagonist is fighting the system, be it a culture or subculture, or society's norms, laws, or values. The protagonist may also be fighting an individual who is symbolic of a larger whole. In the movie *Philadelphia*, the protagonist, Denzel Washington, is fighting the stigma and injustices society has put upon people with AIDS.

You can also trace the conflict man versus himself back through history. In man versus himself, the protagonist is his or her own worst enemy. The protagonist must battle with himself and face his inner demons. The most classic example of man versus himself is William Shakespeare's *Hamlet*. "To be or not to be. . . ."

The last type of conflict is a relatively new one. In man versus machine, the protagonist is fighting against technology. In recent years, the computer age has spawned many films dealing with this theme. The movie *The Terminator* is credited with establishing the conflict man versus machine. The protagonist, Linda Hamilton, must escape a killing machine sent back in time to terminate her.

### The Paradigm of a Drama

No matter which category of conflict your story falls into, it needs to have the basic elements of any story: a beginning, middle, and end. This standard three-act formula for a drama is called a **paradigm**.

 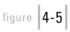

The formula for a dramatic screenplay is a three-act structure called a paradigm.

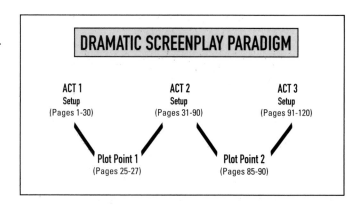

### Act One

During the first act of a screenplay, the characters are introduced, the place and time is set, and the main idea of the story is identified. This is called the **setup**. The first ten pages of a screenplay are the most crucial because studies have shown that is how long it takes for people to make up their minds as to whether or not they like a film. For a two-hour movie, the entire first act typically runs thirty pages long.

### Plot Point One

At the end of act one is the first plot point. A **plot point** is an event that swings the story into another direction. In the movie *Star Wars*, the protagonist, Luke Skywalker, learns that his family has been murdered, and he decides to join the fight against the evil empire. The entire story changes direction at this point.

### Act Two

The second act of a screenplay is called the **confrontation**. This is where most of the story takes place because it is where most of the conflict occurs. The second act is approximately sixty pages of a two-hour film.

### Plot Point Two

At the end of act two, the second plot point occurs. Once again this plot point changes the direction of the story. The entire second act has been building up to this moment. The second plot point in *Star Wars* would be when Luke Skywalker tries to blow up the Death Star. He abandons his computer guidance targeting system and decides to trust the force. (Of course, he succeeds and saves the universe!)

## Act Three

The final act of a screenplay is the **resolution**. During the third act, the conflict is completely resolved and all the loose ends are tied up. Failure to resolve the conflict runs the risk of having the audience feeling unsatisfied. Cliffhangers are notorious for their abrupt endings. In a two-hour film, the resolution is typically thirty pages long.

While there are variations on the page lengths of the acts, most films follow this basic three-act structure. There are always exceptions to the rule, but this paradigm has proven to be successful.

## Television Scripts

Writing for television is more structured than writing for film because time dictates how a story unfolds. Stories are written with the commercial breaks in mind to keep the audience tuned in. In daytime television, soap opera writers often write in teams, with each writer being responsible for a different story line.

Television scripts take on various forms depending on their purpose. A script written for a commercial or PSA (public service announcement) that is to be filmed in the television studio would include camera and technical directions. Regardless of the type of show, a television script needs to be precise; timing is everything.

## Voice-Over Scripts

A **voice-over script** is provided to the narrator or narrators who will record a voice-over to convey additional information not conveyed in on-camera dialogue. Timing is also important here, as parts of the script need to coincide with the various shots.

The voice-over script can be approached in one of two ways: by writing first and filming second, or vice versa. Ideally, the script is written first, conveying all the necessary information. Then the video is shot specifically to complement each segment of the script. However, this isn't always the case. Sometimes the video is shot first and the story

figure | 4-6 |

This is one version of a script written for television.

figure | 4-7 |

| SAMPLE VOICE-OVER SCRIPT | | |
|---|---|---|
| Client: | **PRO SET** | |
| Title: | **Poly Pro** | |
| Date: | **January 27, 2003** | |

| TIMECODE | VIDEO | AUDIO |
|---|---|---|
| 00:00:00:00-<br>00:00:10:00 | Color Bars | (Tone) |
| 00:00:10:00-<br>00:00:13:00 | Black | (Silence) |
| 00:00:13:00-<br>00:00:18:00 | Pro Set Logo | (Music fades in.) |
| 00:00:18:00-<br>00:00:33:00 | Poly Pro Animation | Poly Pro is an industrial coating made of a polyurea spray elastomer. Recent advances in spray elastomer technology have lead to the development of polyurea. |
| 00:00:33:00<br>00:01:00:00 | Application Video Super Titles | Pro Set has refined this technology, improving its strength, texture, adhesion, and elongation, thus making Poly Pro the ideal industrial coating for a multitude of applications. |

This is a portion of a voice-over script written for a client who produces industrial spray coatings.

evolves around it. In this instance, the video dictates the story, and the script is tailored to fit it.

A typical voice-over script lists the timecode numbers on the left, the video in the middle, and the audio on the right side. Any audio that is not being read out loud, like music and sound effects, needs to be distinguishable. If there are multiple narrators, the names of the characters/narrators are listed to differentiate everyone's part. A brief description of each video segment is provided. The timing of a voice-over script is critical, so it is important that the times allotted for each segment be sufficiently long enough for the narrator to read the copy.

The following are suggestions for recording your own voice-overs in a nonstudio environment. The tips are intended for personal projects, not necessarily for professional productions.

1. Practice the timing of your voice-over, using a stopwatch.

2. Read clearly and steadily, at an appropriate pace.

3. Make certain that you are speaking loudly enough.

4. Don't speak too closely into the microphone.

5. Avoid popping your Ps. (The sound of the letter P is the loudest and makes a popping noise.)

6. Turn off the ringers of any telephones.

7. Turn off the heat or air conditioning so it doesn't start up during the middle of your recording session. Also, certain florescent lights can have a loud hum.

8. Post signs and alert people to be quiet while you are taping.

9. Isolate yourself from distractions, like pets and kids.

10. If possible, record to tape so you can easily play it back and check your timing.

# THE ART OF CREATIVITY

## *robin landa*

Robin Landa is an accomplished author of books on art and design. A professor at Kean University, Robin gives lectures around the country and has been interviewed extensively on the subjects of design, creativity, and art. She also serves as a creative consultant to major corporations.

Creativity seems mysterious. When I ask illustrious creative directors, art directors, designers, and copywriters how they come up with creative ideas, many claim that they don't know. Some say they don't think about a problem directly, but, rather, go off to take in a film or museum exhibit and a solution seems to come to them in a state of relaxation. Other creatives are able to articulate something about their thinking process:

"I noticed how…"

"I saw that and thought of this."

"I heard someone say…"

"I thought, What if…"

After years of doing research into creative thinking—observing, teaching, designing, writing, formulating theories, and interviewing hundreds of creative professionals—I noted some fascinating commonalties among creative thinkers. What seems to distinguish a creative mind may seem, at first, unremarkable; however, upon further examination, one can see why the following markers can yield rich creative output.

**BEING SHARP-EYED** Part of almost any design or art education is learning to be an active viewer/seer. Whether you learn to draw a blind contour or observe the position of forms in space, you learn to be completely attentive to the visual world. Maintaining that state of alertness, of being a sharp-eyed observer, allows one to notice the inherent creative possibilities in any given situation. Being watchful when observing one's surroundings, everyday juxtapositions, allows one to see what others may miss or not even think is of note.

**BEING RECEPTIVE** If you've ever worked with or lived with a stubborn person, then you know the value of a person who is flexible, open to suggestions, other opinions, constructive criticism, and different schools of thought. Receptivity, as a marker of creativity, means more than being open to ideas. It means embracing the notion of incoming information, and new ideas. Being flexible allows one to let go of dogmatic thinking, and to shift when necessary, to bend with the path of a blossoming idea.

**COURAGE** Having the courage to take risks is part of the creative spirit. For many, the fear of failure or appearing foolish inhibits risk-taking. Fear squashes that inner voice urging you to go out on a creative limb. Fearlessness coupled with intellectual curiosity, a desire to explore and be an adventurer, an interest in many things (not just one thing), rather than play it safe and comfortable, feeds creativity.

**ASSOCIATIVE THINKING** The ability to connect the outwardly unconnected feeds creative thinking. Bring two old things together to form a new combination. Merge two objects into a seamless different one. Creative people seem to be able to arrange associative hierarchies in ways that allow them to make connections that might seem remote to, or even elude, all others.

Creativity is truly a way of thinking, a way of examining the world and interacting with information and ideas. Whether you're designing a book jacket or taking a photograph doesn't matter. What matters is how you think about almost anything. When you are sharp-eyed, stay receptive, have courage, think associatively, and approach life with energy, then your work will be buoyed.

# STORYBOARDS

After the script is written, it is broken down shot by shot and storyboards are drawn. **Storyboards** are used in television, film, video, and even 3D animation. In storyboards, the composition of the video frame is decided. While they can be time consuming to create, storyboards facilitate the video shoot and save time and money in the long run.

## Format

The size and layout of storyboards can vary depending on their intended uses. Some require great artistry and color, while others can be simple pencil sketches that are a means to an end. Regardless of their purpose, storyboards usually convey the following information. The shot number and type of shot are clearly labeled at the top. An accurately framed picture of the subject of the shot is drawn in the box. In a separate box underneath the picture, there is either a description of the shot, dialogue, or a combination of both.

## ECU, Extreme Close-up

The **extreme close-up**, or **ECU**, is a shot that is usually reserved for dramatic effect. Typically, a succession of tighter and tighter shots leads up to the ECU, building dramatic tension. The ECU occurs at the most crucial moment. The chin remains completely in frame during the ECU, so it doesn't get cut off when an actor opens his mouth to speak. The shot cuts off at the actor's hairline or forehead. Sometimes an even tighter extreme close-up is used for added impact; for example, focusing on just an actor's eyes or mouth.

### Storyboard Example

**1. SHOT TYPE (Abbreviated)**

> DRAWING
> OF SHOT

> Description of action or dialogue.

figure | 4-8 |

figures | 4-9 to 4-14 |

### Extreme Close-up

**2. ECU**

The ECU has no headroom. It cuts off across the forehead and the chin is completely in frame.

### Close-up

**3. CU**

The CU is a head shot that includes the top of the shoulders.

### Medium Close-up

**4. MCU**

The MCU is a bust shot that cuts off at the bustline.

## CU, Close-up

The **close-up**, or **CU**, is your typical head shot of a person. However, you can also have a close-up of an object. Close-ups help the viewer become more engaged with the action by creating a feeling of intimacy. When you first introduce a character in a scene, one of the first few shots should be a close-up. This allows the viewer to get a good look at the character. Your goal is always to engage and maintain the viewer's interest. It's rather difficult to do that if the viewer can't see what the subject looks like.

## MCU, Medium Close-up

The **medium close-up**, or **MCU**, is halfway between a close-up and a medium shot. The character's entire head and shoulders are in frame. The MCU cuts off at the bustline.

## MS, Medium Shot

The **medium shot**, or **MS**, cuts off at the waistline, with the subject's upper body being completely in frame.

## MLS, Medium Long Shot

The **medium long shot**, or **MLS**, is halfway between the medium shot and the long shot. It cuts off at the subject's knees.

## LS, Long Shot

The **long shot**, or **LS**, is a head to toe shot of a person, with the entire body being in frame.

| **TIP** |

To get a feel for the pacing and variety of shots, try counting the number of shots during one scene of a movie. You will have a greater appreciation for the amount of work that goes into making a film. Try to count the shots during your favorite scene in an action movie; action films move at a much quicker pace and require more shots, angles, and editing.

### Medium Shot
**5. MS**

The MS cuts off at the waistline.

### Medium Long Shot
**6. MLS**

The MLS cuts off at the knees.

### Long Shot
**7. LS**

The LS is a head to toe shot.

## Wide Shot
### 8. WS

The WS, also called an establishing shot, shows the location for the scene.

figures | 4-15 |

## Over The Shoulder
### 9. OTS

The OTS shot shows part of the back of the head and shoulders of one person.

figures | 4-16 |

## Headroom
### 10. CU

Headroom is the space given at the top of the video frame in a CU, MCU, MS, MLS, LS, and OTS.

figure | 4-17 |

Headroom refers to the empty space left deliberately at the top of the video frame.

## WS, Wide Shot

The **wide shot**, or **WS**, is also called an *establishing* shot. The wide shot is used to establish or set the scene, by putting the location into some kind of overall context. It can be an exterior shot, an interior shot, or both, cutting from an exterior WS to an interior WS. It is also used to differentiate between locations.

For example, if we open up with a scene in a bedroom and then cut to a shot in a living room, the logical assumption would be that both rooms are in the same house. However, we would need to alert the viewer if this was not the case. We could do this by first showing an exterior WS of house number one, cutting to the bedroom, then showing an exterior WS of house number two, before cutting to the living room. Once the two locations are established, there is no need to continue showing wide shots as we cut back and forth.

## OTS

The **over the shoulder shot**, or **OTS**, shows part of the back of one person's head while another person or subject is the focus of the frame. The camera appears to be peering over the shoulder of someone. The OTS shot is frequently used when two people are having a conversation. Depending on the importance of the delivery of the line, or of the reaction to the line, either person could be the focus of the shot during the dialogue. There are also variations to this shot, where another portion of the person is in frame, for example, an OTS of someone's hand and arm opening a door.

| NOTE |

A **point of view shot**, or **POV**, doesn't show the subject at all, but rather what the subject sees. The lens of the camera becomes the subject's eyes and the viewer is put into the character's shoes.

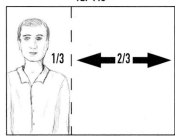

**Leadroom**
11. LS

Leadroom is the 2/3 empty space given in front of the subject in the direction the subject is moving.

**Bluescreen Shot**
12. MS

A typical bluescreen shot is a MS with the subject on 1/3 of either side of the screen.

figure |4-18|

Leadroom is the empty space that is maintained in front of an actor who is moving toward the edge of the video frame.

figure |4-19|

A typical bluescreen shot is a Medium Shot during which the actor is positioned to one side of the video frame, reserving the rest of the frame for superimposition during postproduction.

## Headroom

With the exception of the extreme close up, most shots have headroom. **Headroom** is the space given at the top of the video frame. If you want to create an uneasy feeling in the viewer, remove the headroom from the shot. For instance, if people are supposed to be trapped in an elevator, eliminating the headroom will add to the feeling of panic.

## Leadroom

When someone walks or runs during a shot, the camera pans with him, providing **leadroom**, or space, so that the subject never "bumps" into the edge of the video frame. Usually the subject takes up one third of the screen, and two thirds of the screen is devoted to leadroom. If a person is standing still and facing the edge of the screen, leadroom is also provided.

## Bluescreen

Many digital video editors will incorporate **bluescreen** or **greenscreen** into their projects. By isolating a subject against one of these backgrounds, the background can be removed in postproduction and another image, or set of images, may be substituted in its place. The bluescreen technique is frequently used in interviews. Typically, the subject is positioned to either side of the video frame, with two thirds of the frame being used to display the bluescreen.

Shot variety is important in video production. The viewer can easily lose interest if the same shot is on the screen for too long, or if all the shots look similar. In order to make your video more engaging, vary the framing and length of your shots.

| TIP |

To adjust for headroom while filming, have the actor stand with his hand, thumb down, on top of his head. Frame the shot so that the edge of the frame lines up with the edge of the subject's hand.

# DV PROFILE

## *Ned Eckhardt*

## Biography

**Name:** Ned Eckhardt

**Job Title:** Chair of the Radio/TV/Film Department and Professor of Television Production

**Department/Institution:** Rowan University

**Degrees/Certifications:** MA, Case-Western Reserve University (Dramatic Arts); BA Colgate University (English Literature)

**Classes taught:** Television Production I and II (Advanced), Documentary Production, Television Program Packaging

**Number of years in current position:** Twenty-five years teaching, three years as Chair

**Number of years in field:** Thirty years as an independent professional Producer, Director, Writer, and Editor

**Work experience:** Producer, WCAU-TV, Philadelphia, PA; Video Producer (promotional spots, magazine shows, talk shows, documentaries), Odyssey of the Mind, Inc. (writer/director/producer/editor of promotional spots, recruitment videos, and training videos); Video Producer, Southern New Jersey Technology Consortium; Professor of

Professor Ned Eckhardt sits in front of one of the Avids in a television production control room at Rowan University.

Television Production, Radio/TV/Film Department, Rowan University

**Career highlights/accomplishments:** Emmy nomination for "Neighborhood Moments" for WCAU-TV, Philadelphia; AP Broadcasters Award for "Neighborhood Moments"; two Telly Awards; three Cindy Awards; two Educational Press Awards; four ITVA Awards; three Communicator Awards; two American Corporate Video Awards; one Silver Intercom Award, fourteen documentaries (including four award winners)

**Professional affiliations:** UFVA (University Film and Video Association), BEA (Broadcast Education Association), NATPE, Inc. (National Association of Television Program Executives), NATAS (National Academy of Television Arts and Sciences – Philadelphia Region), MCA-1 New Jersey (ITVA)

**Web site:** www.rowan.edu

## Questions & Answers

**Q. When and how did your school begin incorporating digital video technology?**

**A.** Rowan's Radio/TV/Film Department began its digital post in 1999 for the film production classes. Adobe Premiere was the software program. Avids were added in 2000 for television production and postproduction.

**Q. What digital video equipment do you currently use? Which courses use the equipment?**

**A.** DVCPRO broadcast digital cameras, Sony PD-150s, Panasonic DVX-100s; Adobe Premiere and Avid; Film I , Film II, Film III, TV I, TV II, and TV Documentary Production.

**Q. How has digital video technology impacted your courses?**

**A.** Camera training has undergone extensive revision. Size and operation have changed. The aesthetics of shooting with a small camera are different and necessitate a redefinition of camera operation. Related disciplines involving sound and lighting systems need to be rethought and taught.

**Q. How did you learn to use the new technology?**

**A.** I have attended two Avid training schools. We hire an Avid consultant who runs workshops for the faculty and staff on a yearly basis. I create and design the equipment training procedures. I consult with our video engineer often, and he orients me on the equipment and has input into the training procedures. I read the operations manuals and many industry magazines. At the BEA and UFVA annual conferences, I discuss the new technology with other production teachers and technical people. I also spend many hours practicing by myself.

**Q. What challenges have you experienced using the equipment?**

**A.** Mini-DV cameras are so light they are hard to hold still sometimes. The temptation is to not use a tripod. Not a good idea. The LCD viewfinder often doesn't give a true color representation. The menus are very complex and often a mistaken selection can lead to long periods of trying to undo a mistake. It is a temptation to always think you don't need to light a subject because the camera is digital. The result is almost always a flat-looking picture in a fluorescent light environment. But, used properly they make exceptional pictures, don't need a lot of battery time, and lead to creative, freestyle shooting.

As far as using digital post computers, learning the basic operation of digitizing and working in the timeline is relatively easy. Managing folders and bins is harder. Learning complex special FX programs takes a lot of time and trial

## DV PROFILE
*continued*

*Ned Eckhardt*

and error. The titling programs are often good for simple titling but hard or impossible on layered, animated titling. Learning how to use the potential of the computer creatively in your project is the biggest challenge digital editing poses. Organizing a number of projects in one machine is another challenge. Limiting the amount of digitized footage so there will be enough memory for all of the projects is almost an art form!

**Q. What do your students think of the digital video equipment you are currently using?**

**A.** Students love the digital universe of production and postproduction. They have almost no fear of it. But they often are frustrated because they find out the hard way that they need to spend time learning the operation of both cameras and computers before they can create a piece they can be proud of. They tend to blame the equipment when things go wrong. But 95 percent of the time it is operator error.

**Q. Has digital video technology allowed you to try things you weren't previously able to do?**

**A.** Two areas where the new digital technology has changed things for the better:

1. Cameras are cheaper and easier to operate. Students/anybody can take more time to shoot a sequence or piece. This results in more usable footage and the chances for a better, more varied, creative piece.

2. Nonlinear editing allows for more options on sequences. It is possible to cut many versions of scenes/sequences and the end result is a better, more creative/effective piece. Layering allows graphics, information and special FX sequences to be more visually appealing and effective. Of course, sometimes having so many tools can cause indecision. But for the most part having many options is good.

**Q. How have you modified your courses to include the new technology?**

**A.** Because acquiring footage and editing it has speeded up, the projects can be longer and more complex. Crews don't need to be as big. More students can be both shooters and sound people. On many shoots you don't need PAs or grips. I can now request a documentary as a

project in TV 2. In the past this would have been too big a project.

Training on our Avids takes longer than on the linear systems. Getting up to speed takes more than one session. But the actual edit time is much shorter. Creating tutorial footage for practice editing is easier, and the finished product is much more creative.

**Q. What are your thoughts on how digital video technology has impacted the field?**

**A.** Digital technology is the now and the future. The tools for high-quality production and postproduction are available to everyone. Students/people have their own production and postproduction systems at home. What the schools can teach them is how to integrate the operation of the camera and computer (easy) with telling stories and documenting reality (hard). The cost of making television/film is dropping and the need for programming is increasing . . . creating an exciting workplace where just about anyone with a hard-work ethic and dedication can become a success and create a career in production and postproduction. Is it easy? No. Can you do it? Yes! Exciting stuff.

**Q. What advice can you offer to students interested in pursuing a career in this field?**

**A.** I talk to approximately a hundred employers a year in the media production field.

They all say that the most important qualities a person breaking into the field should have are a strong work ethic, good attitude, be a team player, and never be late. As far as essential skills: digital expertise is primo, especially computer skills with postproduction software and Web-friendly software.

If you are going creative, know the new, digital production process, be a good communicator, and be a people person. If you are going technical, know as much about all digital equipment as you can.

You are going to break in, working long hours for relatively low pay. But your passion for news and information and/or telling stories will get you through. In two to five years you will be competitive with all other media professions. And do at least one internship where you think you might want to work. And create a network of successful practitioners in the media production field. Join organizations. Always have a plan for yourself. The plan can change, but be able to articulate who you are, what you want, and where you are going.

# PRODUCTION SCHEDULE

After the storyboards have been created, the shots can be broken down into a **production schedule** to facilitate shooting. This is often the most challenging part of the preproduction process. A variety of considerations need to be taken into account when devising a production schedule. A production is rarely filmed in chronological order, but rather in order of necessity and availability. For example, an actor or location may only be available for a brief period of time.

## Shot Sheet

Begin by making a list of all the individual shots that need to be filmed. This is called a **shot sheet**. Their shot numbers should correspond with the storyboards. List the shot type and a brief description of the shots, so all the shots can be identified.

figure | 4-20 |

This is a sample format for a shot sheet, which is a list of all the shots for a particular video shoot.

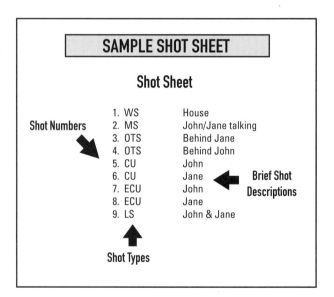

## Camera Setups

Then determine which shots can be filmed from the same angle and relative placement of the camera. This will determine how many **camera setups** there will be. Each time the camera needs to be moved to another location, it takes up time. It is more time consuming to do camera setups for film than it is for video because in film, the lighting has to be more precise. Each film stock has different latitudes for the amount of light that needs to be present in the shot.

Each shot that can be acquired through a single setup, usually is, even if it requires the actors to deliver their lines out of order. For example, in a conversation using over the shoulder shots, all of one person's lines would be filmed at once, and then the second person's lines would be filmed. Thus, this would require only two camera setups, as opposed to dragging the camera back and forth each time. One actor usually runs lines with the other actor, even though one actor's audio won't be used, to help the other actor by having someone to react to.

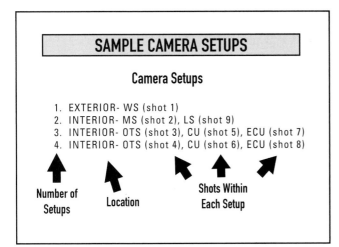

figure | 4-21 |

Shots are grouped according to how many can be achieved during one camera setup.

## Production Schedule

The production schedule also includes important information like shoot times, meeting places, directions, and the actors and crew members that are required to be there each day. When writing the schedule, start by determining which actors are needed for each scene and how many shots each actor will be in. Then organize the shots factoring in this consideration. You wouldn't want to pay an actor to stand around all day when he wasn't needed.

figure | 4-22 |

The beginning of the production schedule includes useful contact information.

**SAMPLE PRODUCTION SCHEDULE**
(Cover Page)

**Production Schedule**

| | |
|---|---|
| PROJECT: | Title of video production |
| DATE: | Date of shoot |
| ARRIVAL TIME: | Time to meet for shoot |
| MEETING PLACE: | Place to meet– at location or elsewhere |
| SHOOT LOCATION: | Address of shoot location |
| DIRECTIONS: | Directions to shoot location |
| CREW: | Crew members required for shoot day |
| TALENT: | Talent required for shoot day |
| CONTACT NAME: | Person to contact in case of a problem |
| CONTACT NUMBER: | Phone number of contact person to call |

figure | 4-23 |

**SAMPLE PRODUCTION SCHEDULE**
(1/2 Day Shoot, Continued)

| | | |
|---|---|---|
| 8:30 am | Meet at Location/Start Make-up/Wardrobe | |
| 8:45 am | **Camera Setup #1** | |
| 9:00 am | Time to meet for shoot | |
| 9:15 am | Shot 1 | WS (House) |
| 9:30 am | **Camera Setup #2** | |
| 9:45 am | Shot 2 | MS (John & Jane) |
| 10:00 am | Shot 9 | LS (John & Jane) |
| 10:15 am | BREAK | |
| 10:30 am | **Camera Setup #3** | |
| 10:45 am | Shot 3 | OTS (Behind Jane) |
| 11:00 am | Shot 5 | CU (John) |
| 11:15 am | Shot 7 | ECU (John) |
| 11:30 am | **Camera Setup #4** | |
| 11:45 am | Shot 4 | OTS (Behind John) |
| 12:00 pm | Shot 6 | CU (Jane) |
| 12:15 pm | Shot 8 | ECU (Jane) |
| 12:30 pm | Breakdown | |
| 12:45 pm | Wrap | |

# RELEASE FORMS AND PERMITS

Before filming any professional or organized video production, the proper paperwork must be obtained. Failure to do so can make you liable in a lawsuit. You can't just show up with a video crew and start taping without permission. In most towns and cities, you need to have permits to film in public places. Start by contacting the nearest film office; most major cities have one. If you are filming in a smaller town, try contacting the city hall for more information.

## Site Release

To film outside and inside a private building, you need to obtain a **site release** from the owner of the property. This may or may not be the person residing there. All parties should be notified and permission should be obtained in writing prior to filming.

## Video Release

You also need to have permission to videotape people. You cannot use someone's likeness without his or her consent in the form of a **video release**. If the person is a minor, a parent or guardian needs to grant permission. If you are filming in a crowd, post notification signs stating that by being in that location during a particular time, they are granting their permission to be videotaped. If someone has an objection, make sure they are removed from the shot.

**SAMPLE SITE RELEASE FORM**

**(VIDEO COMPANY NAME OR LOGO)**

**Site Release**

I hereby grant (NAME OF VIDEO COMPANY) the right to record videotape and/or expose motion picture film of and in the establishment listed below for use in a videotape/film production. I have read this release and understand and agree to its terms.

_____     _____
Signature                                   Date

_____     _____
Witness                                     Date

_____
_____
Name of Establishment

_____
Street Address

_____
City                    State       Zip Code

figure | 4-24 |

You should obtain permission in writing before shooting video at any location.

**SAMPLE VIDEO RELEASE**

**(VIDEO COMPANY NAME OR LOGO)**

**Video Release**

In consideration for value received, I (video subject) _____
do hereby give (NAME OF VIDEO COMPANY) and parties designated by (NAME OF VIDEO COMPANY), including clients, licensees, purchasers, agencies, and others, the irrevocable right to use my name (and any fictional name) and audio & video image for sale to and reproduction in, medium for purposes of advertising, trade, display, exhibition, competition, or editorial use. I have read this release and understand and agree to its terms. I affirm that I am more than 18 years of age.

_____     _____
Signature                                   Date

_____     _____
Witness                                     Date

figure | 4-25 |

Each person being filmed should sign a video release, granting you permission to use his or her likeness.

## CHAPTER SUMMARY

After refining your idea, writing your script, drawing your storyboards, creating your production schedule, and obtaining the necessary permits and release forms, you are finally ready to begin filming. Film and video production is hard work. A lot of time, thought, planning, and preparation go into the preproduction process. However, when the actual production itself goes well, all the hard work will be worth it.

## in review

1. What is a premise?

2. What is a plot point?

3. Describe the paradigm of a dramatic structure.

4. What are the elements of a voice-over script?

5. What is headroom?

6. What is leadroom?

7. Describe the basic shot types.

8. What is a shot sheet?

9. Describe the elements of a production schedule.

10. Why are release forms important?

## exercises

1. Pick a movie (not a comedy). Define the premise for the film. What type of conflict is it? Using the paradigm of a dramatic structure, identify Acts 1, 2, & 3 and the two plot points.

2. Think of a joke, a fairytale, or a short scene from a story. Write a film script for it that's between two and three pages long.

3. Using the film script from exercise two, draw storyboards to convey the action, dialogue, and story. Then break the storyboards down into a production schedule, beginning with the shot sheet and camera setups.

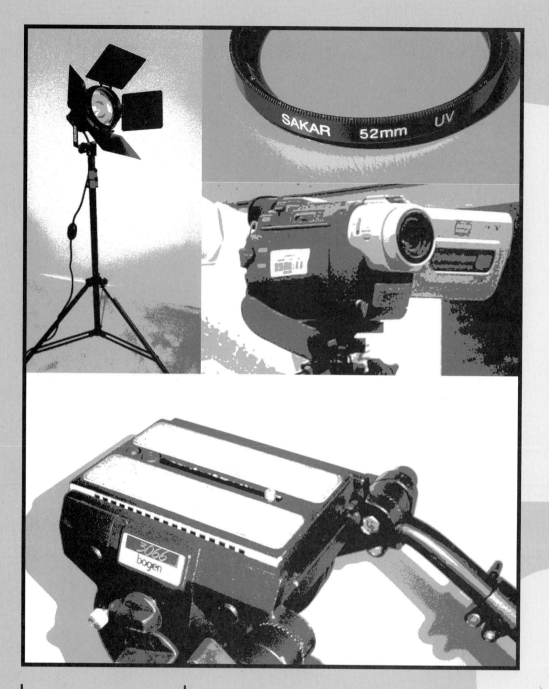

digital video production

# *objectives*

Evaluate the various types of video production equipment

Understand video composition and framing

Learn how to use a tripod

Understand basic lighting principles

Learn how to shoot bluescreen and greenscreen video

# *introduction*

There are a number of books available about video production, lighting, and audio production, and if you are new to the field, you should investigate them. This chapter provides a brief overview of the types of video production equipment, including lighting and audio, as well as the fundamentals of video production.

DIGITAL VIDEO PRODUCTION

# VIDEO PRODUCTION EQUIPMENT

Whether you are shooting digital video professionally or as an amateur, the equipment you use is an important part of the acquisition process. Every videographer has a preference when it comes to selecting equipment. Many swear by a particular brand and tend to stick with that product line. Others are more concerned with performance and features than they are with the manufacturer. While your budget will dictate individual purchasing decisions, the fundamental equipment required for entry-level video production is relatively the same. You should start by purchasing the best camera you can afford, a good tripod, and a basic lighting kit.

figure | 5-1 |

Today's video cameras, like this consumer model from Sony, are more compact and lighter in weight than their predecessors.

## Video Cameras

The video camera is the single most important piece of video equipment you will select. There are many models from which to choose. The method by which the camera records the video signal to tape is the fundamental difference between the cameras. Another important factor is the number and size of the CCDs, which directly affect image quality.

### Lenses

The video camera's lens is another important factor in image quality and reproduction. Many lower-end video cameras do not come with interchangeable lenses. This means you are stuck with the lens that comes with the video camera, and you cannot upgrade it at a later time. Typically, this lens is a zoom, which is a combination of a normal, a wide angle, and a telephoto lens. Higher-end video cameras have interchangeable lenses. You can purchase high-quality prime lenses for these cameras, which are lenses that are optimized for one particular function.

### Filters

You can also purchase **filters**, which attach directly onto the lens of the camera. Camera filters can adjust the color or contrast of the image. For example, a **polarizing filter** can be used to eliminate glare from reflected surfaces, such as water and glass. Reflected light can wash out the color of an image, especially outdoors, so by reducing it, polarizing filters can also improve an image's color saturation. A **diffusion filter** can be used to hide wrinkles and facial blemishes. A **mist filter** is used to create a mood by lightening the shadows in an image. A **fog filter**, as its name suggests, can simulate fog and create a soft glow. A **color graduated**

| TIP |

If you are interested in digital video editing, you will probably want to purchase a digital video camera as opposed to an analog one.

| TIP |

An ultraviolet filter can protect your camera's lens from accidental scratches. It is inexpensive and does not alter the color of your video.

figure **5-2**

An ultraviolet filter is an inexpensive way to help protect your camera's lens from scratches. It also reduces atmospheric haze.

**NOTE**

Tiffen makes a complete line of high-quality filters. Their Web site, www.tiffen.com, provides a detailed discussion of the types of filters available, as well as their purpose and function.

**filter**, or color grad, adds a color to a specific area of an image. **Contrast filters** adjust the contrast of an image, or its brightness and darkness values. A neutral density, or ND, filter reduces the amount of light that enters the lens without altering its color. An **ultraviolet filter** can help reduce atmospheric haze.

### Batteries

You should consider purchasing a spare battery for your camera. The size of the battery determines how long it will hold its charge, as well as how the camera is being used. For example, shooting with the LCD screen open draws more power than simply using the viewfinder, so the battery loses its charge more quickly. Today's lithium ion batteries hold a charge much better than their NiCad predecessors. They are also not effected by **battery memory**.

Battery belts, and even vests, are also available for shooting on location for extended periods of time. Companies like Bescor and NRG make rechargeable battery belts for shooting in the field.

**NOTE**

A battery that has memory, like a NiCad, should be fully discharged before it is recharged, or the battery's life will be greatly reduced. Lithium ion batteries are not affected by battery memory.

**TIP**

Cold temperatures can decrease battery performance. Be sure to take that into consideration if you are shooting outdoors in cold weather for a prolonged period of time.

figure **5-3**

Lithium batteries hold their charges for various lengths of time, depending on their size.

figure 5-4

LCD displays are a great alternative to carrying around a cumbersome field monitor.

### LCD Displays

While LCD displays are very convenient, offering a built-in alternative to lugging around a portable monitor, there are some issues to take into consideration regarding lighting. LCD displays usually have individual brightness controls. These controls affect only the brightness of the LCD display, not the brightness of the video signal being recorded. Therefore, the LCD should never be used solely to determine lighting for a scene. If the display's brightness is turned all the way up, the scene being recorded could appear to have sufficient lighting, when in fact it is really underexposed. Likewise, depending on the particular viewing angle of the LCD, the lighting of the scene could change. In addition to viewing the LCD display, be sure to use the camera's built-in viewfinder or a portable monitor to check lighting.

## Monitors

Video monitors are custom displays optimized for video production. They can be portable monitors that are used in the field, or studio monitors. Monitors can be black and white or color, and most offer multiple inputs for the video signal, including composite, component, and S-video jacks, as well as audio inputs. They offer controls for color, brightness, and contrast. Video monitors can have switchable aspect ratios to accept both 4:3 and 16:9 signals. Some monitors are even capable of receiving NTSC, PAL, and SECAM video signals. Most monitors will offer underscan and overscan modes. **Underscan** mode shrinks the image, showing it in its entirety including the edges of the picture. **Overscan** mode increases the image's size, typically by five percent.

figure 5-5

Video monitors are used both in the field and in the studio for precise control.

# Tripods

No matter what kind of video production you do, a good tripod is a wise investment. Be sure to select a video tripod as opposed to a still photography tripod, as a video tripod is rated to carry more weight than a still camera tripod. It is sturdier in its design, and should provide smooth and steady movement. A professional tripod usually comes in two pieces: the head and the legs.

figure |5-6|

A good tripod is a must for any video professional.

figure |5-7|

Bogen manufactures the fluid head of this tripod.

## Tripod Heads

The head of a tripod is the part that controls the movement of the camera. You can pan the camera from side to side, or tilt it up and down by using the arm that attaches to the tripod head. The camera connects to the tripod using a mounting system. Some mounts are quick release, while others slide and lock into the base. Most video cameras have threaded holes on the bottom that attach with either a 3/8 or 1/4-inch camera screw; these come standard on most tripods. Most tripod heads also have a level.

Be sure to investigate the tripod's leg locking mechanism. Avoid plastic snaps that can break off easily, rendering the tripod useless.

You can also purchase dollies for your tripod. A **dolly** is a wheeled platform that attaches to the tripod's legs, enabling the tripod to be easily wheeled around.

## Tripod Legs

The tripod's legs can be raised or lowered to adjust the tripod's overall height. Depending upon the style of the legs, some can be spread and positioned at various angles.

figure |5-8|

The legs of this model can be spread all the way down to the ground and are secured by a chain.

## Stabilization Systems

In addition to using a tripod, there are other methods for camera support. A Steadicam is a camera support that uses a vest and an articulated arm to help support the video camera. Other options for camera support include shoulder braces and specialized grips.

## Lights

If you can't see it, you can't shoot it. Do not underestimate the importance of good lighting. Amateur digital video enthusiasts often neglect lighting, opting instead to rely on the digital video software's color correction filters to compensate for it. While these filters can often be quite sophisticated, they are never an adequate substitute for properly lit footage.

figure |5-9|

This light by NRG can be focused in either a spot or a flood position.

There are many types of lighting from which to choose. Keep in mind that all light has a particular color temperature, measured in degrees Kelvin (K). In addition to color temperature, different types of lighting also generate different amounts of heat. **Tungsten lights** (3,200 K) are considered to be *hot lights* because they reach extremely high temperatures. Be sure to use caution when working with them. Tungsten lights come in a variety of fixture configurations and price ranges. **HMI lights** are also considered to be hot lights. HMI lights are usually more expensive and have the same color temperature of daylight (5,500 K). **Fluorescent lights** are considered to be *cool lights* because they generate less heat. The lamps also tend to last longer. Fluorescent lights can be color balanced for either daylight or tungsten.

Whether you are using tungsten, HMI, or fluorescent lighting, there are many fixture configurations from which to choose. A lighting fixture refers to how the light is actually constructed and housed. An **ellipsoidal light**, more commonly known as a *spotlight*, produces a narrow beam of light with a defined edge. A **broadlight**, or *floodlight*, spreads the light evenly over a large, broad area. A **focus lens light** is a light whose beam can be adjusted to either the spotlight or floodlight position. A **fresnel light** has a glass lens with concentric circles. A **cyc light** is used to evenly light large studio backgrounds called cycloramas. A **softlight** redirects or bounces the light to diffuse it. Lights can be mounted overhead on lighting grids, mounted individually on stands, or joined together in lighting strips.

| NOTE |

With regard to professional lighting equipment, light bulbs are referred to as **lamps**.

### On-Camera Lights

You can also choose a smaller light that mounts directly on top of a video camera. Keep in mind that these on-camera lights still need to be connected to a power source, either a battery pack or an electrical outlet.

figure | 5-10 |

Smaller lights can be mounted directly on top of a video camera.

| TIP |

If you are planning to use an on-camera light, look for one with a dimmer control. This will allow you to use a particular wattage lamp, for example 100 watts, and adjust it down to lower light levels, like 75, 60, or 50 watts.

| NOTE |

**Barndoors** are folding metal doors that attach onto a light fixture. The doors can be positioned to adjust the beam of light. **Umbrellas** can be attached to lights to soften the light and diffuse it.

| TIP |

Certain lighting manufacturers sell lighting kits customized for digital video professionals. Lowel sells several DVcreator light kits that feature several different lights, and an assortment of gels and other accessories, in both hard and soft case configurations.

figure | 5-11 |

Lighting kits come in various configurations. This three-light kit uses tungsten lights.

### Lighting Kits

You can purchase **lighting kits**, which are several lights sold together in one package, typically at a reduced rate. A lighting kit usually consists of two or more lights, complete with stands and a carrying case. It may include spare lamps and accessories like gels, barndoors, and umbrellas.

### Gels and Color Filters

A **gel**, or color filter, is a piece of colored flexible plastic that is used to alter the hue of light. The term *gel* comes from the word gelatin, which is the material that color filters were made out of before plastic.

Filters are available in a wide array of colors. Other specialty filters, like gold and silver metallics, can be used to produce reflections. You can request filter swatchbooks from manufacturers to examine their product lines. Filters are named and numbered and additional information, such as the percentage of light that is transmitted through each filter and its wavelength, is usually included. This information is called the **spectral energy distribution curve** and is typically provided in the form of a chart.

figure | 5-12 |

Gels are used to alter the color or intensity of light. These are swatchbooks from two filter manufacturers, Roscolux and LEE.

figure | 5-13 |

This gel, or filter, is clipped onto a removable frame.

**Diffusion filters** are used to decrease the amount of light on a subject. They only affect the intensity of the light and do not alter its color. They are broken down into increments equivalent to f-stops. For example, typical increments for diffusion filters are 1/8 f-stop, 1/4 f-stop, 3/8 f-stop, 1/2 f-stop, 3/4 f-stop, and 1 full f-stop.

Filters can be attached to lights by being clipped onto a special metal frame that connects directly to the light. They can also be attached to barndoors with wooden, not plastic, clothespins. Keep in mind that lights generate a lot of heat, and gels and filters will melt if they come in direct contact with the lamp.

### Other Lighting Accessories

There are other accessories you can select to manipulate lighting. **Reflector boards**, or *bounce boards*, are boards with hard or soft surfaces that reflect and redirect light. These boards are often made of fabric with silver, white, black, or gold surfaces. They are often collapsible and stored in a zipper pouch. A **softbox** is fabric mounted to a metal frame that forms an enclosed box around the light to soften it. An umbrella, which is often made out of satin, can be attached to a light to diffuse it. A **scrim** is fabric attached to a metal frame that hangs in front of a light to diffuse it, reflect it, or project a pattern. Patterns, or **gobos**, are metal disks that attach to a light fixture and produce a design or pattern to create atmosphere. A **gobo rotator** is a motorized device that rotates the gobo and creates a moving pattern.

| **NOTE** |

Filters that attach directly to the lens of the camera are rigid and usually made out of glass with a special coating applied to the surface. Filters, or gels, that attach to lights are flexible and usually made out of plastic. Both types of filters can be used to alter the color and intensity of light.

# COLOR MY WORLD

## *richard palatini*

*Richard Palatini is Senior Vice President and Associate Creative Director at Gianettino Meredith Advertising. Rich is also an instructor of Visual Communication at Kean University in New Jersey.*

People are affected and influenced by color in many obvious and not-so-obvious ways. We use color to describe feelings: "I'm in a blue mood," "She's green with envy," and "He's got me seeing red." It's used to identify everything from military organizations (navy blue), to businesses (IBM "Big Blue"), to life stages (baby blue). Beyond words and images, color communicates instantly and powerfully. A world without color would be a world without emotion.

**THE "LIFE" OF COLORS** People develop feelings about color that change and evolve as they reach different life stages and they also relate to color in different ways during each stage. For example, red and blue are colors to which young children are most responsive. Adolescents are drawn to colors that are most outrageous, intense, and used in unusual ways (think green catsup!). The same red that children are drawn to is the color that adults perceive as danger.

**THE WIDE WORLD OF COLORS** When considering use of a color, we also need to understand how well it "travels." And, more specifically, how does a specific culture perceive a color or color combination. Historically, white has been associated with mourning by the Chinese, yet, in America, white is the color of wedding gowns. Because each culture has its own color symbolism, perceptive designers I know will often research countries and regions of the world to more fully understand what specific colors represent to them.

Be aware, that in today's mobile global society, people will bring their color "baggage" with them on their travels. Still, individuals can also seek to assimilate into their new societal environment by emulating the new colors they find there. It's most important to consider all these factors when making color decisions that have "international travel" on their itinerary.

**COLOR WITH FEELING** Think of the emotional response you want to elicit from your audience. Is it serene, sensual, exciting, powerful? Whatever it is, there are colors and color combinations for each and every one. Using light to midtones of greens, lavenders or blues and in combination will communicate that peaceful, serene feeling. Dense purples, deep reds and intense pinks are sensually provocative. Combining them with black will only increase the sensation. And, while black is THE power color, combining it with another hue can be even more powerful, such as black with a regal purple or royal blue. Many colors can bring feelings of excitement, but these should be warm and vivid. If your audience is young, consider vibrant warms and cools from every color family especially in combination.

**CRIMES OF COLOR** Sometimes, breaking the laws of color can be the right thing to do. In creating a distinct identity it's better to be different than to use the right symbolic color. Car rental companies are a perfect example of this. Hertz's color is yellow, Avis is red, and National is green. Each has created its own distinct, yet appropriate color personality. Remember, it's ok to be different but it must be with a clear purpose in mind.

Color can be the most direct and memorable way of making your communication, whatever it may be, effective and successful. Consider your audience, their emotions, and culture and life stage. Understand how colors communicate your message best, and when necessary, break the rules.

## Microphones

While most video cameras come with a built-in microphone, this is usually insufficient for professional-quality video production. Professional audio equipment uses **XLR** cables and connectors. There are many different types of microphones that are used to acquire audio for video production. Microphones can be handheld, wireless, or mounted on a boom or camera.

Microphones can be **unidirectional**, which is optimized to pick up sound from one particular direction, or **omnidirectional**, which is optimized to pick up sound from all directions. In addition to handheld microphones, lavalier and shotgun microphones are commonly used in video production. A **lavalier microphone** is a small microphone that is clipped onto the clothing of a person. A **shotgun microphone** is a directional microphone used to capture audio from a distance.

figure |5-14|

This handheld microphone can be used for on-camera narration or voice-overs.

figure |5-15|

This shotgun microphone by Sennheiser can be mounted directly on top of a video camera.

## Cables

Maintaining the quality of the video signal is dependent upon the type of cables you use. High-quality cables are more expensive for a reason. They can be shielded to maintain the integrity of the video signal by reducing the amount of interference. Also, gold-plated connectors provide better conductivity, but do add to the cost. Predominantly, the type of cable and connection itself dictates the quality of the video signal.

Professional cables used to transmit the component video signal usually have **BNC connectors**. A separate cable is used for the color red, the color blue, the color green, and the luminance portion of the video signal.

figure |5-16|

This shielded, broadcast-quality cable has BNC connectors.

| NOTE |

When using an S-video cable, you still need to use audio cables to get sound. Some people mistakenly think the S-video cable replaces the three wire yellow, white, and red audio video cable. It only replaces the yellow video cable.

The S-video cable separates the chrominance and luminance portions of the video signal. It is better quality than composite, but not as good as component.

figure |5-17|

The S-video cable separates the luminance and chrominance portions of the video signal.

The composite audio video cable typically comes with three interconnected cables using standard **RCA connectors**. The yellow cable is used for video. The red and white cables are used for stereo audio. Sometimes the audio cables are colored red and black. A mono audio video cable only has two cables: yellow for video and white for audio. Typically, if a particular device only has mono audio and you have a stereo audio cable, only the white cable is used.

A four-to-six-pin FireWire cable is usually used to connect a digital video camera or deck to a computer. The four-pin end connects to the camera or deck and the six-pin end connects to the computer.

figure |5-18|

This consumer video cable has gold-plated connectors for improved conductivity.

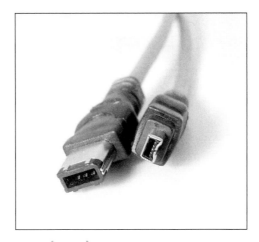

figure |5-19|

This four-to-six-pin FireWire cable is used to connect a digital video camera to a computer.

Other cables you may encounter when doing digital video are stereo mini audio cables. The **stereo mini** jack is the typical jack used for plugging headsets into portable CD players. Stereo mini jacks are used to import and export built-in audio on Macintosh computers. You may also see an audio cable that has two RCA jacks on one end and a stereo mini jack on the other. You can even purchase audio splitters. A standard **Y splitter** takes a mono audio signal and distributes it to both stereo channels. Adapters can also be used to convert cables. You can purchase adapters to go from RCA to BNC, from RCA to stereo mini, and others.

## Cases

Safely transporting your expensive video equipment is an issue. You can purchase hard or soft cases for video cameras, lights, tripods, and other production equipment. Obviously, hard cases provide better protection, and are therefore more expensive. Hard cases can be made out of either plastic or metal. Many come with foam linings. In some cases, the foam can even be

customizable by removing individual sections to ensure that the various pieces of your equipment do not come into contact with each other. You can even purchase airtight cases with water resistant seals.

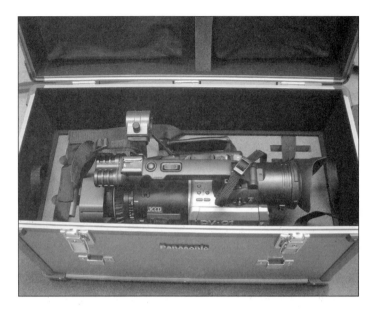

figure | 5-20 |

A hard case is a prudent investment for an expensive video camera.

# SHOOTING VIDEO

However, even the best equipment money can buy does not automatically make someone a video professional. And even video professionals are not experts in every aspect of video production. It takes years of training and experience to become a master in this field. So whether your interest is in production or postproduction, be prepared to work hard if you want to succeed. Here are a few video basics to help you get started.

## Composition and Framing

In spite of the technology involved, you need to be somewhat of an artist to be a good videographer. Video is very much like still photography. While you need to understand shutter speeds and f-stops, you still need to have an artistic eye. It can be argued that people are either artistic or not, that art cannot be taught. However, even if you don't consider yourself an artist, all hope is not lost! You can still study and learn the basic principles that govern still photography and video.

The composition of the video frame is very important. The framing of the standard video shots discussed in the previous chapter are conventions that don't require any artistry. However, there are other elements that make a good composition, some of which are listed below.

1. **Alter the Viewpoint**—Where you choose to place yourself with the camera in respect to the subject can significantly affect what your video frame will look like. Try different vantage points; don't just settle for the obvious one.

2. **Vary the Angles**—In addition to moving yourself around with the camera, try angling the camera itself. You can create the feeling of dominance by looking down at your subject, or inferiority by looking up at your subject. Tilting the camera angle to the side can even create the feeling of chaos.

3. **Emphasize the Action**—Take note of the action in every shot. Try various angles until you find the one that best emphasizes it.

4. **Crop the Frame**—Focus the frame on the subject and eliminate any irrelevant images that detract your attention from the subject.

5. **Create Balance or Imbalance**—You can create balance, or conversely imbalance, by not only manipulating space and the placement of objects, but also through the use of color.

6. **Understand Size and Space**—You can increase drama and impact by showing size in its relation to space. The towering cliff only looks towering if an object is shown to give proportion to it.

7. **Study Shapes and Lines**—Learn to take notice of shapes and lines. Look for unusual patterns. See how lines can create perspective.

8. **Look for Textures**—Textures appeal to our sense of touch, and can give the viewer a greater sense of realism.

9. **Experiment with Light**—Manipulate the light to see how it changes the image. Adjust the contrast and then notice the subtleties in the shadows, highlights, and grays.

10. **Create with Color**—Use color to create mood and enhance the image. Subdue or intensify them. Try changing their hues.

## Focus

Most professional cameramen retain control over their camera's focus, while most novices rely on the autofocus feature. While you can frequently get away with using a camera's automatic focus feature, you still need to know how to use it manually if the situation warrants it. Sometimes when you are zoomed in tightly on a subject, the camera can have trouble focusing. You need to know how to override your video camera's autofocus feature, and manually control the focus. Also, if your subject is moving around a bit, the camera's automatic focus may change when you don't want it to. Finally, there are special situations when you may want the focus to be intentionally blurry before becoming sharp. For instance, a **rack focus** is a technique where the focus shifts from a sharp foreground image with a blurry background, to a blurry foreground with a sharp image in the background, or vice versa.

The range of the distance in which the image remains in focus in front of and behind its focus point is called **depth of field**. The design of the lens (focal length), the f-stop, and the distance between the camera and the subject determine depth of field. The depth of field is considered shallow when the either the background or foreground is blurry, whereas greater depth of field makes the entire image sharp. The smaller the aperture, or f-stop setting, the greater the depth of field. Typically, the closer the subject is to the camera, the shallower the depth of field is. Given the same aperture setting and the camera's distance from the subject, the lens with the shorter focal length has greater depth of field.

figure | 5-21 |

Most video cameras can be switched effortlessly between automatic and manual focus modes.

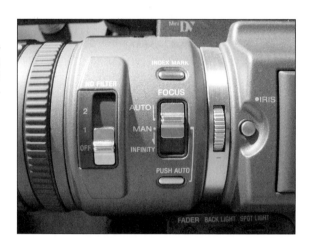

## Exposure

Again, you can rely on the video camera's automatic exposure mode, or you can control the exposure manually. Exposure is controlled by how much light enters the lens. The opening of the lens through which the light passes is called its aperture. It is measured in increments

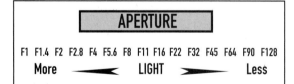

figure | 5-22 |

The aperture controls the amount of light that enters the lens.

called f-stops. The higher the f-stop, the lesser the amount of light that passes through the lens. The mechanism that controls the opening of the aperture is called the iris.

The time during which the aperture remains open is called shutter speed. It is measured in fractions of a second. The longer the shutter remains open, the more light enters through the lens.

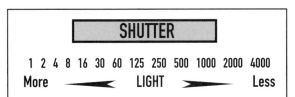

figure | 5-23 |

The shutter opens for a fraction of a second to let the light in.

## Leveling the Tripod

While you will probably shoot handheld video from time to time, most professional video production requires the use of a tripod. Before you attach the camera to the tripod, you need to make sure the tripod is level. The ground upon which you set your tripod will not always be level. Therefore, in order to ensure a level or straight horizon line, you need to be able to adjust the tripod's legs in order to compensate for any uneven terrain. Most professional tripods come with a built-in level, similar to a carpenter's level. To level a tripod, you adjust its legs until the air bubble becomes centered in its target circle.

figure | 5-24 |

A level is used to make sure the tripod is even to the horizon line regardless of the terrain.

Here are three tips to keep in mind when working with tripods to avoid risking possible damage to the camera.

- Always level the tripod before attaching the camera.
- Never move the tripod while the camera is still attached.
- Always lock down the tripod's tilt when you are not operating the camera. The weight of the camera's lens could cause the tripod to tilt and fall over accidentally.

| **NOTE** |

You *pan* a camera from side to side.

You *tilt* a camera up and down.

You *zoom* a camera in and out.

## Shooting Handheld

Sometimes you need to shoot without a tripod. Your subject may be moving quickly and you may need to follow along with it, or the area in which you are shooting may be too tight to accommodate a tripod. Other times, you may want the camera to sway slightly to create a mood or effect. Regardless of why you are shooting handheld, keep in mind you have a responsibility to the viewer to prevent motion sickness. Too much movement with the camera can be really disorienting, to the point of not even being bearable to watch. If possible, use camera stabilization equipment like a Steadicam, shoulder brace, or grip. If that is not an option, try to brace the camera using your body, or use an object in the field to lean on.

figure |5-25|

Use your body as a brace to steady handheld camera work.

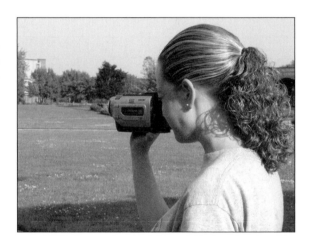

## Setting the White Balance

Because daylight and artificial light have different color temperatures, you may need to periodically adjust the camera's white balance. While most cameras have an automatic white balance feature, some high-end models will give you the option of controlling it manually. Setting the white balance is relatively simple, but you can check your camera's instruction manual for specific information. You need to focus the entire video frame on a white board or piece of paper and press the white balance button. This will adjust your camera's entire color range accordingly.

figure |5-26|

Most high-end cameras will allow you to set the white balance manually.

## Using a Monitor

Most professionals will use a monitor when shooting video. Using a portable monitor in the field makes it easier to check your framing and your lighting. It is very easy to connect your camera to a video monitor. First check to make sure you have the right cables and/or adapters. Then connect the *video out* of your camera to the *video in* on your monitor. When the video camera is in camera mode, you should be able to see the picture on the monitor. You can also use the monitor to play back your video when the camera is in VTR mode. If you are using a monitor for playback, make sure the audio cable is disconnected before switching back to camera mode or you may get audio feedback.

## Camera Notes

You can save yourself a lot of time and effort in postproduction if you take **camera notes** while you are shooting. You can use a form to record the starting and ending timecodes for each shot. You can also make notes regarding the quality of each particular shot. For example, you could make a notation if the actor messed up his line, if the audio quality wasn't good, or if the zoom was too fast. You could also identify the best takes. If you take the time to identify the good shots as you are shooting, you can save time during editing by knowing exactly which shots you need to capture.

| SAMPLE CAMERA NOTES | | | | |
|---|---|---|---|---|
| Shot | Take | Timecode In | Timecode Out | Comments |
| 32 | 1 | 00:00:20:00 | 00:01:13:16 | bad audio |
| 32 | 2 | 00:01:13:17 | 00:1:58:28 | keeper! |
| 15 | 1 | 0:01:58:29 | 00:02:30:02 | pan too fast |
| 15 | 2 | 00:02:30:03 | 00:03:01:19 | better |
| 15 | 3 | 00:03:38:20 | 00:04:12:08 | keeper! |
| | | | | |
| | | | | |

figure | 5-27 |

Professional videographers will record each shot filmed on a form, commenting on the quality of every take.

# DV PROFILE

## *Tommy Rosa*

**Name:** Tommy Rosa

**Job Title:** President, Director of Photography, and Senior Editor

**Organization:** Tommy Productions

**Number of years in current position:** Eighteen

**Number of years in field:** Twenty

**Partial client list:** ABC, *America's Funniest People;* Bally's Casino; Caesar's, Atlantic City; Fruit of the Loom; GE Aerospace; Honey Baked Ham; *Inside Edition*; McDonald's LPGA; Miss America Pageant; Jiffy Lube; Mobil Research; PepsiCo Corporation; Progresso Soup; Prudential Insurance Company; Sony Music of America; Sunoco; Taco Bell; Trump Castle; Wal-Mart; and West Coast Video.

**Degrees/Certifications:** BA, Radio TV Film, Rowan University

**Professional affiliations:** National Religious Broadcasters Association, National Farm Bureau

**Future Goals:** To become a consultant, teaching people excellence in television production theory and practical hands-on training; to help schools and churches design, purchase, and install equipment that they can grow with; to produce a docudrama about Maggie's Law for television; to produce a feature about my early career doing weddings; to become a freelance

Small business owner Tommy Rosa sits in front of a Final Cut Pro editing system in his studio at Tommy Productions.

director of photography for high-end short features; and to expand our repair and transfer services we currently offer via the Internet.

**Web sites:** tommyproductions.com, videorepair.com, filmtovideotransfers.com, photographrepair.com

## Questions & Answers

**Q. What type of work do you do at Tommy Productions?**

**A.** Video production and editing for large and medium businesses and private home use; film to video transfers, videotape repairs; video duplication: foreign and domestic, DVD authoring and duplication; photographs from video/photograph restoration; video consultants in system design, purchase, installation, equipment use, and training; and I am a teacher in theory and practical application of the television documentary.

**Q. What made you decide to go into business for yourself, as opposed to working for a large video production house?**

**A.** Back in 1985, cable was still in its infancy. I tried to volunteer in some local cable stations, but they were not interested in internships. The big three in Philadelphia (channels 3, 6, 10) I didn't even try to pursue. (Cannot work in the corporate 9 to 5 scene.) So my girlfriend, Karen, who's now my wife, encouraged me to take a loan and start the business. The bank would not lend me money to start a business, but they said they would lend me money to buy furniture. I did not buy ten thousand dollars of furniture, but I did buy 10K of Sony Super Beta equipment that failed completely on me within fourteen months. So I had to rent equipment for two years to stay in business. Later I purchased S-VHS, Hi-8 mm, then DVCPRO, Adobe Premiere, Panasonic Mini-DV, then Sony Mini-DV and a Mac.

**Q. How do you find your clients?**

**A.** Verizon phone book, satisfied customers, peers, recommendations from vendors and friendly competitors in related services, Internet, immediate follow up, and I recently began a newsletter.

**Q. How do you decide what to charge for your services?**

**A.** Survey the competition's prices. The goal is based on what you want to earn. We offer quality and service. Do research to determine an industry standard of fair rates. The goal is to net 30 percent after all expenses have been paid. Also, educate other professionals not to undercharge.

**Q. What are some of the challenges you face as a small business owner in this field?**

**A.** Not getting paid for good hard work, finding money for marketing, and being able to hire good help five days per week.

**Q. What are some of the advantages of owning your own digital video business?**

**A.** It's like having a hobby each day. It's like getting paid for creating vision and making people's dreams come true. I can work as long as I want. I create my own future and I create opportunity for others.

**Q. What are some of the disadvantages of owning your own digital video business?**

**A.** Waiting ninety days for payment, being underbid by starving semitalented individuals who have some of the tools to do a good job, and expecting all employees to give 110 percent like I do for a project.

**Q. What type of digital video equipment (hardware, software, cameras) are you currently using?**

**A.** Two Mac G4's with Final Cut Pro, Panasonic 2000 DV/DVCAM editor, Sony PD-150 camera, Panasonic EZ 30, Mackie mixer, Sennheiser wireless and hardwire microphones, and Adobe Premiere.

**Q. What advice can you offer to someone just getting started in the field?**

**A.** If you want to be an independent, never be too proud to learn by shooting and editing weddings, parties, and dance recitals. At least you'll get paid to experiment. Buy a brand-named Mini-DV camera with a true fluid tripod like a Bogen, a decent wireless microphone like Sampson or Sennheiser, two camera lights with diffusion, and a couple of battery belts to back up your camera's power and camera lights.

**Q. What advice can you offer to someone thinking about starting a digital video business?**

**A.** Learn how to charge. Learn what things cost, like good equipment and quality crews.

# LIGHTING

Lighting is an important part of video. There are many books written specifically about lighting, be it for video, still photography, or film. You can attend lighting classes and seminars and purchase instructional videos. Even the video novice needs to understand a few fundamentals regarding lighting.

## The Electromagnetic Spectrum

As discussed previously, all light has a color temperature measured in degrees Kelvin. The **electromagnetic spectrum** is broken down into two portions, visible light and invisible light. Ultraviolet light and infra-red light are invisible to the naked eye. The visible portion of the light spectrum includes blue, green, yellow, orange, and red.

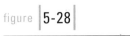

figure 5-28

The spectrum of light is broken down into visible and invisible portions. Infra-red light and ultraviolet light can't be seen by the naked eye.

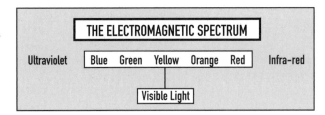

## Three-point Lighting

**Three-point lighting**, or *triangle lighting*, is a basic lighting setup used frequently in video production. In three-point lighting, a key light, a fill light, and a back light are used in conjunction with one another to light a subject.

The **key light**, which is usually a spotlight, is the principle light used to illuminate the subject. It is positioned to the front and side of the subject, on an angle. The key light will generate shadows on the far side of the subject. The **fill light**, which is usually a spotlight, is used to reduce the shadows caused by the key light. It is also placed in front and to the side of the subject, but opposite the key light. The **back light**, which is typically a spotlight, is used to provide definition between the subject and the background. It is usually placed above and behind the subject, opposite the camera.

## Lighting Tips

Here are a few guidelines to keep in mind when working with lights:

1. Lights can get extremely hot! Make sure you wear gloves if you are touching any metal surface to adjust a light.

2. Never move a hot light. Power it down and let the light cool first. Moving a hot light increases the risk of shattering its lamp.

3. Weigh down a light stand with sandbags to prevent it from being accidentally knocked over.

4. Be sure that all gels never come in contact with the lamp, or they will melt!

5. Keep spare bulbs handy at all times. They can blow out or break.

6. Know the number of watts each light draws and which electrical outlets belong to which circuit breakers. Attaching too many lights to the same breaker can trip it.

7. Always plug lights into properly grounded outlets.

8. Keep industrial grade, grounded extension cords on hand.

9. Carefully check the edges of the video frame to make sure no part of the light, its stand, or its sandbag is visible.

10. Watch out for mirrors and other reflective surfaces that may show the light or its glare in the video frame.

figure | **5-29** |

Standard three-point lighting, also known as triangle lighting, uses a key light, a fill light, and a back light to illuminate the subject.

# BLUESCREEN AND GREENSCREEN

When you edit digital video, you can select any color to become transparent. This process is called **chroma keying**. Chroma is short for chrominance, or the color portion of the video signal. A color is selected to be *keyed out*, or to become transparent. Traditionally, blue was the color of choice to be keyed out, hence the term *bluescreen*. A subject, such as the TV weatherman, was filmed against a blue background, and the blue was keyed out; other footage was substituted in its place, such as the weather map. In recent years, green has also become a popular keying color, hence the term *greenscreen*. Blue and green were selected as keying colors because they are not present in flesh tones, and people are most often the subject being keyed.

The first step is filming the bluescreen or greenscreen. You can use a collapsible fabric bluescreen or greenscreen stand, or you can use a bluescreen or greenscreen cyc in a studio environment. Chroma key blue and chroma key green equipment is made with special light-reflecting properties. Paint is available for hard surfaces, and special fabric is sold by the yard. Companies like Rosco and Markertek sell bluescreen supplies.

figure | **5-30**

This collapsible background is greenscreen on one side and bluescreen on the other side.

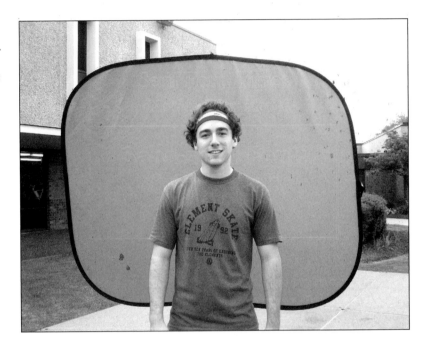

## Lighting for Bluescreen

Perhaps one of the most important elements of bluescreen or greenscreen keying—second only to your subject not wearing anything in the vicinity of the color you are trying to key—is proper lighting. Your goal is to light the background as evenly as possible. Avoid glaring hotspots or shadow areas, as they will become problematic in postproduction. You also want as much definition between your subject and the background as you can get. Typically, the greater the distance between your subject and the background, the easier it is to key. At least six feet is recommended, more if feasible. Light your subject separately. You can put a color filter on the back light to counteract any blue or green spill you may encounter on the edges of your subject. Yellow, typically a straw-colored filter, is used to counteract the blue because it is its color complement. A magenta filter is used to counteract the green for the same reason.

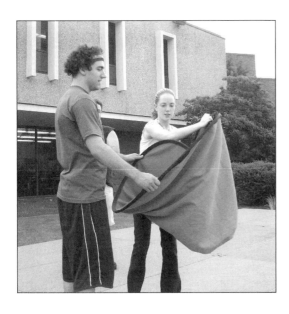

figure | 5-31 |

The portable bluescreen can be dismantled from its frame, rolled up, and moved in a matter of minutes.

## Keying

Most digital video editing software programs will do chroma keying, bluescreen, and greenscreen. However, 4:1:1 digital video is much more difficult to key than 4:2:2 digital video due to the way the video signals are sampled and compressed. Nevertheless, in recent years better keying packages have become available for 4:1:1 footage. The Adobe After Effects production bundle has an array of keying tools. Other hardware and software keying packages are available from companies like Ultimatte, Canopus, and Matrox.

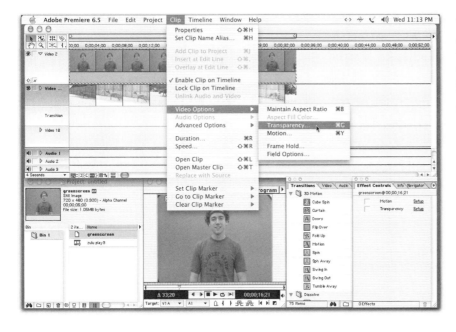

figure | 5-32 |

To key out bluescreen, greenscreen, or any color, select Video Options | Transparency from the Clip menu in Adobe Premiere.

figure 5-33

The chroma key setting has the most control, allowing adjustments with the similarity, blend, threshold, and cutoff sliders.

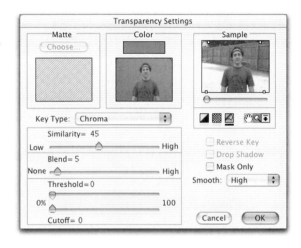

figure 5-34

The collapsible background was keyed out, or removed, from this shot and a video clip was substituted in its place.

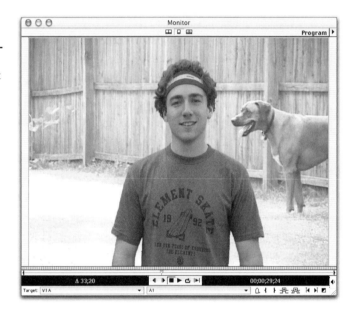

# CHAPTER SUMMARY

Evaluating video production equipment is another important step in the process. In addition to the camera, you need to be aware of which equipment to choose to best suit your production needs. Selecting video equipment is as important to the videographer as selecting paint and brushes is to an artist. Likewise, traditional video production skills are also an important part of creating digital video. Proper composition, framing, and lighting have a profound impact on the overall quality of a production. Becoming a skilled videographer takes time and experience, so make sure you put forth the effort to properly learn your craft.

## in review

1. What types of equipment do you need for entry-level video production?

2. What are hot and cool lights?

3. What are color filters and gels?

4. What are the elements that make a good composition?

5. What is aperture and what is shutter speed?

6. What is depth of field?

7. How and why do you level a tripod?

8. What is three-point lighting?

9. List three lighting tips.

10. What is chroma keying?

## exercises

1. Using the techniques you've learned in this chapter, videotape the shots according to the production schedule you made in the previous chapter. Be sure to take camera notes!

2. Experiment with the ten elements that make a good composition as you film your shots.

3. Experiment with color and lighting as you film your shots.

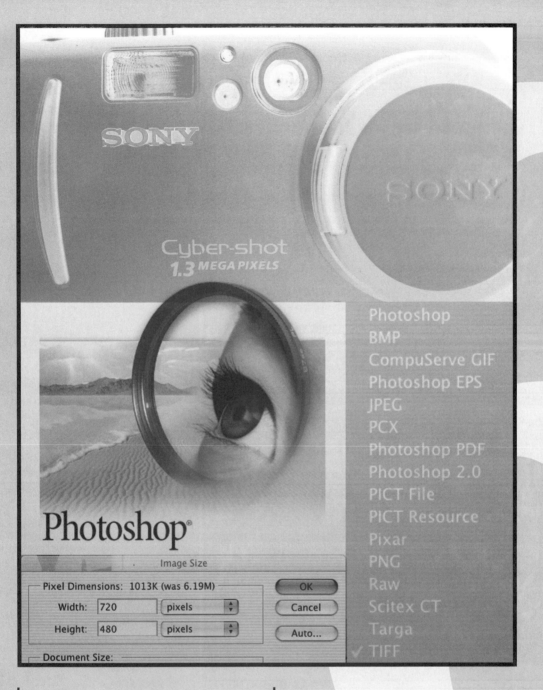

Photoshop
BMP
CompuServe GIF
Photoshop EPS
JPEG
PCX
Photoshop PDF
Photoshop 2.0
PICT File
PICT Resource
Pixar
PNG
Raw
Scitex CT
Targa
✓ TIFF

Image Size

Pixel Dimensions: 1013K (was 6.19M)

Width: 720  pixels

Height: 480  pixels

OK

Cancel

Auto...

Document Size:

| preparing photographs for digital video |

# *objectives*

Learn how to properly prepare a photograph for digital video

Understand how color depth, resolution, and compression affect the quality of a photograph

Learn how to crop a horizontal photograph for digital video

Learn how to crop a vertical photograph for digital video

Learn how to mat a vertical photograph for digital video

# *introduction*

Digital video is rarely comprised of video footage alone. Often photographs, graphics, titles, audio, and other elements are integrated into a digital video project. These additional elements usually require special preparation. For example, if a photograph is not cropped correctly, the picture may become distorted or lose its resolution. Likewise, a title that has been mishandled could result in jagged text. However, when these additional elements are prepared properly, they can greatly enhance any digital video project.

figure | 6-1 |

Adobe Photoshop is the software program of choice by top industry professionals for digital photography and image editing.

| NOTE |

Color depth is measured in bits. 1 bit represents two colors, black and white. 8 bits is 256 colors. 16 bits is 4,000 colors. 24 bits is 16.7 million colors. 32 bits is 16.7 million colors with 256 levels of transparency.

## ADDING PHOTOGRAPHS

Photographs are commonly added to digital video projects. Additional software is required to prepare the pictures before they are imported into a digital video editing program. While there are many low-cost image editing programs, in addition to numerous freeware and shareware programs, Adobe Photoshop is still the industry standard software application when it comes to manipulating photographs.

## IMAGE QUALITY

When working with photographs, quality is paramount. There are several factors that contribute to a picture's quality: resolution, color depth, and compression. A photograph's resolution is measured in pixels—the more pixels, the higher the image's resolution. Color depth is measured in bits and determines how many colors are represented in an image.

Compression determines which CODEC is used to create the file. Like video CODECs, still images also use these mathematical algorithms to compress the size of the file. Some popular CODECs used to compress photographs are JPEG, TIFF, and PICT. Most CODECs allow you to determine how much compression is applied; therefore, you can control the file size and quality of the image.

## ACQUIRING PHOTOGRAPHS

There are three primary methods for acquiring photographs. Pictures are commonly taken with a traditional still camera. The film is processed and the consumer scans the pictures into a computer, either from the negatives or from the photographs themselves. Some photo processing companies also give the option of having pictures transferred directly to a disk or a photo CD for a nominal fee.

figure | 6-2 |

Sony's Cyber-shot digital still photography cameras are popular with consumers.

Digital still cameras are also gaining popularity. A computerized camera records the picture directly in digital format onto a removable media, such as Sony's Memory Stick or Nikon's CompactFlash Card. Because the photographs are already in digital format, the time-consuming process of scanning can be eliminated. Photographs can be recorded in various resolutions, with the more expensive cameras offering the highest picture quality and, unlike film, the cards can be erased and reused.

A third option for acquiring photographs is taking them with a digital video camera. Many digital video cameras have a still photograph option that allows still pictures to be recorded either directly onto videotape or a removable media. However, these pictures can only be recorded at the same resolution at which video is recorded—720 x 480 pixels at 72 dpi, or dots per inch. The resolution for video, 72 dpi, is significantly lower than print media, which can be 300 dpi or greater. Keep in mind that traditional still cameras were designed to generate images specifically for print media, not video, and therefore have a higher resolution.

figure | 6-3 |

Removable media, such as Sony's Memory Stick, can be accessed by connecting the camera directly to the computer or by using a reader/writer. Certain photographic printers are also enabled to read popular removable media formats.

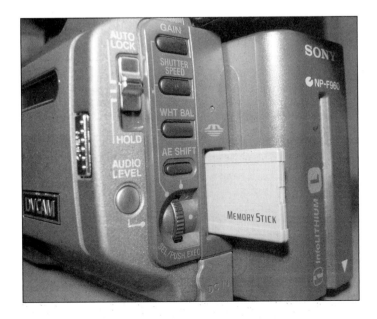

figure | 6-4 |

Many digital video cameras are enabled to take still pictures. They can capture the photos directly to tape and/or removable media.

An advantage to using a digital video camera over a digital still camera is that the photographs are already in the proper format and resolution for digital video. No additional preparation is necessary. However, there is also a major drawback. Photographs taken with a digital video camera cannot be manipulated later on the computer in terms of their size and scope without suffering a significant loss of image quality. Because pictures taken with a still camera have a higher resolution, they can be zoomed in on and cropped later on the computer without any loss of quality.

Provided that there is enough resolution in the image taken with a still camera, a photograph showing a person from head to toe can be cropped to a close-up of just the person's face and still maintain its resolution. If that same picture was taken with a digital video camera, the camera's lens would have to perform the zoom at the time the picture was recorded. If the lens did not, the lower resolution video image would suffer a significant loss of quality if the picture was later zoomed in on and cropped on the computer.

## SCANNING AND IMPORTING PHOTOGRAPHS

Whether you are taking your photographs with a traditional still camera or a digital still camera, the pictures should be prepared for video before they can be imported into a digital video editing software program.

### RGB

First and foremost, any picture that is intended for video must be in RGB mode. RGB stands for the colors red, green, and blue, the three additive primary colors that make up a video image. Print media, on the other hand, uses CMYK: cyan, magenta, yellow, and black. Preferably, pictures intended for video should be scanned directly in RGB mode. They can also be converted from CMYK into RGB using an image editing program like Adobe Photoshop. However, there is a difference in color reproduction that takes place during the conversion between CMYK and RGB that should be manually adjusted for using the image editing software's color correction features.

Even photographs that are black and white should be in RGB mode when used in digital video. You can scan black-and-white photos in RGB mode and use the image editing software's desaturate function to remove any unwanted yellowing of the image.

figure | 6-5 |

This scanner by Hewlett Packard connects to the computer's USB port.

## Color Depth

If you are scanning your photographs, be sure to choose the highest color depth setting your scanner will allow. Again, color depth determines how many colors are represented in an image —the more colors that are present, the higher the image's quality. Color depth, like resolution and dpi, directly correlates with the size of a file. Higher quality settings yield larger file sizes, so make sure you have adequate hard drive space to work with your images.

## Resolution

The resolution of a still photograph is measured in pixels. The target resolution for digital video via FireWire is 720 pixels wide by 480 pixels high.

However, you should work with images that are above the target resolution, so the images can be manipulated without suffering any loss in quality. If you are using a digital still camera that gives you a choice of resolutions, consult your manual to see what the actual pixel sizes are and select one that is higher than 720 x 480.

## DPI

When scanning a photograph manually, you should have the ability to control its dpi, or dots per inch. This setting controls how many pixels make up the image. The higher the number of pixels, the greater the

| NOTE |

Typically, video that is digitized using a traditional video card that converts the analog video signal into a digital one has a resolution of 640 pixels wide by 480 pixels high.

image's resolution, and thus the larger its file size. Largest is not always best here. Video has a relatively low resolution of 72 dpi, so there is no point spending the extra time scanning at a high dpi, like 1,200, which will in turn also cause your image editing software to run more slowly, when you are eventually going to lower it to 72 dpi at the end of the process anyway. However, you do want to scan higher than the end resolution of 72 dpi so you can manipulate and crop the photographs without losing any image quality.

Every photograph is different, and different photographs require different dpi's. There are no hard and fast rules here, but rather many considerations. The size of the picture is the primary factor, and this correlates directly with the picture's suggested scanning dpi. A small wallet-size photograph should be scanned in at a higher dpi, such as 600, because it will need to be blown up from its original size to fill the video frame. Consequently, a large 8 x 10-inch photograph would require a lower dpi, such as 100, because it will have to be scaled down to fit the video frame. Typical 3 x 5-inch and 4 x 6-inch photographs are standard sizes that fill the video frame relatively well if scanned around 200 dpi.

Again, while there is no magic number for dpi when scanning images for video because each photograph is different, these suggestions will help you obtain a high enough resolution the first time around when you scan. If you find that you do not have a sufficient resolution while you are manipulating the picture in the image editing software program, simply scan the photograph again at a higher dpi. If you are not planning to zoom in and crop a small portion of the photograph, which would require a higher dpi, then the standard dpi's suggested previously should be sufficient to obtain a high enough resolution to allow for minimal cropping with manageable file sizes.

Please keep in mind that any photograph which would require special manipulation should be scanned at a higher than "normal" dpi. For example, suppose you had a photograph that was torn. You would probably want to scan this at a higher dpi so you could zoom in and paint back in the missing information, pixel by pixel. Likewise, a photograph that had yellowed with age would require special color correction and should also be scanned in at a higher resolution.

## Compression

Whether you are acquiring photographs with a digital camera or scanning them into your computer, you must use a CODEC, or a method of compression, to create the files. You want to avoid compressing the images any more than you have to in order to preserve the highest possible quality. For example, JPEG is notorious for creating small file sizes, which results in missing information and lower-quality images. If you are using a digital camera and it gives you a choice between CODECs, you may want to consider selecting the one that yields the largest file size.

figure 6-6

Programs like Adobe Photoshop will allow you to compress digital photographs in a variety of formats.

If you are scanning photographs into your computer, it is better to use the software's native CODEC, such as Photoshop, which will yield a higher-quality image. You can later compress the file with another CODEC after cropping it if your digital video editing software prefers another file format. If you do use a CODEC that requires you to select settings, always choose the options with the highest resolution and the largest file size.

## Color Correction

Most photographs, whether scanned or recorded with a digital camera, will benefit from color correction. Different image editing software programs have different controls for correcting color. Many programs will allow you to adjust the image's brightness and contrast, hue, and saturation. Brightness and contrast adjusts the image's light and dark values. Hue is the actual shade of the color, while saturation is the intensity of the color.

figure 6-7

Image editing programs, like Adobe Photoshop, offer an array of tools to color correct photographs.

| NOTE |

You should color correct your photographs before bringing them into a digital video editing program in order to save rendering time. While most digital video editing software programs include color correction filters, it is render intensive to color correct still images in a video program. Each frame of the still image, although identical, needs to be rendered in the digital video program. Keep in mind that there are 30 frames in one second of video. Therefore, a photograph that is three seconds long would take 90 times as long to render in a digital video program as it would in an image editing program.

A high-end software program, such as Adobe Photoshop, has a filter called Levels that allows you to adjust the image's brightness and contrast, color balance, and gamma correction at the same time. Color balance allows you to control the hue of an image by independently manipulating the red, blue, and green channels. Gamma correction manipulates the middle grays, or gamma, in the image without altering its highlights or shadows.

## CROPPING

After the photographs have been imported from a digital camera or scanned into the computer, they still have to be cropped to fit properly into the video frame. Failure to do so will result in distorted images.

figure | 6-8 |

This 4 x 6-inch vertical photograph needs to be prepared for digital video before it can be successfully fitted into the horizontal, rectangular shape of the television frame.

For example, a vertical photograph requires special manipulation to get the vertical, rectangular shape to fit inside the horizontal, rectangular shape of the video frame. Without accounting for this difference in shape, the vertical photograph would become distorted from trying to squeeze it into the rectangular shape of the television screen. Think of this process as being similar in effect to standing in front of a fun house mirror that makes you look much shorter and heavier than you actually are.

figure | 6-9 |

Failure to properly prepare photographs for digital video will distort them. This vertical photograph needed to be cropped or matted first.

## Aspect Ratio

The horizontal shape of the video frame is a rectangle that is wider than it is high.

This width to height proportion is called an aspect ratio. Photographs, like video, also have aspect ratios that must been maintained. If you take a little off the height of a photograph, you have to take a proportionate amount off the width as well. If you do not, the image in the photograph will become distorted. The aspect ratio for video is 4:3, or four units across by three units high. High-definition television, or HDTV, has an aspect ratio of 16:9.

## ASPECT RATIO AND PROPORTION

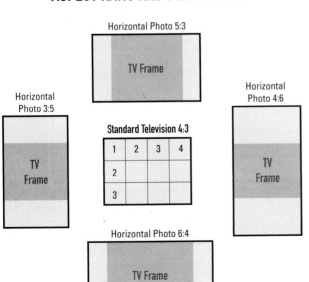

figure | 6-10 |

The aspect ratio of a photograph needs to be maintained while resizing it to fit the video frame. This diagram illustrates how typical 3 x 5-inch and 4 x 6-inch photographs fill the standard 4:3 aspect ratio of the video frame.

## Horizontal Photographs

The horizontal photograph is the easiest to crop because its horizontal, rectangular shape is similar to that of the video frame. After scanning the picture at around 200 dpi, bring it into an image editing software program like Adobe Photoshop. Save a copy of the original photograph before attempting to crop it, in case you make a mistake. This way you don't have to worry about accidentally losing the file and having to scan it all over again. Again, cropping photographs for video is not an exact science. There are no explicit rules. However, if you want your images to look crisp and clean, follow these suggestions to maintain high resolution and image quality.

figure | 6-11

This 3 x 5-inch photograph has a resolution of 200 dpi.

Once inside your image editing software program, look for a command that allows you to see and change the resolution of the picture, like Photoshop's Image Size command. First, check to make sure the image's resolution is sufficient. At 200 dpi, the pixels should already be above 720 x 480. If they are not, you need to rescan the image at a higher dpi.

Next, you want to make sure you lock the aspect ratio, so both the width and height of the photograph are affected proportionally. In Photoshop, this feature is called Constrain Proportions. After locking the aspect ratio, lower the dpi from 200 to 72, which is the required dpi for video.

Then, change the height of the photograph to 720 pixels. What did the width proportionately change to? Is it close to 480 pixels? Allow yourself a ten-pixel latitude, which is negligible to the average eye. For example, if the height is between 470 and 490 pixels, then the resolution is close enough to the required 480 pixels for video. If you are within the ten-pixel latitude, then it is safe to uncheck Constrain Proportions and enter 480 for the height. Remember, each photograph must be exactly 720 x 480 pixels before it can be imported into a video editing software program.

figure **6-12**

Using Photoshop's Image Size command, with Constrain Proportions checked, the dpi was lowered to 72, and 720 pixels was entered for the width. The height changed proportionally and became 446 pixels, 34 pixels shy of the 480 pixels required for video. Therefore, some of this photograph's width needs to be cropped off before it can be fitted into the video frame without becoming distorted.

However, if you are not within the ten-pixel latitude, then you should cancel the Image Size command and crop the photograph first. Using Photoshop's Crop tool, or a similar program's crop tool, draw a rectangle that is similar in shape to the video frame, shaving the necessary amount of pixels off the height. This is an acquired skill, so don't expect to crop your photographs for video right every time. It will eventually become easier to visualize the exact size of the video frame.

figure **6-13**

Using Photoshop's Crop tool, a portion of the photograph's original width is removed.

Again, use Image Size, or a similar command in your software program. Make sure the aspect ratio is locked. Then lower the dpi to 72. Enter 720 for the width and see how close you come to 480 pixels for the height. If you are within the ten-pixels latitude, then uncheck Constrain Proportions and enter 480 for the height. If you are still not within the ten-pixel latitude, cancel the Image Size command, undo the crop, and try again.

figure | **6-14** |

After cropping this photograph, too much of the width was removed. The height is now 494 pixels, which is not within the ten-pixel latitude of 470 to 490 pixels. Therefore, this crop needs to be undone and attempted again, so that the photograph doesn't lose any of its resolution.

figure | **6-15** |

After the second try at the crop, the height becomes 476 pixels, well within the ten-pixel latitude of 470 to 490 pixels. It is now safe to uncheck Constrain Proportions and enter 480 pixels for the height in the Image Size command.

Unfortunately, there are no shortcuts to properly cropping photographs for video. (Setting the crop tool to Fixed Target Size distorts the image's resolution—it's like applying Image Size.) If you want to maintain the highest possible image resolution and control the area you wish to crop, you'll probably want to exercise a little patience and stick with this procedure.

figure | 6-16 |

This photograph is now properly prepared for video at 720 x 480 pixels and 72 dpi. Note that its file size is 1013k. Each photograph prepared at this resolution for digital video will be the same size.

figure | 6-17 |

This is the original 3 x 5-inch photograph. If you compare it to the cropped photograph, you will notice some of the width was trimmed off, with the cropped photograph suffering little to no distortion. Keep in mind that the original photograph has a resolution of 300 dpi and the cropped photograph is optimized for video's lower resolution of 72 dpi.

## Vertical Photographs

As mentioned previously, vertical photographs require special treatment when it comes to preparing them for video. There are three basic techniques used to incorporate vertical photographs. The first method is the same one used to crop horizontal photographs, only when it is applied to a vertical photograph, a much larger percentage of the photograph must be sacrificed. This technique is zooming in and cropping a small area of the vertical photograph in the shape of a horizontal rectangle. In this process, over two thirds of the original photograph is lost.

figure | 6-18 |

In order to get this vertical photograph to fit into the horizontal video frame, much of the original image's height will need to be cropped off or the photograph will become distorted.

figure | 6-19 |

Without cropping any of the height off the original photograph, the Image Size command is used to resize this image to the video standard of 720 x 480 pixels at 72 dpi.

figure | 6-20 |

Failure to crop any of the height off the original photograph caused this image to become radically distorted after the Image Size command was applied.

figure | 6-21 |

This time Photoshop's Crop tool is used to remove a large portion of the photograph's height, changing its shape from a vertical rectangle to a horizontal rectangle that fits nicely into the video frame.

figure | 6-22 |

The Image Size command is applied to the cropped image. At 72 dpi, with 720 pixels entered for the width, the height changes proportionally (Constrain Proportions is checked) to 473 pixels.

figure |6-23|

Because the height of 473 pixels is within the ten-pixel latitude, t is now safe to uncheck Constrain Proportions and enter 480 pixels for the height.

figure |6-24|

The resulting image is not distorted, although a major portion of its height needed to be sacrificed. At 720 x 480 pixels and 72 dpi, the photograph is optimized for video. Its file size is 1013K.

However, this technique is not an option when the entire photograph needs to be seen. For example, in a vertical photograph of the leaning tower of Pisa, it is necessary to see the entire image to get the full dramatic effect. Therefore, zooming in and cropping out the uppermost portion of the tower would not be a viable option. The other two techniques for manipulating vertical photographs offer solutions for maintaining the height.

## Matting

The second option for preparing a vertical photograph for video is to zoom out and mat the photograph onto a background, allowing the background to compensate for the missing portion of the width. Begin by preparing a new background image that is 720 x 480 pixels at

72 dpi. In Photoshop, use the New Window command to specify the resolution, or a similar command in another program. The background could be black or white, a solid color, a pattern or gradient, or even another image.

Then use Image Size or a similar command on the vertical photograph. Lower the resolution to 72 dpi. Make certain that the aspect ratio is locked, so the image does not become distorted. Because you want to maintain the height of the photograph, change this number to 480 pixels.

figure | 6-25 |

In Photoshop, create a new window
that is 720 x 480 pixels at 72 dpi.
Be sure to choose RGB Color Mode
for video. This window will serve as
your background mat.

figure | 6-26 |

Because we want to maintain
the height of the vertical
photograph, 480 pixels, the
required height for standard
video, is entered. The width
changes proportionally to
319 pixels. This width,
when combined with the
background mat, will later
become 720 pixels, ensuring
that the photograph will not
become distorted.

It does not matter what number the width proportionally changes to because the width of the vertical photograph, plus the necessary amount of the background's pixels, will equal 720 pixels. The background pixels plus the pixels of your photograph's width need to equal 720 pixels.

**Width (pixels) + X (background pixels) = 720 pixels**

Drag the photograph as a new layer onto the background image and position it to the left, to the right, or in the center with parts of the background clip showing through on either side. In Photoshop, the Move tool allows you to move layers among images. Most photographic editing software programs have this feature. You may need to merge the two layers, the photograph layer and the background layer, into a single layer before saving the image in a particular file format.

figure | 6-27 |

This photograph has been matted on top of the white background. The 401 pixels of the white background and the 319 pixels of the photograph's width equal the 720-pixel required width for video. The photograph can be centered on the mat or placed on either the right or left side.

## Panning

A final option for preparing vertical photographs for video would be to pan a portion of the photograph at a time. You can pan in either direction in most video editing software programs, either from the top down to the bottom, or from the bottom up to the top. Horizontal panning is also possible. This works well for photographs taken in landscape or panoramic mode, now an option on certain camera models. In Adobe Premiere, the Image Pan effect can be applied to the photograph to create a vertical or horizontal pan.

To prepare a vertical photograph to be panned, the width of the image must conform to the required video resolution of 720. It doesn't matter what the total height is, because with the

panning option, you are only viewing 480 pixels of the height at any given time. Using Image Size, or a similar command, lock the aspect ratio of the vertical photograph so that the image does not become distorted by checking Constrain Proportions. Lower the resolution to 72 dpi. Then enter 720 for the width. The height will change proportionally. Import the photograph into the video editing software program and apply Image Pan, or a similar effect.

figure | 6-28 |

When the dpi is lowered to 72 and 720 pixels is entered for the width, the height changes proportionally to 1082.

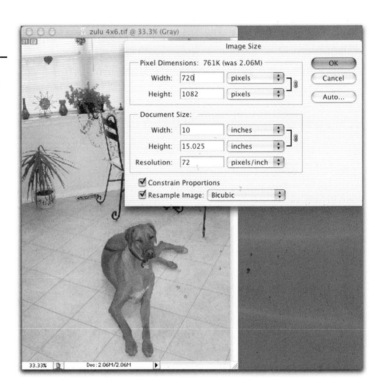

figure | 6-29 |

The photograph is imported into Adobe Premiere and the Image Pan filter is applied. The 1082-pixel height is changed to 480 pixels, forming a 720 x 480-pixel box at the top of the photograph, the exact viewing area of the video frame.

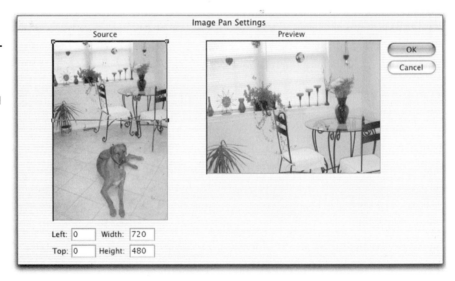

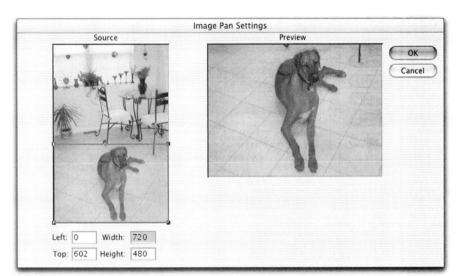

figure |6-30|

At the end of the photograph's five second duration, Image Pan is again applied. 480 pixels is again entered for the height, changing it from 1082 pixels. This time the 720 x 480-pixel box is pulled down to the bottom of the photograph.

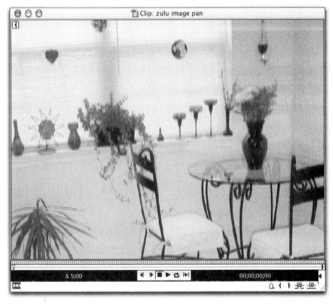

figure |6-31|

When the Image Pan filter is rendered, the program pans from the top of the photograph down to the bottom, viewing only 480 pixels of the photograph's entire 1082-pixel height at a time. This is the top portion of the photograph.

figure | 6-32 |

This image shows the middle portion of the photograph rendered using the Image Pan filter.

figure | 6-33 |

This image shows the bottom portion of the photograph rendered with the Image Pan filter applied.

# CHAPTER SUMMARY

No matter if you decide to pan, mat, or simply include photographs in your digital video project, they will become an important design element. Therefore, it is important to take the time to prepare your photographs correctly for digital video. While this procedure might seem a little cumbersome until you get the hang of it, the result—crisp, clean, high-resolution photographs—will be well worth the effort.

## in review

1. What factors contribute to a photograph's quality?

2. What are the three primary methods for acquiring photographs for digital video?

3. What factors should be considered when scanning photographs for digital video?

4. What is the difference between dpi and resolution in digital video?

5. Why is aspect ratio important when cropping photographs for digital video?

6. What types of compression are used on photographs?

7. How do you crop a horizontal photograph for digital video?

8. How do you crop a vertical photograph for digital video?

9. How do you mat a vertical photograph for digital video?

10. How do you pan across a photograph in a digital video editing program?

## exercises

1. Resize and crop three horizontal photographs for digital video.

2. Resize and crop three vertical photographs for digital video.

3. Resize, crop, and mat the same three vertical photographs for digital video.

incorporating titles, graphics, and audio

# objectives

Understand the basic design principles used to create titles for digital video

Learn how two-dimensional graphics are used in digital video

Learn how three-dimensional graphics and animation are used in digital video

Understand the importance of using alpha channels in digital video

Learn how to prepare audio files for use in digital video

# introduction

In addition to incorporating photographs into a digital video project, other design elements are frequently used, such as titles, two-dimensional and three-dimensional graphics and animation, audio, and music. When digital video is successfully integrated with these other elements, the result is a professional and sophisticated creative piece.

# TITLES

Titles are popular elements to add to your digital video project. **Titles** are simply text files made up of a single word, multiple words, or phrases, and are used to provide supplementary information such as names and dates. They are also used to reinforce important concepts or to clarify unusual terminology. **Credits**, on the other hand, are a list of names attributing who worked on a project and what their roles were.

Some video editing software programs include a built-in feature for creating titles; others offer additional titling capabilities as third-party plug-ins. Titles can also be generated in image design programs like Adobe Photoshop and Adobe Illustrator and later imported into the video editing program.

## Action and Title Safe Areas

No matter where you create your title, there are some conventions it should adhere to. First of all, like photographs, titles prepared for full-motion digital video need to be 720 x 480 pixels at 72 dpi. However, never extend your type completely to the edges of the title window, or you'll run the risk of having letters cut off. On the computer, you see the entire video window, including the border. However, televisions and other video equipment were designed to overscan the video image deliberately so any imperfections around the edges would not be seen.

figure |7-1|

The Adobe Title Designer is a feature of Adobe Premiere.

To compensate for the overscanning, title and action safe areas were designated for the NTSC video frame. These safe areas are marked by a set of two lines forming a rectangle within a rectangle inside the video frame. The outermost line is called the **action safe area**, and any video image within the action safe area will be displayed in its entirety. The innermost line is called the **title safe area**. A separate line was created just for titles because they run a higher risk of becoming distorted if they get too close to the edges of the video frame.

Most video editing software programs that include titling capability designate the title and action safe areas. However, if you are creating titles in another software program that does not provide these boundaries, be sure to import the title into a video editing program to verify that the title adheres to the safe areas designated by the NTSC video frame.

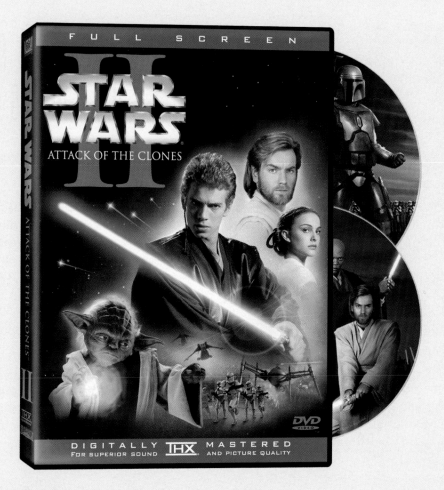

A LONG TIME AGO, IN A STUDIO FAR, FAR AWAY, writer and director George Lucas embarked on an adventure. He created the *Star Wars* saga, and forever changed the art of making movies. Many of us who grew up watching *Star Wars* became more than just fans of the films, but also fans of the art and technology that created them. With his movies, George Lucas inspired a whole new generation of filmmakers who dared to dream of achieving the impossible. From his early use of bluescreen and motion control cameras, to his trust and reliance on burgeoning computer technology, it was George Lucas who first realized the true creative potential of computerized visual effects. In doing so, he also pioneered the field of digital video. In 1984, Lucasfilm unveiled EditDroid, one of the first computerized nonlinear editing systems, which was later acquired by Avid Technology; subsequent generations soon became the industry standard. The innovations in digital technology continued over the years, and in 2002, the release of *Star Wars*: Episode II *Attack of the Clones* marked the dawn of a new era. It became the first major motion picture to be shot on high-definition digital video instead of film, and George Lucas's vision of creative freedom was finally realized.

## Best Visual Effects Nominations and Academy Awards

2003 *Master and Commander: The Far Side of the World*

2003 *Pirates of the Caribbean*

2002 *Star Wars: Episode II Attack of the Clones*

2001 *A.I. Artificial Intelligence*

2001 *Pearl Harbor*

2000 *The Perfect Storm*

1999 *Star Wars: Episode I The Phantom Menace*

1998 *Mighty Joe Young*

1997 *The Lost World: Jurassic Park*

1996 *Twister*

1994 *The Mask*

1994 *Forrest Gump* *

1993 *Jurassic Park* *

1992 *Death Becomes Her* *

1991 *Hook*

1991 *Star Trek VI*

1991 *Terminator 2: Judgment Day* *

1991 *Backdraft*

1989 *Back to the Future, Part II*

1989 *The Abyss* *

1988 *Who Framed Roger Rabbit?* *

1988 *Willow*

1987 *Innerspace* *

1985 *Young Sherlock Holmes*

1985 *Cocoon* *

1984 *Indiana Jones and the Temple of Doom* *

1983 *Return of the Jedi* *

1982 *E.T. The Extra-Terrestrial* *

1982 *Poltergeist*

1981 *Dragonslayer*

1981 *Raiders of the Lost Ark* *

1980 *The Empire Strikes Back* *

1977 *Star Wars* *

*\* Received Academy Award*

COURTESY OF LUCASFILM LTD.

**FOUNDED IN 1975 BY GEORGE LUCAS,** Industrial Light & Magic (ILM) soon became the leading visual effects company in the world. In fact, ILM has worked on seven out of the top ten worldwide box office hits of all time. Creating the effects for films like *Star Wars, The Abyss, Terminator 2: Judgment Day,* and *Jurassic Park,* ILM has revolutionized the visual effects industry. Bluescreen. Motion control cameras. Optical compositing. Computer graphics. Digital imaging. Morfing. You name it, and they can create it.

In addition to ILM's renowned visual effects supervisors, over 1,000 core employees, including producers, art directors, model makers, stage technicians, animators, software engineers, editors, and camera operators, have worked tirelessly behind the scenes to create movie magic for nearly 200 films.

ILM has won fourteen Academy Awards for Best Visual Effects and seventeen Scientific Technical Achievement Awards. It has also been nominated for nineteen British Academy Awards—of which it received fourteen—recognizing films like *The Mummy, Saving Private Ryan,* and *Men in Black.* ILM has been raising the bar for decades, researching, developing, and creating groundbreaking cinematic visual effects, entertaining us with its stunning imagery, and immersing us in worlds we could once only imagine.

## Fred Meyers

Principle Engineer, Industrial Light & Magic

COURTESY OF LUCASFILM LTD.

FRED MEYERS, A NATIVE OF MARIN COUNTY, studied television production and electrical engineering at San Francisco State University. Meyer's early work included creating sound systems and sound mixing, engineering for television documentaries and special events, and high-end 2D and 3D graphics systems for video postproduction. In 1990, he joined ILM to build the video engineering department. Meyers designed the company's electronic dailies and digital editing systems. He also built the production engineering department, which integrated the computer, video, and production software groups and created history with films like *T2* and *Jurassic Park*. Meyers currently leads special projects for Lucasfilm, including high-definition digital video for feature films. He is considered an expert in the field of digital cinema.

**CREDITS:**

2002-2003   HD Supervisor: *Star Wars*: Episodes II & III

1998-2003   Principle Engineer: *Once Upon a Time in Mexico*; *The Adventures of Rocky and Bullwinkle*; *Wild, Wild West*; *Star Wars*: Episode I *The Phantom Menace*; *The Mummy*; *Mighty Joe Young*

1996-1998   Director of Production Engineering: *Jack Frost, Saving Private Ryan, Small Soldiers, Deep Impact, Flubber, Spawn, Contact, Men In Black, Speed 2: Cruise Control, The Lost World: Jurassic Park, Star Wars Trilogy Special Edition, Mars Attacks!, Star Trek: First Contact, 101 Dalmatians*

1991-1996   Chief Engineer of Video Engineering: *Daylight, Dragonheart, Twister, Mission: Impossible, Jumanji, The Indian in the Cupboard, Casper, Village of the Damned, Radioland Murders, The Mask, Forrest Gump, Baby's Day Out, The Flintstones, Schindler's List, Jurassic Park, Meteorman, Death Becomes Her, Alive, Memoirs of an Invisible Man, The Young Indiana Jones Chronicles, Hook, Star Trek VI, Space Race, Terminator 2: Judgment Day, The Rocketeer*

## Ben Snow

Visual Effects Supervisor, Industrial Light & Magic

COURTESY OF LUCASFILM LTD.

AN AUSTRALIAN NATIVE, BEN SNOW studied film and computing at the University of Canberra. He got his start in the field as a runner for a computer graphics house in London. Snow returned to Australia to set up the computer animation department for a company in Sydney, where he also worked on commercials, broadcast openers, and computer graphics title sequences. He joined ILM in 1994, where he pioneered effects work for *Star Trek Generations,* which integrated computer graphics and motion control models. Snow has also done key research and development for the groundbreaking effects seen in *Twister, Deep Impact,* and *Pearl Harbor.* His work as Visual Effects Supervisor for *Star Wars*: Episode II *Attack of the Clones* was recognized with an Academy Award nomination for Best Visual Effects.

**CREDITS:**

2004   *Van Hesling*—Visual Effects Supervisor

2002   *Star Wars*: Episode II *Attack of the Clones*—Visual Effects Supervisor

2001   *Pearl Harbor*—Associate Visual Effects Supervisor

1999   *Galaxy Quest*—Associate Visual Effects Supervisor

1999   *The Mummy*—Computer Graphics Supervisor

1998   *Deep Impact*—Computer Graphics Supervisor; Head of R&D Team

1997   *The Lost World: Jurassic Park*—Computer Graphics Sequence Supervisor

1996   *Dragonheart*—Technical Director

1996   *Twister*—Technical Director; R&D Team

1996   *Mars Attacks!*—Computer Graphics Sequence Supervisor

1995   *Casper*—Technical Director

1994   *Star Trek Generations*—Technical Director

COURTESY OF LUCASFILM LTD.

# BEHIND THE SCENES WITH FRED MEYERS

## High-Definition Supervisor, Star Wars: Episodes II & III

**Q. How does shooting HD video compare to film in terms of color reproduction and depth of field?**

**A.** Let me just start by using some kind of framing regarding shooting HD video. I have noticed that some of the terms like HD and video are used to describe what we're doing in going to digital acquisition. But often those terms, both HD and video, may have other connotative uses, both in the consumer and in the professional worlds, meaning something that isn't necessarily the best way to describe what we're doing. We're transitioning to an all-digital motion picture production pipeline. We're shooting with tools that have evolved out of HD technology and out of video technology, but where we are now is, we're shooting digitally and these are basically digital motion picture tools. When you make comparisons or people bring up discussions about what are the differences in say, color or depth of field, often those are comparisons made to video and not necessarily to digital, the types of cameras that we're using currently. We're using the evolving tools that came out of HD technology and video. The current state is that they're not the same in many senses that, for example, HD and HD broadcast, or video in the sense of videotape formats, and that kind of thing. Using that as a frame, I think probably the thing that's most obvious is that in going digitally, you now have a lot more control over what you shoot at the time you shoot it. You're not limited to the reproduction of a particular negative that you might load in a film camera. In that sense, just like in postproduction where there's all kinds of digital tools to work with the image and create what you need at the time you're shooting, you have a whole new set of tools and kind

COURTESY OF LUCASFILM LTD.

of a different, adjustable palette. In terms of colors, you've got a much wider range of what you can actually get out of the camera. I think most of the comparisons have been to film in terms of maybe looking at limitations in some of the specific areas of video cameras. Once you actually are focused in a color depth and a bit depth that is the same as would be in postproduction even for a film-originated project, you actually have a wider color gamut than you did initially with film. In terms of color and changeable characteristics of acquisition, you've got a lot more range there. In terms of depth of field, it is related to the size of the actual imaging sensor, and as a result, the lens technology that's used. With current cameras, including the ones that we've used both on Episode II and now on III, the physical image sensor has been the same size and that has set the depth of field to something closer to 16 mm film than it is to 35 mm film. There is a depth of field difference and it's about two and a half times greater with these digital cameras. Most of the discussions, though, about depth of field have again been on the

comparisons to 35 mm, or even 35 mm anamorphic, which has the least depth of field of a film format and often that has been exploited artistically. In the case of the *Star Wars* pictures, I think George has taken the tack, and so has David Tattersall, the DP, that whereas if you have reduced depth of field you can't change it later, if you have increased depth of field, you can manipulate it and you can change it later. It's better to have more of something that could give you control than to have less of something where you're not going to be able to get control over it. That being said, and that being where we are right now with the 2/3-inch image sensors, there are other digital cameras that we're working with that have different image sensor size and as a result would have less depth of field, which may help some projects and may hurt others. It's a comparison to where we are with image sensor sizing, and it can be looked at as an advantage in some projects.

*For more excerpts from the interview with Fred Meyers, please see Appendix D.*

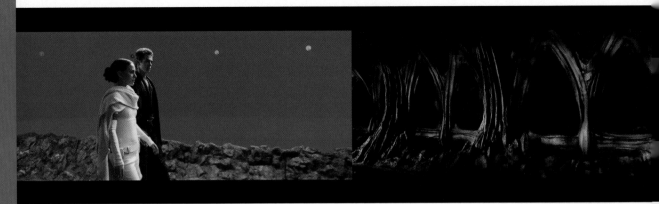

COURTESY OF LUCASFILM LTD.                    COURTESY OF LUCASFILM LTD.

# BEHIND THE SCENES WITH BEN SNOW

## Visual Effects Supervisor, Star Wars: Episode II

This is a combination of computer graphics, miniature, and live-action photography. The first image is bluescreen with a partial set showing Padmé and Anakin walking along a corridor that's part of the entrance to a big industrial complex on the planet of Geonosis. This was a sequence in *Episode II* that really came together a little later in the film. One of the ways George Lucas uses new technologies is to shoot a bunch of film, go back and assemble it, and then work out what else he needs. In this case, he wanted to expand this sequence and shoot some new material. There was some concept art created based on his ideas, but they went out and made it up on the day a little bit. The bluescreen actually came first in this case. They knew they were going to do a rocky set, and they redressed another set they had with some of this rock material. From that point, George started cutting

this together and talking to the art directors up at Skywalker Ranch about what he wanted, and they designed the Geonosis sleeping chamber. The animatics team made an animatic built entirely in Maya to give a rough idea of what the action would be in the scene. The little dots on the bluescreen background are for tracking information. Our camera match move team uses those markers, and whatever information is on the set, to track and re-create a computer graphics camera that matches exactly what they did on location. If there's a bluescreen, you don't have a lot of points of reference to track what's going on. Those markers are fairly easy to remove for us, but when someone goes in front of them, it's a little bit tricky. You try to minimize that to make it easier for our match move team.

When we started work on the shot, we loaded it online, and the camera match move team matched it. We took a look at all the bluescreen photography and said, "What are we looking at here? How many shots have we got in this environment? Should I build it as miniature or CG? How much is it going to cost to build, and how much of it should I build? Are we always looking in this direction?" If we're looking in other directions—as we were for this sequence— we can cheat and reflect the same piece of miniature or CG over to make the other side. I'd make a map of the camera angles to help plan the visual effects. "Are we locked into the camera moves

COURTESY OF LUCASFILM LTD.

because of the bluescreen photography?" If we are, it makes life easier. But George Lucas isn't always constrained by the original framing. He and the editors will scale and flop images to create new framings on the Avid, sometimes even combining takes of two different people together. He really knows the full capabilities of this technology.

The second image is a still of the miniature set piece we created at one-sixth scale by carving and painting foam. There's a lot of work to get a good looking rocky surface in CG, and the model shop's always been really good at doing that sort of stuff. We decided to build a carved foam model for this. We made the miniature rock chamber, matched the cameras in the computer, and sent that data out to our motion control stage to use for shooting the miniature. Our DP on stage used lots of lights to create and add scale to the miniature, and he and I worked together to try and devise the lighting scheme based on the concept art and the live-action photography. When they're shooting a live-action bluescreen, the filmmakers try to anticipate what we're going to do in the background. We can also control and manipulate the image via compositing to make it work better with our miniature photography.

In the third still, we took the photography we'd shot on HD and loaded it onto the computers. Because we were going to add computer graphics creatures, we needed to make a CG version of the rock wall. We used photo modeling. We set up an HD camera to slowly pan across the set and revolve the camera around the set. Our match move department used that to place points to re-create the miniature set on the computer in a crude form that would serve as a guide for the animators and allow us to get the creatures to cast shadows onto objects. The animation team added the little Geonosian guys that you see here. A computer graphics model of the creature was built. It was painted by a painter, and we created the materials so it felt like an insect. We also created a lower-resolution version that was faster for the animators to manipulate. They used that version to create the animation of the creatures coming out of the walls. They loaded a background into the animation software and rendered fast gray plastic tests to judge animation.

In the fourth frame, the animation's done and it's all working. Sometimes, the animation gets further treatment by the creature development team—a group of technical animators who make sure all the skin works. They also control the enveloping process and any dynamics. If there was hair or if some of these creatures had chains hanging from them, they would do dynamic simulations to make that all work. It gets passed along to the technical directors, who actually do the lighting. I work with them, too. In this case, it was fun because George

COURTESY OF LUCASFILM LTD.

wanted the creatures to not be seen at the start of the shot. They emerge into the light. We lit them to match the stage photography. If we have a painted model of the creature when we shoot the photography, the live action, or in this case the miniature photography, we shoot a version with the painted model so we can get a sense of what these guys would look like if they were really there. We also shoot a gray sphere and a chrome sphere to look at what the reflections are like. "What would a neutral gray thing look like in this lighting environment?" That helps us match our computer graphics into the live action or miniature photography. When the CG creature is lit, a compositor takes that and puts the people from the bluescreen on top. In this case, you'll notice in the first image that they're actually a little closer to us. George wanted to go a little wider on the shot. When we shoot, we have a slightly bigger image on the HD camera—the image is 16 x 9—but on an anamorphic widescreen film like *Star Wars,* you're actually only using a 2.35:1 center crop of that. We have a little bit below the camera's frame line to work with. We used that extra little bit of Padmé and Anakin. Of course, when we shrank the bluescreen plate, the set they were on became somewhat useless to us. Since the set wasn't as nice looking as the little miniature we made, we ended up hand rotoscoping the performers using Commotion. We added a bit of atmosphere and mist, because it was supposed to be eerie and creepy there. To accomplish this, we can use steam that we've shot on set, and we also have some computer graphics smoke. We can shoot things like smoke against black, and then we just put a luminance extraction on them. If it's a daylight scene, we'll shoot it against blue. But this is an eerie sort of creepy nighttime. We put the foreground people, miniature rock wall, computer graphics creatures, and smoke and atmosphere elements together in the composite to make the resulting shot you see on screen.

*For more excerpts from the interview with Ben Snow, please see Appendix E.*

figure 7-2

The composition window in Adobe After Effects shows the title and action safe areas.

## Broadcast Colors

In addition to the differences between the techniques the computer monitor and the television use to display video frames, there is also a difference in the way they display color. The computer monitor has a much greater color depth, or the ability to display more colors, than a television set. Therefore, the color you see on a computer monitor may not be the same color you see on the television. Certain colors are outside of the gamut, or range, of colors that video can accurately reproduce.

figure 7-3

The Color Picker in Adobe Photoshop will warn you with an exclamation point if you select a color that is out of gamut.

Video editing software programs have built-in warnings that inform you when you are selecting a color that is not safe for broadcast. Even some image editing software programs, like Adobe Photoshop, have a special filter that makes certain all the colors are broadcast safe. Most people who edit digital video professionally use an NTSC video monitor to preview their work; this monitor also assists them in selecting colors.

figure 7-4

You can use a filter in Adobe Photoshop to make certain your colors are safe for video.

## Stylistic Concerns

Since you are now aware that video has a problem producing certain colors, you should also know that thin lines are difficult for video to display. Thin lines tend to flicker when they are reproduced on video and should be avoided. Likewise, **serif** fonts, which have thin lines on the points of the letters, can also be a problem. **Sans-serif** fonts do not have these thin lines around the edges of the letters, so they reproduce better.

figure | **7-5**

Sans-serif fonts like Arial Black should be used in titles for digital video.

Serif Font: Times
(Not ideal for video.)

**Sans-serif Font: Arial Black**
**(Ideal for video.)**

Once you have chosen the right font and selected the right color, you want to be certain that the title can be read clearly. Titles are often combined with other video images. To make titles stand out from potentially interfering backgrounds, drop shadows and gradients are often applied.

figure | **7-6**

Color is one way to set apart a title from its background. In this black-and-white photograph, the title has a similar luminance value, making it difficult to see against this busy background.

figure | 7-7 |

In addition to selecting a distinguishable color, you can separate a title from its background by adding a drop shadow.

figure | 7-8 |

Another technique used to set a title apart from its background is to add a gradient. Solid colored shapes such as rectangles are also used, or a combination of both gradients and shapes.

# MAINTAINING THE CREATIVE MACHINE

*Michael Sickinger, an accomplished Graphic Designer, is Art Director of the Creative Marketing Studio at Firmenich, a fragrance company. Michael also frequents colleges and universities, speaking to students about working in the field of graphic design.*

Maintaining the creative machine means exactly that—creativity needs constant maintenance to keep running at maximum potential. Creativity must be fed with anything and everything you can get your hands, eyes and mind on. Tools to keep your thoughts clean and running strong are everywhere, you just need to know how and where to find them.

Having a keen eye is the key to properly maintaining a strong creative mind. A sharp eye will catch all that is around to be seen. Give yourself a new perspective and try to look at things differently. Use your eyes and mind together to see more than just what is there. This not only has you looking for visuals in a more innovative light, but also gives the eyes and mind a good creative workout.

- Keep your eyes peeled when watching television, a movie, or surfing the Web. Leisurely paying attention to graphics will build your creative toolbox with items that could be needed at a later date. Notice how things are laid out, how they animate, if the font matches the mood, and most of all, think to yourself: how can I do that?

- A finely tuned creative engine is always upgrading to something newer and faster; don't become last year's model! One thing that's good, and bad, about a career in visual communications is that it's constantly evolving. Computers have revolutionized the industry and change happens almost every day.

In order to be competitive you must stay up to date with technology and learn as much as you can as fast as you can. There are always things to be learned, don't fall behind and let technology pass you by.

- Another important maintenance procedure for creativity is to keep in tune with the design of the times. Just like computers, design changes over time. An ad created in the early '90s probably won't look as cutting edge during the present. Keep those creative gears greased with current design technique and style in order to keep your creativity looking shiny and new.

- As with any mechanical device, there are things that can keep the device from working properly: inhibitors. Creativity works the same way. Having something on your mind while trying to be creative is like a pebble caught in a cog; there's something in the way of it functioning correctly. If you're too busy thinking about what happened yesterday, you're not going to be able to focus on what you have to do today. Take a walk, have some coffee, or listen to a good CD. Clear your head and get those creative sparkplugs crackling.

A machine will break down and cease to operate if not maintained on a routine basis. Creativity will do the same. In order to keep creativity fresh and exciting, you must be willing to give it what it needs. Keep your creativity on the cutting edge by constantly feeding it with new visuals, technology, up-to-date design exposure, and stay away from creative inhibitors. Keep these things in mind and your creativity will be running at maximum potential.

# GRAPHICS

People often become confused with the difference between titles and graphics. Simply stated, a title is made up of only type, but a **graphic** is made up of computer-generated imagery that may or may not also include type. For example, a client's logo might include the name of the company, which is interwoven or combined with some type of design or shape. In this instance, the logo would be considered a graphic rather than a title. There are countless software programs that generate computer graphics. Primarily they're divided into two categories: two-dimensional graphics, which would include vector-based graphics, and three-dimensional graphics and animation.

## Two-Dimensional Graphics and Animation

**Two-dimensional graphics** and animation are computer-generated images that are created along two axes: the vertical, or Y-axis, and the horizontal, or X-axis. This artwork has width and height, but no depth. Two-dimensional animation is a series of computer-generated, two-dimensional frames played back in succession. Two-dimensional graphics can be created in a variety of software programs, including image editing programs like Adobe Photoshop and drawing programs like Adobe Illustrator.

figure | 7-9 |

Adobe Illustrator is the program of choice for creating two-dimensional graphics for video.

## Vector-based Graphics

**Vector graphics** are two-dimensional graphics that are path based as opposed to pixel based. Adobe Illustrator creates path-based computer imagery. Video editing software programs are pixel based, so any artwork created in Adobe Illustrator must be **rasterized**, or converted into pixel-based art, before it can be imported into most video editing software programs.

However, high-end programs like Adobe After Effects have a feature called Continuous Rasterization, which can be applied to vector-based graphics like Adobe Illustrator EPS (Encapsulated PostScript) files. Using Continuous Rasterization, vector-based graphics can be zoomed in on an infinite amount of times without becoming distorted.

figure │7-10│

In this image, the title, which is an Adobe Illustrator EPS file, is shown at its regular size of 100 percent.

figure │7-11│

With the Continuous Rasterization option selected, the title is transformed to 200 percent of its original size without becoming pixelated.

figure | 7-12 |

In this final image, the title is now 500 percent of its original size without suffering any loss in quality due to the Continuous Rasterization feature.

## Three-Dimensional Graphics and Animation

**Three-dimensional graphics** and animation are computer-generated imagery that is created on three axes: the vertical, or Y-axis; the horizontal, or X-axis; and the depth, or Z-axis. Three-dimensional graphics have width, height, and depth. Three-dimensional animation is a series of computer-generated, three-dimensional frames played back in succession. There are numerous software programs like Alias's Maya and NewTek's LightWave that create three-dimensional graphics and animation.

# ALPHA CHANNELS

Whether you are working with photographs, titles, or graphics, alpha channels can be created in computer-generated artwork that allow part of the image to later become transparent. An **alpha channel** is an extra piece of information that is written with the file, designating a portion of the image, with the option of being activated later in another software program and becoming transparent.

Alpha channels are useful to the video editor because they allow the editor to put several images on the screen at the same time. For example, when a title with the name of a place is superimposed, or layered on top of, the video image of that place, that particular title is utilizing an alpha channel. The letters of the title were designated to be retained, while the background of the image was designated to become transparent, so that another image may be later substituted in place of the background.

figure | 7-13 |

We will later superimpose a title to this image in Adobe Premiere using an alpha channel.

figure | 7-14 |

This is the title we will add to the image. We will designate the white background to become transparent by creating an alpha channel on this title.

*Jersey Shore*

| TIP |

Most three-dimensional animation programs will generate alpha channels. Check for the Alpha Channel option under Render Settings. The animation CODEC usually gives the option for creating alpha channels.

Alpha channels are essentially invisible until they are "turned on" or activated. When viewing an alpha channel that has already been created, the white part of the channel retains the original image and the black part of the image becomes transparent. Most graphic design programs and video editing software programs are capable of creating and using alpha channels. There are two types of alpha channels: straight, or unmatted, alpha channels; and premultiplied, or matted, alpha channels.

## Straight, or Unmatted, Alpha Channels

In a **straight,** or **unmatted**, **alpha channel**, the transparency information is kept in a separate channel, not with the color information in the red, green, and blue channels. Because this information is kept separately, straight alpha channels have the highest quality.

## Premultiplied, or Matted, Alpha Channels

In a **premultiplied**, or **matted**, **alpha channel**, the transparency information is still kept in a separate channel, but it is also kept with the color information in the red, green, and blue channels. The matted alpha channel is premultiplied with a color, usually white or black. While the premultiplied alpha channel is not as high quality as the straight alpha channel, it is compatible with a wider range of software programs.

## Creating Alpha Channels in Adobe Photoshop

It is very easy to create alpha channels in Adobe Photoshop. First, you must make a selection of the portion of the image you wish to make transparent. If the part of the image you wish to make transparent has all the same color pixels, the Magic Wand tool can easily make the selection.

| TIP |

Some software programs give you a choice as to which type of alpha channel to create, others do not. If you incorrectly identify a straight alpha channel as a premultiplied one, or vice versa, when attempting to use one, you can get what is referred to as the halo effect, or color distortion around the edges of the channel. If the halo effect occurs, try changing the interpretation mode of the alpha channel to remedy the problem.

figure |7-15|

Using the Magic Wand tool in Adobe Photoshop, the white background is selected.

However, if you wish to cut out an object from the background of a photograph and the colors are not the same, the Magnetic Lasso tool is a better choice. The Magnetic Lasso tool will allow you to trace along the edges of an image by clinging to pixels that are in the same color range.

If you are taking photographs for a digital video project and you intend to add alpha channels to them later, try to isolate your subject against a solid-colored background, so you will have an easier time making your selection for the alpha channel.

If you are working with multiple layers in Adobe Photoshop, merge your layers into a single layer before making your alpha channel selection.

figure 7-16

After making your selection, the next step is to save the selection by choosing Save Selection from the Select menu.

figure 7-17

Save your selection as a new channel.

figure 7-18

In order to view your alpha channel, open the Channels window.

figure |7-19|

Select the alpha channel to view it. The white portion of the alpha channel retains the image. The black portion of the alpha channel becomes transparent.

figure |7-20|

If your selection is the opposite of what you desire, go to the Channel Options pop-up menu and toggle back and forth between the Masked and Selected view options until your selection is correct.

| NOTE |

Do not mistake a mask in Adobe Photoshop for an alpha channel. Only alpha channels can be successfully keyed out, or made transparent, in video editing programs like Adobe Premiere.

| NOTE |

Be sure to check the Save Alpha Channels option when saving your file in Adobe Photoshop.

figure |7-21|

You can then import your alpha channel into a video editing program like Adobe Premiere to verify that the alpha channel is recognized. Double-click on the alpha channel to open it.

figure | 7-22 |

Toggle back and forth between the RGB and alpha buttons to check your alpha channel.

figure | 7-23 |

Once you have verified your alpha channel, you can utilize it by placing it on a transparency track. In Adobe Premiere, the transparency tracks are Video 2 and higher. Place another image or video clip on Video 1. Select your alpha channel with the Selection tool and go to the Clip menu and choose Video Options | Transparency.

figure | 7-24 |

You can choose between Alpha Channel, White Alpha Matte, and Black Alpha Matte.

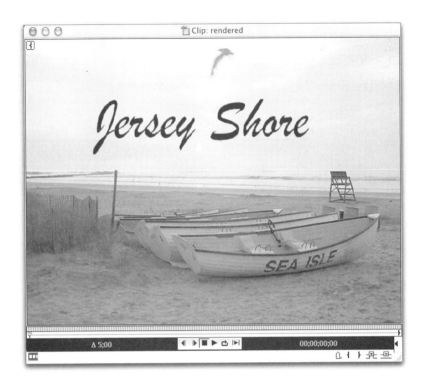

figure |7-25|

In the rendered clip, the alpha channel becomes transparent and the title is superimposed on top of the video image.

| TIP |

If you are not sure what type of alpha channel you have, select the generic Alpha Channel option. If you choose Black Alpha Matte and it was in fact a White Alpha Matte, or vice versa, you will get some undesirable color variations, or the halo effect, around the edges of the alpha channel.

# FILE FORMATS

Different video editing software programs accept different file formats for still images such as titles and graphics. Some programs will accept native Adobe Photoshop, PSD, and Adobe Illustrator, AI, file formats. Programs capable of rasterization will accept Encapsulated PostScript, EPS, files. Other common file formats such as PICT, TIFF, and JPEG are also usually accepted. Animation sequences are typically best imported as QuickTime, MOV, files, but numbered PIC sequences are also usually accepted. Check your software's documentation to see what the preferred file formats are for your digital video editing program.

# AUDIO

When we think of video, many people tend to become so caught up in the visual part of it that they tend to overlook the audio portion. Keep in mind that video includes audio as well, and neglecting audio when you edit can detract from the overall effect of your work. While good audio may go unnoticed, bad audio never does.

Audio is used with video in a variety of ways. It can be recorded and linked directly with the video clip, so that if you move the video, the

audio portion moves with it. Audio can also be recorded separately, such as adding a voice-over or ambient sound. Sound effects can also be added to create dramatic impact. Finally, music is often used to enhance video. Music should never overpower or detract from a video, but rather support the video and add to its overall effect.

## Synch

Nothing is more apparent than when audio goes out of synchronization, or loses its timing with a video clip. Out of synch audio can resemble a poorly dubbed movie, where the actors' mouths move out of time with the spoken words. This occurs when the audio portion of a video clip becomes unlinked from its video counterpart and is shifted in time. Most video editing software programs designate clips that lose their synch with an identifiable marker to alert editors of a potential problem. Audio can also lose its synchronization if frames are dropped during capture, or if there is a problem with playback.

## Levels

Another noticeable audio problem occurs when audio levels are not set correctly and the audio is recorded too loudly or too softly. Most software programs that allow you to capture audio have level meters to help you adjust the volume of the audio as it is being recorded. Green typically signifies a good level, yellow warns it is becoming louder, and red signifies that it is too loud. Audio that has been recorded too loudly is referred to as **hot audio**. When an audio signal is hot, the audio becomes distorted and has a crackling sound. Audio that is too low, or soft in volume, doesn't produce high enough green levels on the meter.

Most software programs that work with audio will draw a graphic representation of the audio sound wave. The smaller the sound wave, the lower the audio, and the larger the sound wave, the louder the audio. A flat line represents no audio, while audio that is hot stretches outside the parameters of the sound wave diagram.

## Sample Rate

When recording audio, you need to select a sample rate, which determines the quality of the audio you are recording. Typically, audio is recorded at either 8 bits, 12 bits, or 16 bits, with 16 bits being superior

figure | 7-26 |

Adobe Premiere has an audio mixing feature that allows you to adjust levels.

figure | 7-27 |

This is the sound wave of an audio music file.

in quality. In addition to the bit depth, the frequency of an audio clip is also measured in kHz. Typical sampling rates are 11 kHz, 22 kHz, 32 kHz, 44 kHz, and 48 kHz, with 48 kHz being the highest quality.

| NOTE |

Digital video cameras record audio at either **12 bits** or **16 bits** and at either **32 kHz** or **48 kHz**.

## Interleave

When selecting a sampling size for audio, you may also be able to select an interleave setting. Interleave, which is also known as audio block size, determines how the audio is written and played back within the video file. Interleave is broken into time increments, with one half second and one second being the most common. Certain video cards will only work correctly with audio at a specified interleave setting, so be sure to consult your manual if you have a third-party video card.

figure | 7-28 |

Audio settings like sampling, interleave, and compression can be adjusted in the Project Settings window of Adobe Premiere.

## Compression

There are many methods for compressing the size of an audio file, but they all adversely affect quality. Uncompressed audio is always the preferred option if file size is not an issue. Because audio takes up

relatively little file space compared to video, compressing the audio is often negligible. However, if you are creating digital video for the Internet, small file sizes are of paramount importance and compressing your audio may be your only option.

| NOTE |

Most video editing programs will accept the AIFF audio file format. MP3s, WAVs, MOVs, and AVIs may also be imported, depending on the software.

## MUSIC

If you are editing any digital video project for professional use, you must obtain permission or pay a royalty fee to use music that is copyrighted. You can also buy collections of royalty-free music. There are software programs like SmartSound for Multimedia that allow you to create royalty-free music specifically for digital video projects. These programs are useful if paying for an original score is not within the budget. Programs like SmartSound for Multimedia have features that allow you to customize the music to fit a particular length and style.

figure |7-29|

SmartSound for Multimedia works with digital video programs like Adobe Premiere to create customizable music files.

## CHAPTER SUMMARY

By understanding the principles of designing titles and graphics for video, you can greatly enhance any digital video project. Incorporating alpha channels gives the digital video editor more creative freedom. Finally, while digital video is predominantly a visual medium, the importance of good audio and music should not be overlooked.

## in review

1. What are the action and title safe areas, and why are they important?

2. What type of fonts should be used when creating titles for video, and why?

3. Which has greater color depth, the computer monitor or the television set? How does this affect color selection for digital video?

4. What is rasterization, and how does it pertain to digital video?

5. Why are alpha channels important to the digital video editor?

6. What is a straight alpha channel?

7. What is a premultiplied alpha channel?

8. Why is it important to monitor audio levels?

9. What type of sampling is used for audio files?

10. Why should thin lines be avoided when creating graphics for video?

## exercises

1. Create three titles with alpha channels for your project.

2. Create three graphics with alpha channels for your project.

3. Record music and any necessary audio or sound effects for your project.

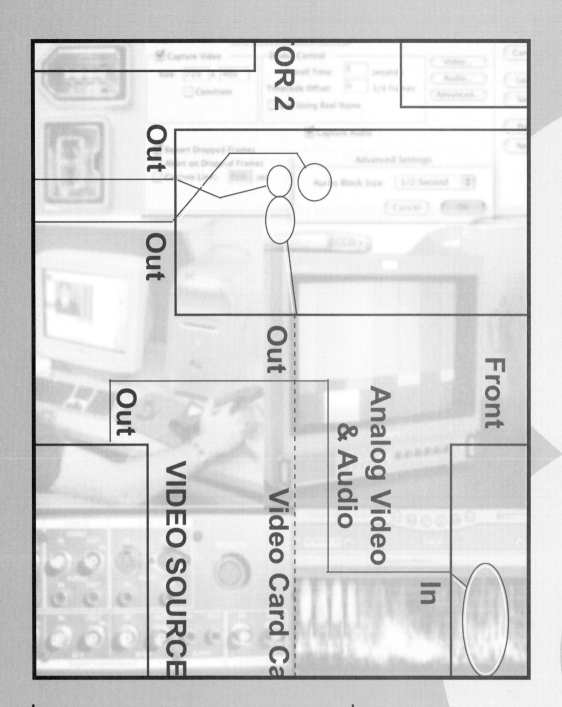

## *objectives*

Learn how to connect digital video equipment

Understand how to capture video using FireWire

Understand how to capture video using a video card

Learn how to set video capture settings

Learn how to capture video

Learn how to capture audio

## *introduction*

Capturing video is a lot easier today than it was not so very long ago, due to the creation of FireWire (IEEE 1394). FireWire is a communications protocol that allows your computer and your digital video camera to speak the same language. Most Macintosh computer models come with FireWire built in. On PC computers, you need to buy a FireWire card that fits into a spare PCI slot. Most digital video cameras have FireWire; analog video cameras do not, though, because FireWire requires a digital video signal. The FireWire port works in both directions, so only one jack is required to input and output video.

Another option is to purchase a digital video card, which also fits into the PCI slot of your computer. This card will convert the analog video signal into a digital one, so you can edit it, and then convert it back into an analog signal again when you are ready to export your finished project back out to tape.

**CONNECTING EQUIPMENT AND CAPTURING DIGITAL VIDEO**

# VIDEO CAPTURE USING FIREWIRE

To capture video using FireWire, you need a computer with either built-in FireWire or a FireWire PCI card, and a digital video camera. You will also need a four-to-six-pin FireWire cable. The four-pin connector attaches to the digital video camera and the six-pin connector attaches to the FireWire port in the computer. Six-to-six-pin FireWire cables are used to attach devices like FireWire hard drives to the computer. One of the more reasonably priced places to purchase a four-to-six-pin FireWire cable is through a computer store. You can also purchase them at most places that sell video equipment.

figure | 8-1 |

Using a FireWire cable, this Sony DCR-VX2000 digital video camera is linked to a Macintosh computer.

| NOTE |

Most digital video cameras do NOT come with a FireWire cable, but rather come with a USB cable. You usually need to purchase the four-to-six-pin FireWire cable separately. The USB cable is used for digital still photographs, not full-motion video. Be careful not to mistake the USB port for the FireWire port!

## Attaching a Digital Video Camera

One of the easiest ways to get video into a computer is to attach a digital video camera directly to the FireWire port.

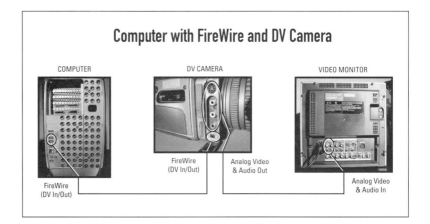

**Computer with FireWire and DV Camera**

COMPUTER

DV CAMERA

VIDEO MONITOR

FireWire
(DV In/Out)

FireWire
(DV In/Out)

Analog Video
& Audio Out

Analog Video
& Audio In

figure | 8-2 |

This diagram depicts the typical connections for linking a computer with FireWire to a digital video camera.

To attach a digital video camera to the FireWire port of your computer, do the following:

1. Identify the FireWire port on the back of your computer. This could be a built-in port on the Mac, or the port on a PCI card on the PC. It is typically a six-pin connector.

2. Identify the FireWire port on your digital video camera. This is typically a four-pin connector. It may say DV In/Out. Be sure you do not mistake a USB port for the FireWire port. (Sony calls this connection i.LINK.)

3. Connect the four-to-six-pin FireWire cable from the digital video camera (four-pin) to the FireWire port of the computer (six-pin). FireWire is **hot swappable**, which means that the devices (computer, video camera, etc.) can be turned on and off while the cables are plugged in and the power is on.

4. Turn your devices on, if they are not on already. Put the digital video camera in VTR or VCR mode. Make sure there is a tape with footage on it in the camera.

5. Launch your video editing software program and any third-party device control software. Adobe Premiere versions 6 and higher have device control software built in. Companies like Pipeline Digital sell third-party device control software.

6. If you are using a video monitor, attach the *analog video out* of your camera to the monitor's *analog video in*. Make sure the monitor is plugged in and turned on.

7. Make sure the computer recognizes the video camera and the tape's timecode before continuing. Then proceed with the video capture instructions specified later in this chapter.

## Attaching a Video Deck

You can also use a digital video deck instead of a digital video camera to capture video to and export video from your computer. Just connect the FireWire cable from your digital video deck (four-pin) to the FireWire port on your computer (six-pin). Many digital video decks also have additional interfaces for connecting equipment, such as the RS-422 protocol.

## Attaching a Video Monitor

You can also connect a *video monitor* to the *analog video out* of your video camera or video deck. The video monitor has more accurate color representation than the computer monitor. Remember that computers

figure |8-3|

The FireWire port (DV In/Out) uses the IEEE 1394 standard.

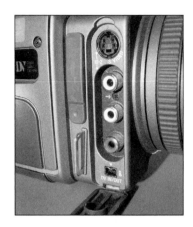

| NOTE |

If the computer does not recognize the video camera, play the tape manually and relaunch the software. If a connection between the digital video camera and the computer is still not established, see the DV Troubleshooting Guide at the back of this book for more information.

| NOTE |

High-end digital video cameras, decks, and video cards are equipped with **SDI**, **serial digital interface**. This connection provides lossless quality and is superior to standard DV In/Out (FireWire, IEEE 1394).

have a much higher color depth than video. Therefore, the colors that you select on your computer screen when you edit are not going to be the same as the colors you see on the television. Professional video editors use video monitors to preview their work. While it is not required to have a video monitor in order to edit digital video, it is highly recommended.

This combination Mini-DV/S-video deck by JVC is linked to both the computer and the NTSC video monitor.

| NOTE |

If you cannot afford to purchase a professional video monitor, use a small color television set instead. Connect the analog video signal out of the camera to the AV input on the television. If you have an older television set that does not have an AV input, then loop the video signal through a VCR. Any video monitor is better than no video monitor!

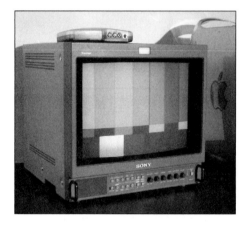

figure | 8-5 |

The video monitor is an integral part of any digital video editing system.

Professional video monitors have composite (consumer), S-video (prosumer), and component (broadcast) video connections. Most have multiple video inputs for connecting several video devices simultaneously. They also usually have an overscan and underscan feature, which allows you to view the action and title safe areas. They have sophisticated color adjustments for precision color correction. Most of the higher-end models have switchable aspect ratios, allowing the user to select either standard 4:3 or 16:9 widescreen mode.

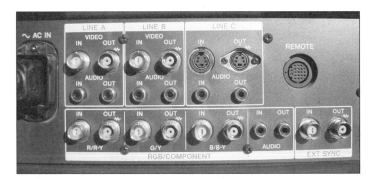

figure |8-6|

This model monitor has component, composite, and S-video connections.

# VIDEO CAPTURE USING A VIDEO CARD

Video capture cards, like the Matrox RTMac, have come a long way in recent years. Originally, the primary purpose of the video capture card was to convert an analog video signal into a digital one. The early consumer capture cards weren't even able to convert the digital signal back into an analog one. They couldn't capture full-screen (640 x 480 pixels) or full-motion (30 fps) video.

However, today's capture cards do all that and a whole lot more. Most have support for a second computer monitor, in addition to a video monitor. Low-end cards support composite video, prosumer cards support S-video, and high-end cards support component video and SDI. Pinnacle's CineWave card even supports HDTV.

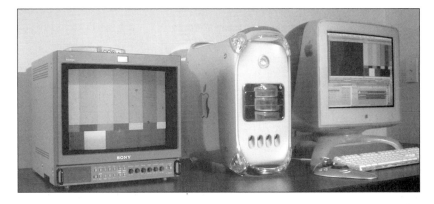

figure |8-7|

Today's digital video cards not only convert an analog signal into a digital one, but also allow for real-time previewing and additional monitor support.

These video cards will also support several layers of video for real-time previewing of effects. With real-time preview, you don't have to wait for certain special effects to render in order to see what they will look like. The digital video card is capable of playing certain features directly from the timeline, such as basic transitions, motion, and alpha channels. However, you will still have to wait for these effects to render in the finished movie. The advantage is faster, easier editing.

figure │8-8│

This diagram depicts the typical connections for a video card with one computer monitor and a video monitor.

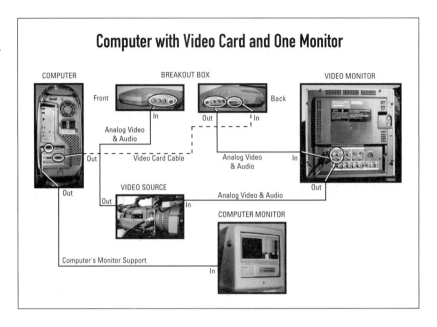

## Using the Breakout Box

Many digital video cards come with a breakout box. A breakout box is a separate unit that uses a cable to plug into the video card. You can connect your video cameras, decks, and monitors directly to the inputs and outputs provided on the box.

figure │8-9│

The breakout box, like this one by Matrox, allows editors to easily plug in their video equipment.

To use the breakout box, do the following:

1. With the computer's power turned off, attach the cable from the breakout box to the video card in the back of your computer.

2. Using a video source like a video camera or deck, connect the source's *analog video out* to the breakout box's *analog video in*.

3. Connect the breakout box's *analog video out* to a video recording device's *analog video in*. You can use either a video deck or a camera to record your video.

4. Connect your recording device's *analog video out* to a video monitor's *analog video in*.

figure |8-10|

The back of this breakout box has composite and S-video connections, as well as an interface cable for the video card.

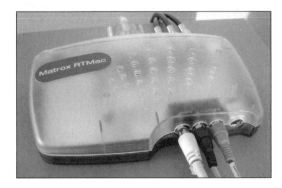

figure |8-11|

This Matrox RTMac breakout box is wired using composite video inputs and outputs.

## Attaching a Second Computer Monitor

Most digital video cards will support an additional computer monitor. The computer's main monitor should be plugged into the computer's built-in monitor support. A second monitor plugs into the video card's monitor support. Typically, digital video editors use a 17-inch monitor or larger. They prefer a two-monitor configuration, with a third video monitor. Screen space is valuable to the digital video professional because most editing software programs use many windows. With dual monitor support, you can extend your workspace from the edge of one monitor to the next by simply dragging your mouse across the desktop.

figure |8-12|

This diagram depicts the typical connections for using a video card with two computer monitors and a video monitor.

figure |8-13|

The back of this computer shows the built-in monitor support in the upper slot and a video card with additional monitor support in the bottom PCI slot.

# CAPTURING VIDEO

Once you have finished properly connecting your video equipment to your computer, you can program your video editing software for capture. Most digital video novices fail to pay proper attention to the various ways the digital video software can be configured. Instead they prefer to jump right in and begin editing. However, to be a true digital video professional, you need to understand exactly what the software does and how it works.

figure |8-14|

This Sony DSR-PD150 is linked to a video card using composite video cables.

## Project Settings

There are various places to preset configurations in most video editing software programs. When you launch Adobe Premiere to begin a new project, it asks you to select the appropriate project settings. By doing so, Premiere will automatically enter the appropriate configurations for capturing, rendering, and outputting digital video for your particular project.

Most digital video editors will select the DV-NTSC preset. This is the one optimized for FireWire. It uses the DV-NTSC video CODEC for compression, which is recognized by all FireWire-compatible video cameras. It captures, renders, and outputs at a resolution of 720 x 480 pixels at 29.97 frames per second (drop-frame).

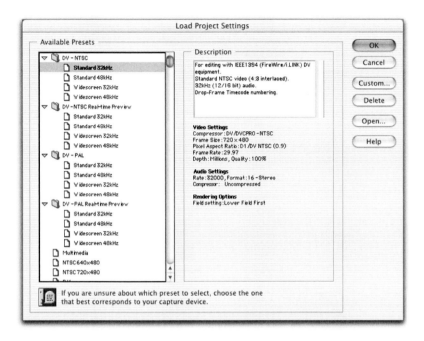

figure |8-15|

The Project Settings window in Adobe Premiere lets you preset the appropriate video settings for your editing system.

The choices for audio are either 12 bit or 16 bit and 32 kHz or 48 kHz. Depending on the audio capabilities of your particular video camera, you would select the appropriate audio settings. For example, the Sony DSR-PD150 will record two stereo sounds at 32 kHz, 12 bit, or one high-quality stereo sound at 48 kHz, 16 bit.

## Selecting a Scratch Disk

Before you begin capturing digital video, you should designate a hard drive to become your scratch disk. The software program will capture your video files directly to whichever hard drive is designated as the scratch disk.

figure |8-16|

Adobe Premiere allows you to select a scratch disk, which is the hard drive that the software program captures the video to.

In Adobe Premiere, go to Adobe Premiere | Preferences | Scratch Disks & Device Control to select the hard drive that will become your scratch disk.

Because hard drive speed and size are both significant factors in digital video, you want to select your fastest hard drive with enough available

| NOTE |

There are two types of timecode in digital video editing: **drop-frame** and **nondrop-frame**. Drop-frame is 29.97 frames per second, and the numbers are separated using semicolons (00;00;00;00). Nondrop-frame is 30 frames per second, and it uses colons to separate the numbers (00:00:00:00).

| NOTE |

By default, most digital video programs use whatever hard drive runs the application software as the scratch disk, until you tell it otherwise.

space to become your scratch disk. Using your fastest drive will minimize the risk of dropping frames when you capture your digital video.

Dropped frames are a digital video editor's worst nightmare. Even a few dropped frames will cause stuttered playback and looks completely unprofessional. Dropped frames occur when the hard drive can't keep up with the amount of information that is coming through at a given moment (digital video data transfer rate). SCSI accelerator cards and RAIDs are used to prevent dropped frames in the professional arena. However, if a high-end system isn't in your budget and you are experiencing dropped frames, you can lower the quality slider to reduce the digital video data transfer rate. Doing so sacrifices color depth and the overall quality of your image, but this is better than giving up full-screen or full-motion video.

After selecting the Scratch Disks & Device Control menu option, choose your fastest hard drive from the pop-up menu to become your scratch disk. Be sure you have enough free space, preferably gigabytes, to capture the video.

| NOTE |

Remember, the three factors that determine file size in digital video are resolution (pixels), frame rate (FPS), and color depth (bits).

figure |8-17|

You should designate your fastest hard drive as the scratch disk to ensure there are no dropped frames when capturing video.

## Using Device Control

You can also designate your device control under the same Preferences menu in Adobe Premiere. Device control is software that allows your video source, such as a camera or deck, to communicate with your computer. Premiere offers built-in device control software. Third-party developers like Pipeline Digital make device control software that plugs into most popular video editing programs.

With device control software and timecode, the computer can fast-forward, rewind, play, pause, stop, and record your video

frame—accurately, with a click of the mouse. There is no need to push the buttons directly on your video camera or deck. The computer even prerolls, or cues up, your video footage so it is ready and waiting to record at the specified frame.

| DV Device Control Options | |
|---|---|
| Video Standard: | NTSC |
| Device Brand: | Sony |
| Device Model: | DSR–PD150 |
| Timecode Format: | Drop–Frame |
| Check Status | Detected |
| Go Online for Device Info | |
| Cancel | OK |

figure **8-18**

Adobe Premiere also comes with built-in device control software that allows the computer to communicate with your video equipment.

Precision control over your video devices is important, especially if you have to piece together a long project on tape. The computer can automatically assemble the segments at the appropriate frame.

In Premiere, you can select the type of device you want the software to control. Many top brand-name cameras and decks are listed. If your particular model is not specified, choose the manufacturer's name and select generic. Be sure to use drop-frame (29.97) timecode for a FireWire-compatible video camera or deck.

The following list will help pave the way during production for smoother postproduction:

* First, when you are recording video out in the field, try not to break the timecode. It makes for much easier editing in postproduction. *Breaking the timecode* is when space occurs between shots, and the timecode begins renumbering again at 00:00:00:00. This makes for difficult capturing because the device control software can lose its place on the tape when multiple shots have the same timecode address. Certain cameras have different menu options for controlling how the timecode is recorded. If you are worried about breaking the timecode, record a few extra seconds at the end of each shot, and then back up and record the next shot over the extra space.

* A second tip to keep in mind while you are shooting is to give an extra second or two at the beginning of each shot, as well as at the end. This makes it easier to edit because you can borrow a few extra frames from either direction. Also remember to direct your actors to pause for a moment after you yell "action" before they begin delivering their lines.

* A third tip to consider is blacking the tape before you shoot. *Blacking the tape* is recording black (no picture or audio) for the duration of the tape and laying down timecode. After blacking your tape, advance ten seconds from the beginning before recording your first shot. You never want to start recording at the beginning of a tape, primarily because there won't be any room for prerolling during capture. Another reason is that over time, the tape may stretch out where it connects to the spindle from repeated rewinding.

## Video Capture

After you have selected your project settings, designated your scratch disks, and selected your device control, you are finally ready to begin capturing video. In Adobe Premiere, go to the File | Capture | Movie Capture.

To capture video in Adobe Premiere, select Capture | Movie Capture from the File menu.

The Movie Capture window in Adobe Premiere also allows you to access the preferences for scratch disks and device control. Keep an eye on the disk space figure as you capture, so you are aware if you begin to run low on disk space. The program will automatically warn you when you are almost about to run out of disk space.

The buttons for the device control software are at the bottom center of the window and resemble the buttons of a VCR. To the right of the buttons is the timecode window. If your camera is turned on, in VTR or VCR mode, and has a tape in it with timecode, press the play button and see if the numbers in the timecode window correspond with the numbers in the camera's display. You should see the picture and hear the sound in the Movie Capture window. If your camera or deck is not responding, see the Digital Video Troubleshooting Guide for more information.

# Video Capture Settings

There are also two tabs in the Movie Capture window for logging your footage and capture settings. You can verify your capture settings by scrolling through the window or change them by clicking on Edit. When you select Edit, a dialog box pops up.

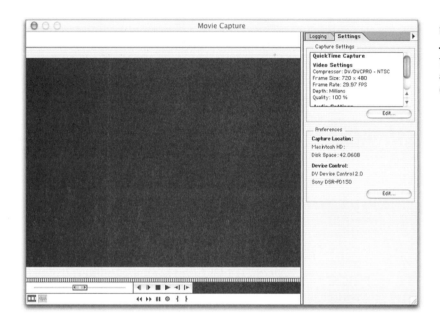

figure | 8-20 |

The Movie Capture window allows you to specify the video capture settings.

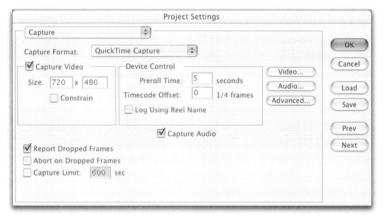

figure | 8-21 |

When you select Edit settings, a dialog box pops up, specifying the capture settings.

Make sure both Capture Video and Capture Audio options are checked. There are options to Report and/or Abort on Dropped Frames, and you can also control the device Preroll Time. Select Video for more settings like Compression and Source. This is where you can lower the quality slider if you are dropping frames.

figure **8-22**

After selecting Video, a second dialog box opens, allowing you to customize the video capture settings, such as compression and source.

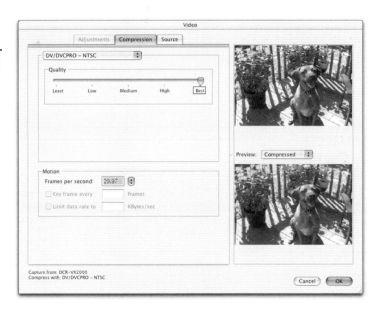

## Audio Capture Settings

You can also customize your audio settings by clicking on the Audio button. A levels meter appears on the right, and there are three tabs on the left for Compression, Sample, and Source. If you leave the internal speaker Off While Recording, you will have less audio interference and a cleaner signal.

figure **8-23**

You could also select Audio, to customize the audio settings. You could select a compression method for the audio or choose no compression.

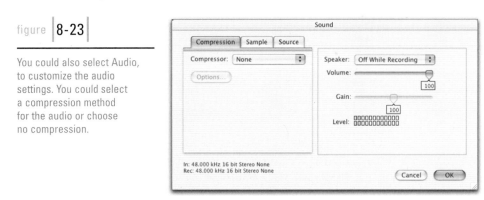

Typically, No Audio Compression is the preferred choice. When compared with the file sizes for digital video, the uncompressed audio is negligible.

The audio sampling method is the quality at which the analog audio signal is converted into a digital one. 16-bit stereo is preferred, while the rate which is measured in kHz depends on the video source. 32 kHz or 48 kHz are the choices for FireWire.

Under the Source settings, you can choose to select the First 2 channels, the Second 2 channels, or to Mix 4 channels. If you have another source to select your audio from, such as the built-in audio on the Macintosh, it will appear in this window.

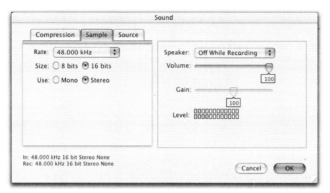

figure 8-24

You can also customize the sampling method for your audio.

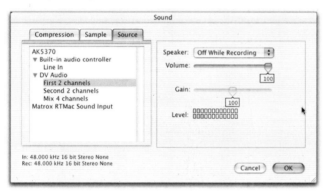

figure 8-25

Under the audio capture settings, you can select the source of your audio.

Under the Advanced button, you can control the audio block size or interleave. Typically, audio that drops out from time to time may have been recorded at an incorrect audio block size. Certain video cards require a specified size for interleave. If applicable, consult your owner's manual.

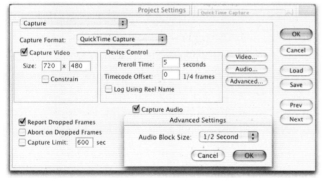

figure 8-26

Finally, under the Advanced button, you can control the audio block size, or interleave.

## Adjusting Color

When you capture from a FireWire video source, you cannot adjust the video or audio levels as you capture. Instead, you must use the video and audio filters in the editing program to correct any problems with color or volume. However, if you also have a video card, you can use your camera's analog output and make the necessary adjustments.

figure | 8-27 |

Using Apple's Final Cut Pro and the Matrox RTMac video card, you can calibrate the color of your analog audio source before capturing it.

Using Apple's Final Cut Pro and Matrox's RTMac video card, you can select the video card's analog input from the Capture/Input pull-down menu. In this example, you can select either Matrox's composite or S-video input.

figure | 8-28 |

A waveform monitor and a vectorscope help you visually adjust the color of your incoming analog video.

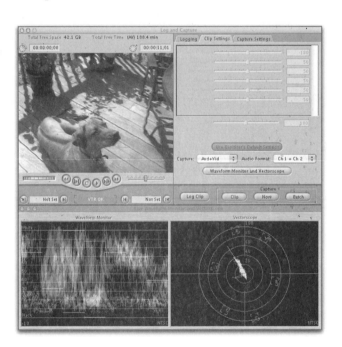

Final Cut Pro has a built-in waveform monitor and vectorscope to help you calibrate the color of your incoming video footage. This professional video signal testing equipment measures the quality of the incoming video signal. The waveform monitor tests the luminance portion of the video signal and the vectorscope tests the chrominance portion of the video signal.

You can manipulate the hue, saturation, brightness, contrast, and the gain of the video signal before it is captured. Color correcting the incoming video signal saves valuable rendering time by eliminating the need to apply filters to correct the color of already digitized footage. Keep in mind, only an analog video signal can be color corrected. FireWire captured video cannot because the video signal is already in digital form.

## Setting In and Out Points

Timecode assigns a numerical address to each frame of video. It is measured in hours, minutes, seconds, and frames. Timecode allows for precision editing. For example, you can identify the exact frame before a glass shatters on the floor. Having this kind of control over your video footage allows the editor greater flexibility when editing.

When you capture digital video, you can set in and out points, or start and stop times, for the video to record from. While you could start recording from the exact frame you want the shot to begin, it is prudent to allow yourself a little extra space at the beginning and end of every shot. Therefore, you can borrow a few frames if you need them later while you are editing without having to go back and recapture the footage. For example, you may want to lengthen your shot so you can add a transition in the beginning or at the end.

figure | 8-29

You can also use a clip's timecode to log in and out points, or the start and stop times the video begins and ends recording.

You can also log all of the in and out points of your clips first, and then tell the computer to go back and capture your list of clips all at once. This is called a **batch capture**. Most digital video editing software programs, like Apple's Final Cut Pro and Adobe Premiere, have this feature.

figure | 8-30

Adobe Premiere will also allow you to log captured clips by setting in and out points.

## Adjusting Audio Levels

In addition to calibrating the color of your analog video footage, you can also adjust the audio levels of your analog audio before you capture it. Conversely, audio levels in FireWire footage cannot be adjusted because the audio file is already in digital form. However, like the video signal, it can be adjusted with audio filters and rendered.

You can adjust the audio gain before it is captured. Adjusting the gain is lowering or boosting the audio signal or volume. In most video editing programs, there is an audio levels meter that measures the incoming audio signal. If the levels remain green, they are good. However, if they hit red, then the audio will be distorted. When the audio levels hit the red zone, the volume is too loud. This is referred to as hot audio.

figure | 8-31 |

You can check the audio levels of your video source to make sure that they are not too hot. Hot audio levels, which surpass the green zone on the level monitor and enter the red zone, will become distorted because the volume is too loud.

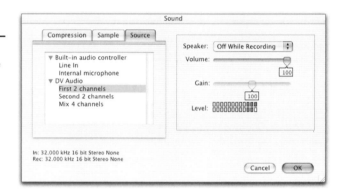

# CHAPTER SUMMARY

In order to get the most out of your digital video equipment, it is important to understand exactly how it works. In addition to knowing the best way to connect your components, it is valuable to become familiar with all of the capabilities of your digital video hardware and software. It is better to begin by capturing the highest quality digital video signal now than to try to fix poor or mediocre footage later.

## in review

1. How do you connect a digital video camera to a computer?

2. What are the features of today's digital video cards?

3. What monitor configurations are typically used to edit digital video?

4. What is a breakout box?

5. What is device control software?

6. What is a scratch disk, and why is it important in digital video?

7. What are dropped frames?

8. What is a batch capture?

9. What do the waveform monitor and vectorscope do?

10. What does it mean when audio levels are hot?

## exercises

1. Practice connecting your digital video equipment as discussed in this chapter.

2. Review the audio and video capture settings.

3. Capture the video clips for your project.

editing digital video

# objectives

Learn how to import files

Learn how to create transitions

Learn how to use motion

Learn how to use filters

Learn how to use transparency

Understand how to work with audio and music

# introduction

This chapter provides an overview for one of the popular digital video programs, Adobe Premiere. Other editing programs will be mentioned when appropriate. Whether you choose to edit with Premiere or another program, familiarize yourself with its environment. Learn its conventions and apply them elsewhere. The more digital video programs you become familiar with, the better you will be able to judge their features. Then you will be able to make an unbiased, informed decision as to which program is the best fit for you.

EDITING DIGITAL VIDEO

# EDITING DIGITAL VIDEO

There are many software programs available for editing digital video. While they are all unique, there are also commonalities among them. In most digital video programs, you import your footage as files, be it movies, graphics, photographs, audio, or music. These files are stored within a particular project. The footage is then arranged on the timeline. There will be a window where you can preview your work. You can add transitions between two footage files. You can also layer footage files on top of one another. You can put motion on them. You can also change their color or appearance. Whether you use Final Cut Pro, Avid, Adobe Premiere, or another editing program, these features are common to digital video. Once you become familiar with one digital editing program, you will be able to find your way around in most others.

## IN MEMORIAL

I began using Adobe Premiere 2.0 on the Macintosh in the early 1990s, and continued to use it, in conjunction with Adobe After Effects for my business, until recently. I taught it for more than five years at the college where I used to work. There are things I loved and things I hated about the program. But I really have to credit Adobe Premiere for inspiring my passion in digital video. While this book was being written, Adobe announced it was no longer making Premiere for the Macintosh, the platform that gave birth to it. I understand Adobe's decision. It was a business decision. With the competition from Apple with Final Cut Pro and the fact that the majority of Premiere users were now PC-based, it made complete sense. It was more cost effective for Adobe to discontinue producing Premiere for the Mac. This decision caused quite an uproar in the digital video community, and understandably so, because most digital video editors are very passionate people. I had made many important DV purchasing decisions over the years, and now I had to make yet another one. I had a significant amount of equipment invested in the Macintosh computer platform, and hardware is always more expensive than software. I prefer the Macintosh to the PC, especially when it comes to editing digital video. Therefore, even though I had been using Premiere for over ten years, I switched editing programs to Final Cut Pro. I know I wasn't the only one who made that decision. The college where I used to teach also switched to Final Cut Pro. It is an impressive program and I am excited to master it. So, even though I am an old DV pro, I have a lot of catching up to do because, in a sense, I'm starting over. That is the way it goes with digital video. There is always something new to learn, but it's fun to explore and discover again. I don't think it really matters which digital video editing program you use. We digital video editors all have one thing in common: we love editing digital video. So I bid a fond farewell to Premiere on my Mac. May you rest in peace, versions 2.0 to 6.5. Thanks for the memories.

## The Project File

After you have finished capturing your digital video footage, cropping your photographs, creating your graphics, and recording your audio and music, you need to be able to import all of those files into your editing program. When it comes to importing your files, most digital video editing programs work the same way. The files themselves do not become part of the

figure | 9-1 |

Adobe Premiere is one of many video software programs that will allow you to edit digital video.

project file, but rather the project file points to the places where the files are located. This is a crucial point to understand, because many digital video novices inadvertently move or delete their source files, thinking that they are included in the project file itself.

A **project file** is the document you create as you edit. It records all the relevant information regarding your project: which files you use; the order and duration the clips appear on the timeline; what motion, transparency, and filters have been applied, etc. This is a very important file. It is all your hard work—your blood, sweat, and tears. Protect it. Save it. Save it frequently. Save it in different places.

You don't want to risk anything happening to your project file. It could represent hours, days, even weeks worth of hard work. In addition to saving it on your hard drive, consider saving it on another media that can be easily and frequently updated, such as a separate hard drive or a Zip disk. Computers crash from time to time. Hard drives wear out. Zip disks malfunction. Files become corrupt. If you have ever lost a project file, you won't make the mistake of not backing up your work again. Losing hours worth of work is a terrible feeling, and having to re-create it is even worse.

For all the hard work the project file represents, it is amazingly small, typically under a megabyte. It is really just a text file of sorts, chronicling all of your editing decisions. Again, it does not save your actual footage as part of the file, but rather points to where the footage is located. Therefore, if you move any of that footage to another location, put it in a different folder, or change the file names, the next time you open the project, the program will have trouble finding your footage. You will have to assist it in locating your files.

| TIP |

Your project file is critical because it saves all of your editing decisions. Save it frequently and in multiple locations.

| NOTE |

Think of your project file as a Web page on the Internet. You have probably come across a page at one time or another that was missing information. A broken link came up marking the place where a graphic was supposed to be. Web page files work the same way as the project file. They point to the source files that they use to create the page. If a file gets moved or renamed, the information is missing.

Therefore, it is very important to keep track of all your source files when you edit digital video. You could have a large number of files in a single project, depending upon its length and complexity. The files may come from different sources. You may have them stored on multiple hard drives. Organization is most important. Here are some tips to help you manage your source files.

1. Name your files carefully. Use file names that will help you identify the content of the clip; don't just use numbers. A word and number naming system can often be effective.

2. Do not rename your files once you have named them. This is how all the confusion starts.

3. Create folders for all your source files. Put all the audio in the audio folder, your titles in the titles folder, your graphics in the graphics folder, your video clips in the video folder, your music in the music folder, etc.

4. Use subfolders when necessary. If you have a lot of video clips, create subfolders to help you identify them. Don't go crazy with the subfolders though. It can become tedious dealing with too many.

5. Put the word "Project" in your project file. You want to be able to easily identify it, and even to be able to search for it if you must.

6. Don't create different project files for the same project. This gets people into a lot of trouble. When they have ten different project files for the same project, they forget which one has what, and before you know it the wrong one gets deleted. Save the project file, with the same name—save, not save as—each time you finish an editing session. Then replace your old backup file with the updated project file.

7. Save client revisions as separate project files labeled with the date of the revision. Often clients will ask you to make changes, and then after seeing them, decide they like what you originally had best. It's always a good idea to hold onto your original work in case you have to go back to it later.

8. Don't bury your project files in multiple folders. You want to be able to get at your project file with ease. Try creating one folder with the name of your project. Inside that folder, save your project file. Also put your titles folder, your graphics folder, your video folder, your audio folder, your music folder, and any other folders in that main folder.

9. If you add new footage at a later date, store it in the same folders as the other media. If you start having multiple titles folders or other folders, you face the same risks as having multiple project files. You could inadvertently discard the wrong one. It's best to stay consistent.

10. Don't think adding a file later to an already existing footage folder automatically makes it a part of the project. You must import the file first. The software program is not psychic, at least not yet! It does not know your intentions; it only knows what you tell it to do.

## Importing Files

Once you have named and organized your footage in their respective folders, you are ready to import them. Most editing programs will let you import one file at a time, multiple files at a time, one folder at a time, or even one project into another.

To import a file into Adobe Premiere, choose Import | File from the File menu. A dialog box will appear. You should already be familiar with how files are stored and organized in your operating system. If you are not, this is something you will want to practice. You should be able to locate your files quickly.

figure **9-2**

In Adobe Premiere, choose Import from the File menu to bring video clips into the software program.

After you import a clip, it should appear in the project window. (In Final Cut Pro, the project window is part of the browser.) Subfolders created within the project window are called bins. You can customize how the project window displays its footage. In this example, the files are listed by name, and only the selected file shows a picture icon and the file details such as pixel size, duration, frame rate, etc.

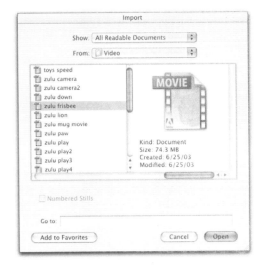

figure **9-3**

The video clips that you select will appear in Adobe Premiere's project folder.

## Using the Timeline

Once you have imported all of your footage, you can begin placing it on the timeline. To move a clip onto the timeline in Adobe Premiere, select

the clip by clicking on it and holding down the mouse. Then, drag the clip to the video 1 track (A or B) on the timeline. You will see the track highlight when the clip is correctly positioned over it. Let go of the mouse and the clip should appear on the track. (This procedure will also work in Final Cut, After Effects, and other programs.)

You could also drag the clip directly from the project window to the monitor window, which will make it appear on the timeline. (This procedure also works in Final Cut and After Effects. In Final Cut Pro, the monitor window is called the canvas window. In After Effects, the monitor window is called the composition window.)

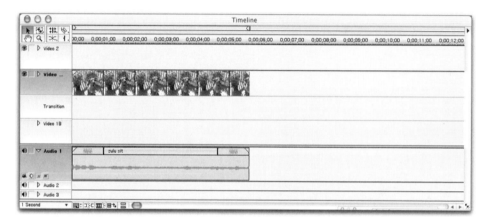

figure | 9-4

Once the video clips have been imported into the project, they can be added to the timeline to begin editing.

If you are having trouble placing clips on the timeline, it may be due to one of the following factors.

- You may be trying to drag the clip to the wrong track. For example, you cannot drag an audio clip to the video track, nor can you drag a video clip onto the transition track.

- There may not be enough room for the duration of the clip; another video clip may be in the way. For example, you may be trying to put a clip that is six seconds long into a space that is five seconds long. In this case, the clip would have to overlap with another video clip for the remaining second. You cannot overlap two video clips on the same track. You can, however, overlap two video clips on different tracks.

- There may be an audio track in the way. You cannot overlap two audio clips on the same track. You can, however, overlap two audio clips on different tracks. Check to see if your clip's duration would overlap with an audio clip that is occupying that same track. If so, you can move one of the clips to a different track to allow for the overlap.

| **NOTE** |

You can customize the appearance of the timeline window by selecting Window Options | Timeline Window Options from the Window menu. The view shown in these examples uses the first track format.

# Adding Transitions

You can place a transition between two footage layers. A transition is a special effect that acts as a bridge between the two layers. First one layer is shown. Then the second layer is slowly revealed. Finally the first layer is no longer visible, and only the second layer can be seen. These two layers can be any type of footage. For example, a transition could occur between two video clips, one video clip and a graphic, two graphics, a video clip and a title, etc. In Adobe Premiere, both footage layers need to be on video 1. Put one clip on track video 1-A and the second clip on track video 1-B. Overlap the clips for the duration you wish the transition to take place. Typically, transitions last anywhere from 10 to 15 frames, up to one to two seconds. Then select a transition and place it on the transition track during the overlap of the two clips.

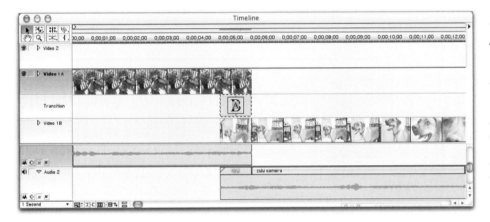

figure 9-5

Premiere uses track video 1 to transition from one video clip to another. One video clip is placed on video 1-A. A second video clip is placed on video 1-B. The transition is placed on the transition track for the duration the two clips overlap.

You can customize a transition's settings in Adobe Premiere by double-clicking on the transition itself. A dialog box appears with the transition's settings. The transition selected in this example is called Tumble Away.

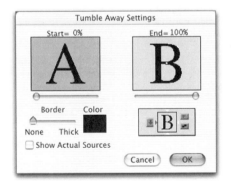

figure 9-6

By double-clicking on the transition, you can customize its settings.

The box on the left, labeled "A," represents video 1-A. The box on the right, labeled "B," represents video 1-B. The downward facing arrow that appears in the smaller box beneath "B" is the directional arrow. This arrow represents whether you are transitioning down from video 1-A to video 1-B, or transitioning up from video 1-B to video 1-A. You can transition in either track direction, depending on the placement of the clips. If you would prefer to see the clips themselves, as opposed to the letters "A" and "B," then check the box that says Show Actual Sources.

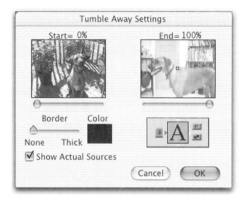

figure |9-7|

You can select Show Actual Sources to view the video clips on A and B in the transition window.

Other customizable settings are available, like a colorized border. Not every transition can be customized, and some transitions have more options than others.

You can also preview what the transition will look like in this window. Select the Start slider and drag it to the right. In this example, 12 percent of the overall duration of the transition is revealed.

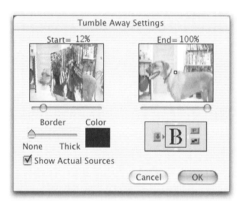

figure |9-8|

By dragging the Start and End sliders, you can preview what the transition will look like.

Continue dragging the slider to 100 percent to see the complete transition. Make sure you return the start point to 0 before exiting. Transitions need to start at 0 and end at 100 to transition completely from one clip to another. However, you can vary these setting to create a special effect if you so choose.

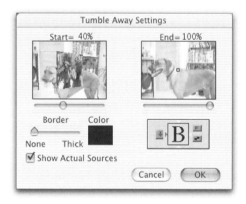

figure |9-9|

Typically, the transition starts at 0 percent and ends at 100 percent, but you can select any start and end times you would like.

You can preview a frame of this transition. This means you can sample what individual frames of the transition would look like without waiting for the entire transition to render. You can preview frames for any video effect that would require rendering, such as transitions, motion, filters, and transparency.

To preview a frame, hold down the Option key and position your cursor over the video frame you wish to see at the top of the timeline. When you are in the correct position on the timeline, the cursor will change to a downward facing arrow. Once the cursor changes, click once with the mouse. Different effects take longer than others, so if you are previewing something that would take a while to render, for instance several layers of video each with effects, you may have to wait a second or two. If your effect does not require a long time to render, you can hold down the mouse button and drag the cursor across the video clip, previewing multiple frames.

figure **9-10**

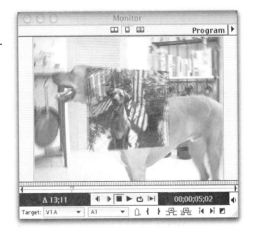

You can also preview a transition, or any other special effect that requires rendering, by holding down the Option key and positioning the cursor at the top of the timeline and clicking on the frame you would like to preview.

## Using Transparency

The transparency feature allows you to see several layers at the same time. These layers can be any combination of video, graphics, titles, etc. To use transparency, the footage must be placed on track video 2 or higher. Place a clip on video 1 and the clip you would like to make partially transparent on video 2.

| **TIP** |

Previewing a frame is a great way to sample what transitions, filters, motion, or transparency will look like without rendering it, regardless of what type of system you are using. It is fast, easy to do, and doesn't take up any hard drive space. It pulls very little system resources and rarely causes the system to crash. If you don't have real-time playback available on your system, or the effects you wish to preview are not available in real-time playback, this option works well.

| **TIP** |

You can use up to ninety-nine video layers in Premiere. To add more tracks to the timeline, go to the triangle pull-down menu in the upper right corner of the timeline. Select either Track Options or Add Video Track. The higher the video track number, the closer the layer is to the top. (Video 2 is on top of video 1; video 3 is on top of video 2; and so on.)

figure **9-11**

You can superimpose one or more layers on top of another layer by using transparency. Put one layer on video 1 and the layer you wish to superimpose on video 2.

Select the clip on video 2 by clicking on it once with the mouse. A bounding box should appear around it, showing that it is selected. Then choose Video Options | Transparency from the Clip menu.

figure **9-12**

Select Video Options | Transparency from the Clip menu.

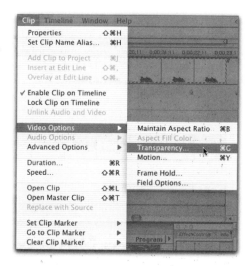

A dialog box will appear. There are various Key Types from which to choose, including alpha channels, mattes, color-based keys, and luminance keys. The clip in this example uses a White Alpha Matte, which is the type of alpha channel that the Premiere title window generates. To see a preview of what the transparency will look like, select the Page Peel icon beneath the sample box.

figure **9-13**

This title generated in Adobe Premiere uses a white alpha matte.

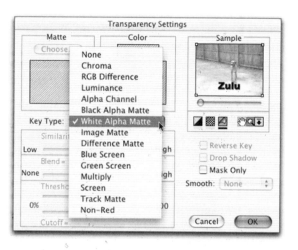

You can preview a frame of this transparency the same way you previewed frames for the transition. Hold down the Option key and position your cursor on top of the frame you wish to preview at the top of the timeline. When the cursor changes to a downward facing arrow, click once with the mouse. The white background of the title disappears, or keys out, revealing the underlying video clip. The type of the title is retained.

figure |9-14|

When you preview the frame, the alpha channel disappears, leaving just the title superimposed over the underlying video clip.

## Adding Motion

Motion can be used in Premiere to move a clip along a particular path. The clip's size can be zoomed in or out, the clip can be rotated, or it can pause in place for a specified period of time. A clip can also be distorted in the motion window.

Motion can be added to any video layer. It can be, but does not have to be, on a transparency layer. In this example, motion is used on the title on video 2. To apply motion, select the title on video 2 by clicking on it once with the mouse. A bounding box will appear around the clip, showing that it is selected. Then choose Video Options | Motion from the Clip menu.

figure |9-15|

To apply motion, you also select it from the Clip menu.

A dialog box appears, showing the clip's motion path. Click Show All to see a preview of what the motion will look like. You need at least two points to create a motion path, but you can add as many as you like. Each point has two coordinates; an "X" value represents the horizontal axis,

and a "Y" value represents the vertical axis. Like geometry, the X value is listed first (x, y). The start point of this clip is (-80, 0).

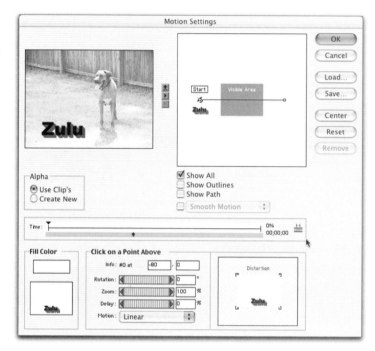

In this example, the title will scroll across the video frame, entering from the left and existing to the right.

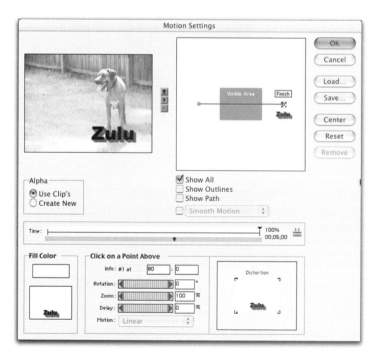

## Using Filters

Filters, or effects, can be added to any video clip, graphic, title, or photograph. There are a variety of special effects from which to choose. A filter makes changes to the individual pixels of the clip. It can alter its chrominance, luminance, or even the very look of the image itself. You can change its color, create a blur, or do just about anything else you can imagine. You can also vary a filter over time by adding keyframes. A **keyframe** is a frame that marks the place in time where a particular change occurs. Keyframes are used in digital video and 3D animation.

To add a filter to a clip, select it from the list of filters on the Video palette and drag it onto the clip on the timeline. When the selected clip inverts, you have positioned the filter on top of it correctly and can let go of the mouse. In this example, the solarize filter is being applied. The solarize filter allows you to control what percentage of an image's colors are inverted.

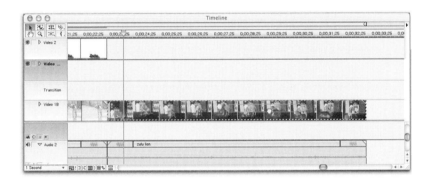

If the filter has customized settings, and most of them do, you can use the Effects Controls palette to adjust them. Select Setup and a dialog box will appear. In this example, you can adjust the percentage of solarize being applied with the threshold slider.

figure **9-19**

By selecting Setup in the Effects Controls palette, a dialog box pops up, allowing you to customize the filter's settings.

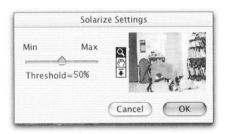

| TIP |

In Premiere, you can tell if motion has been applied by the appearance of a red line running across the bottom of the entire length of the clip.

| TIP |

Third-party plug-ins, such as specialized filters and transitions, can be purchased and used with Premiere, and also for other programs like Adobe After Effects and Final Cut Pro.

figure **9-18**

You can add a filter to a video clip by selecting it from the Video palette and dragging it onto the clip. The clip inverts when the filter is positioned on top of it.

| TIP |

In Premiere, you can tell if a clip has a filter applied by the presence of an aqua line running across the top of the entire length of the clip.

## DV PROFILE

*Rod Harlan*

Rod Harlan is the Executive Director of the Digital Video Professional Association, DVPA.

## Biography

**Name:** Rod Harlan

**Job Title:** Executive Director

**Organization:** Digital Video Professionals Association (DVPA)

**Number of years in current position:** Five

**Number of years in field:** Sixteen

**Additional current employment:** Multimedia Editor, *MacDesign Magazine*

**Past work experience:** President, Cube FX; President, PowerSource Communications

**Degrees/Certifications:** Bachelor of Arts, Carson Newman College

**Web sites:** www.dvpa.com, www.dvpa.org

## Questions & Answers

**Q. When and how did you first become involved in digital video?**

**A.** I started working with computer graphics while I was still in school in the early 80s on the Apple II+, Apple IIe, and the Apple IIc. In 1989 I got to work with the just released Video Toaster on the Amiga platform and I realized that we were only a few short years away from being able to edit broadcast quality digital video completely on a desktop computer. By the mid-90s I had started my own video production company built around a Media 100 system running on a Macintosh Quadra.

**Q. What is DVPA?**

**A.** The Digital Video Professionals Association (DVPA) is an international community of new media professionals that provides membership to all those who are involved as visual communicators using digital media. This includes, but is not limited to, producers, directors, educators, animators, videographers, editors, motion graphic artists, film groups, video game developers, advertising agencies, television stations, and design studios.

**Q. What role does DVPA play in the digital video industry?**

**A.** The purpose of the DVPA is to provide members with technical resources, training, and discounts on hardware and software, to further expand their understanding and appreciation for the field of digital video. Members of the association share their resources and expertise with each other to further the advancement of the DV industry. By providing affordable access to new media tools and training, the DVPA encourages its members to try new forms of communication, which benefit members, their clients, and the visual medium as a whole. The DVPA is the largest organization devoted exclusively to meeting the needs of those who use DV technology.

**Q. What are the benefits of joining a professional trade organization?**

**A.** There are many reasons to join a professional association. Being able to network and communicate with other like-minded individuals is usually at the top of people's list. A place to get product recommendations and a bit of technical help is another. The DVPA has tried to expand the notion of what is possible for an association to offer by including a large discount shopping service and a school for the best in training, among its many offerings.

**Q. Is DVPA the only organization devoted specifically to digital video?**

**A.** As far as we know the Digital Video Professionals Association is the only association in the world devoted exclusively to meeting the needs of those who use DV technology. While there are a few other video-related groups that offer digital video topics as part of their overall message, the DVPA exclusively supports every area of the DV spectrum.

**Q. What does a membership in the DVPA include?**

**A.** The membership plans, just like the association membership, are quite diverse and support a wide range of needs. The membership structure has been carefully designed to allow individuals to select the most affordable and useful plan to meet their professional needs. Whether it is as simple as a basic membership that allows students and hobbyists the opportunity to "get in the mix," as focused as a buying club that saves members hundreds to thousands of dollars every year, as educational as an online university that provides thousands of hours of training for only pennies a day, or as convenient as an affordable membership that gives DV professionals full access to the entire wealth of services provided by the association.

**Q. What are your membership's current needs and how does DVPA meet them?**

**A.** The DVPA expands the technical and creative knowledge of its members by providing access to the latest information and promoting the sharing of techniques. This interactive sharing of knowledge is one of the key ingredients to the DVPA's success. Some of the many topics of interest shared by DVPA members include: Special Effects, DV Editing, Animation, HDTV, DVD equipment and authoring, QuickTime, MPEG, Color Correction

## DV PROFILE
### continued

### Rod Harlan

in Film and Video, Video and Audio Streaming, Analysis of New Production Tools, among many others. The DVPA has also set up the Buyer's Club Membership that is the ultimate online resource for digital video professionals to save money on all their purchases. Buyer's Club members pay just 3 percent above cost for most all of their hardware, software, video gear, and peripheral purchases.

### Q. What kind of training does DVPA offer?

**A.** The DVPA holds several regional conferences throughout the country each year. These conferences bring in the top trainers of the hardware and software products and DVPA members use everyday. Conference attendees get world-class training at a fraction of the cost it would take to bring even ONE of these individuals to their studio for a single day. The DVPA has also produced the Digital Video Production Workshop for the National Association of Broadcasters (NAB) the last two years (2002 & 2003). Besides the conferences, the DVPA offers the DVPA Online University, the ultimate resource for learning DV applications without going into educational debt. This service covers all major software applications with full-screen streaming video clips of step-by-step tutorial-based training available on your desktop 24 hours a day/7 days a week. Members have access to Web-based software training for DV, Graphics, and Animation programs like Final Cut Pro, Premiere, After Effects, Photoshop, Illustrator, Carrara Studio, ProTools, Director, 3D Studio Max, Maya, QuickTime, Acid Pro, Flash MX, Fireworks MX Cleaner, and many more.

### Q. DVPA is currently an online community; do you plan to expand it to include individual chapters in geographical regions?

**A.** We've looked at the issue of setting up individual chapters several times in the past, but the majority of the membership doesn't believe that the benefits of a monthly meeting would warrant the expense. Instead, the association has set up regional networking meetings that occur a couple of times a year. Already in 2003 we've held these events in Chicago and Miami, with San Francisco and Las Vegas still to come. We even held an event in Des Moines, Iowa, to coincide with a Digital Television conference and to provide some face-to-face networking time for those members that live in the Midwest.

Even though we do not have local meetings, members still communicate frequently with each other through our DVPA listserve or in the 200 discussion forums. Members also receive technical resources, training, and discounts on hardware and software, among the long list of benefits. Most members find that these facilities are much more effective and impact their lives to a greater extent than what is available to them through a local chapter.

*Q. What aspirations do you have for DVPA in the future?*

*A.* I definitely envision a future of growth for the DVPA. We are already seeing a convergence of other industries coming to the world of digital video. Graphic designers for print are becoming motion graphic artists and joining the DVPA. Programmers are becoming DVD authors and joining the DVPA. Even broadcast engineers are becoming HDTV editors and joining the DVPA. As the future becomes the present, I believe we will see all industries using digital video for their visual communication medium of choice. This means that the Digital Video Professionals Association needs to be ready to support them when they get here. We are working towards that goal now.

*Q. What advice can you offer to someone interested in learning more about digital video?*

*A.* The best advice I can give is to just get involved. There is no substitute for simply picking up a DV camera and shooting some footage or sitting down in front of an editing program and putting your story together. The mere act of actually doing something makes all the difference in the world. So if you are a student, use the equipment in your school's media center to tell a story that is important to you. If you are a home hobbyist, grab the family camcorder and download some free DV editing software for your home PC and get to work telling your story.

## Incorporating Audio and Music

You can fade audio in and out very easily in Premiere. You can also combine different tracks at different volumes. For example, you could lower the volume of the music during a voice-over segment and raise it again when the segment is over. You can work with up to ninety-nine tracks of audio in Premiere. To add additional audio tracks, go to the triangle pull-down menu in the upper right corner of the timeline. Select either Track Options or Add Audio Track.

If a clip already has an audio track captured with it, the audio portion automatically moves with the video portion when the clip is dragged to the timeline. However, you do not have to use the clip's audio. You can break the link between a video clip and its audio by selecting the clip and choosing Unlink Audio and Video from the Clip menu. You can either delete the clip's audio track, or move it to another location.

You can get a closer look at an audio file's waveform by double-clicking on the clip. From this window you can set markers to make note of specific frames. For example, you may want to mark the place in a music file where the guitar solo begins. By setting markers on specific frames of audio, you can synchronize your visual effects in time with the music.

figure | 9-20 |

You can easily edit audio and
music files in Adobe Premiere.

To set an audio marker from the Clip window, select the Marker menu
button beneath the clip's timecode. From the menu, choose Mark | 1.

figure | 9-21 |

Double-clicking on an audio file will open
up a Clip window, allowing you to see the
audio's waveform. You can set markers to
make note of specific frames, such as key
points in dialog or hits in music.

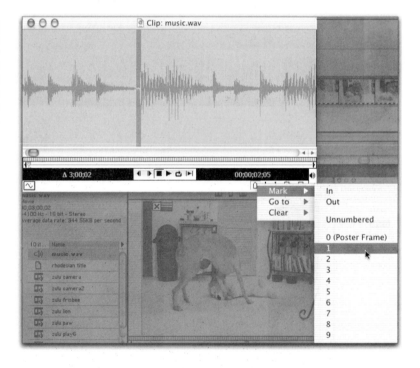

Expand the clip's audio track on the timeline by clicking on the triangle to the left of the audio track number's name. This will allow you to view the audio waveform. After you have set the audio marker, you will see the number one marking the respective frame you have identified on the audio track. You can now line up a video clip to coincide with this marked place in the audio file.

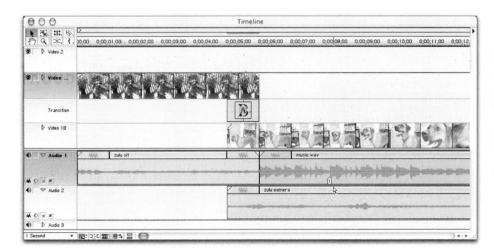

figure | 9-22 |

Once a marker has been set, you can view it in the timeline to help you line up video to coincide with the audio marker. Good editors have frame-by-frame control of their material and precise timing.

# CHAPTER SUMMARY

Editing is the most exciting part of creating digital video. It takes time to learn the various editing features in any digital video program. Although different software programs offer different editing tools, most digital video editing programs are fundamentally similar. Whatever software program you choose to edit with, make sure you take the time to experiment with all of its features. There is a learning curve with every program. Remember, there is a big difference between just knowing how to use a program and actually mastering it. Only when you have truly mastered the software, will you have real creative freedom and unlimited editing possibilities.

## in review

1. Explain what the project file is and how it works.

2. List three tips for organizing and managing your source files.

3. What is a transition?

4. What are the steps for creating transitions?

5. What is transparency?

6. What are the steps for creating transparency?

7. What are the steps for creating motion?

8. What is a filter?

9. What are the steps for creating filters?

10. What is an audio marker, and why is it useful in editing?

## exercises

1. Create your project file and import all your video, audio, titles, and graphics.

2. Arrange your clips on the timeline and add your transitions.

3. Add filters, motion, and transparency to your project.

## notes

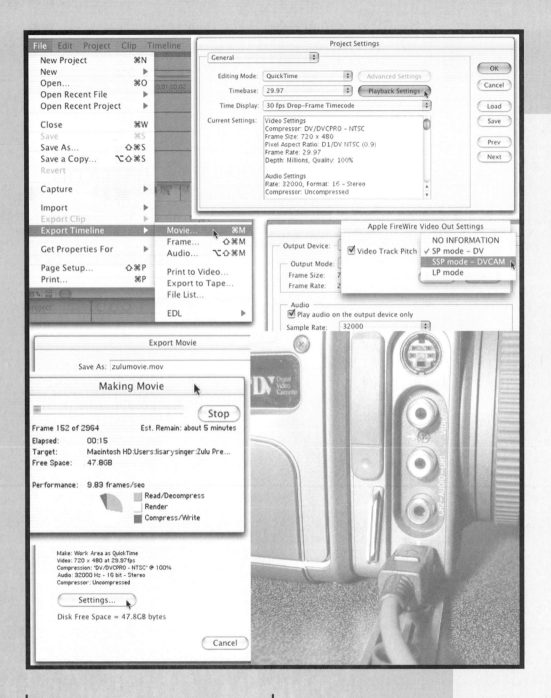

rendering and outputting digital video

# objectives

Learn how to set video render settings

Learn how to set audio render settings

Understand how to render a project

Learn how to set playback settings

Understand how to export a rendered movie to tape

# introduction

Rendering is an important step in the digital video editing process. When you render, you tell the computer to carry out the decisions you made during editing. Any changes to the original video clip need to be rendered. These changes could be in size, color, quality, length, and even in shape. All your transitions, filters, motion, and transparency need to be rendered. Even if your editing system is capable of previewing real-time effects, your final project still requires rendering.

# RENDERING DIGITAL VIDEO

There are many settings to take into consideration when rendering. Before you make any choices, you must determine how the video will be viewed. For example, digital video that will be displayed over the Internet will be treated differently from digital video that will be exported to tape using FireWire (IEEE 1394).

This chapter uses the render settings for Adobe Premiere as an example. Other digital video programs have similar options. In this chapter, the primary focus will be on customizing the render settings for FireWire video. However, standards for CDs, DVDs, and the Internet will also be discussed.

## Preparing the Project

Once you have determined how your digital video will be displayed, you can begin making preparations to render. There are a few recommended steps that may facilitate the rendering process.

### Saving the Project

The first thing you should do is save your project file. This is an important step that needs to be emphasized. If an unforeseen event should happen during the rendering process, such as a computer crash or a power outage, you don't want to run the risk of losing any last minute editing changes.

| TIP |

In addition to saving your project before you render, you should also update your backup project file.

figure | 10-1 |

After you have finished editing, make sure you save your project before rendering it.

### *Viewing the Timeline*

Every digital video editing software program is different. Premiere's rendering time estimates tend to fluctuate based upon how long it will take to render the current segment. For instance, if the opening segment of your movie has six layers, Premiere calculates its estimate based on that information.

While it is rendering the six-layer segment, it may estimate that it will take forty-five minutes to complete the render. However, after it completes the six-layer segment, and the layers drop down to two layers, the rendering estimate may decrease to fifteen minutes. Then later, if it hits a particularly render-intensive set of filters, the estimate may jump up to over an hour.

Therefore, in order to get a better gauge as to how long the project is really going to take to render, it is helpful to view it in its entirety in the timeline window. This is not a required part of the rendering process, but rather a suggestion. Typically, most editors edit with the timeline window set to one-second increments. If your entire project is three minutes long and you are seeing it in one-second increments, you will only see a small portion of the project at any given time. To see the entire project in the timeline window at once, you need to adjust the time zoom level.

| TIP |

Premiere users can get a better idea of how long it will take their projects to render if they can follow its progress in the timeline window. In order to do this, the entire project needs to be made visible at once by adjusting the time zoom level in the lower left corner of the timeline.

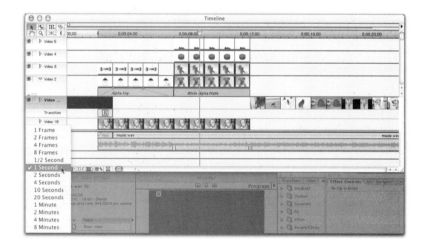

figure | 10-2 |

You can change the view of your timeline, so that the entire project is visible in the window, by adjusting the time zoom level increments in the lower left corner of the window.

The project in this example is a little over one and a half minutes long. To see the project in its entirety, the time zoom level is changed from one-second increments to ten-second increments. Notice that you can still see how many layers are used at what time. You can also see which clips have motion or filters applied to them, as well as where the transitions take place. Now when the project begins to render, you will be able to watch it progress through the timeline.

figure **10-3**

The view of the timeline in this example has been changed from one-second increments to ten-second increments.

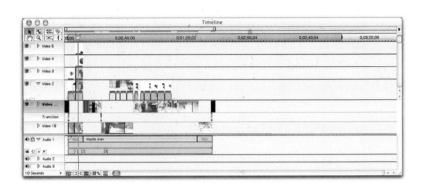

## Exporting the Timeline

After you have saved your project and made any last minute preparations, you can export in Adobe Premiere by selecting Export Timeline | Movie from the File menu. A dialog box will pop up.

figure **10-4**

After you have finished preparing the project, you can begin the rendering process by selecting Export Timeline | Movie from the File menu.

### Designating a Hard Drive

Before you go any further, take this opportunity to name your movie file and decide where it will be saved. (However, DO NOT CLICK SAVE at this time! You will want to adjust your settings first.) You may want to consider putting the word "movie" in the file name so you can easily tell it apart from your other video clips. Also, be sure to designate the appropriate file extension. For QuickTime movies the extension is .mov. For AVI movies, the extension is .avi.

It is very important to render your movie to a hard drive with adequate file space. You don't want to run out of space in the middle of a render.

Keep in mind that full-screen, full-motion digital video files are big! This particular project is one minute and thirty-eight seconds long. It will take up a little over 350 megabytes using the DV-NTSC render settings. With the CODEC changed to Planar RGB, it will jump to over 2 gigabytes! Depending upon which type of video CODEC you use, the quality of the source footage, and the quality setting of the render, sizes can fluctuate. Uncompressed video files can take up a significant amount of hard drive space. So, regardless of which type of digital video you plan to be doing, come prepared with plenty of hard drive space.

figure | 10-5 |

Before you adjust your render settings, name your movie and designate a hard drive to save it to that has adequate file space.

## Exporting Settings

After you name your movie, but before you click Save, you will want to check the render settings. When this project file was first created, the settings for DV-NTSC were chosen. These settings automatically customized video capture and output specifically for DV-NTSC. However, you should get into the habit of verifying your settings before you start a render. This way, if you inadvertently made any changes, you will be able to catch the mistake before wasting time rendering at the wrong settings. You also need to know how to make changes to these settings if you are doing multiple renders for the same project. For example, in addition to exporting your movie to tape, you may also want to create streaming video so it can be shown over the Internet. To verify or change your render settings, click on the Settings button. A dialog box with the general settings will appear.

You can choose to export just video, just audio, or video and audio by checking the appropriate boxes. If you want your movie to automatically open up when it has finished rendering, check Open When Finished. You can also tell the computer to beep when your movie is ready.

figure | 10-6 |

After clicking on the Settings button, you can select whether to export just video, just audio, or both video and audio from the General Settings dialog box.

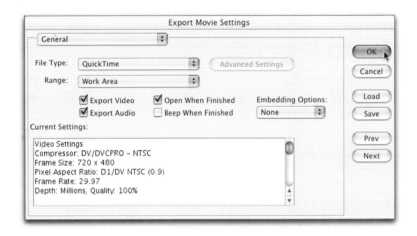

| TIP |

If you are on a PC and do not have QuickTime installed, this option will not be available. QuickTime is a free download from Apple's Web site (www. apple.com). It is available for both Macs and PCs, and using it is highly recommended.

You can designate a file type from the pull-down menu. QuickTime is selected in this example. These options could differ depending upon how your system is configured.

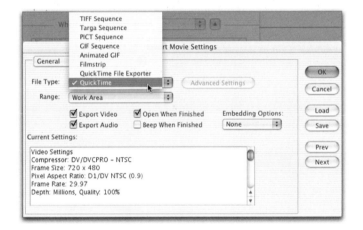

figure | 10-7 |

You can choose what file type you wish to export from the pull-down menu. QuickTime is chosen in this example.

| NOTE |

Many editors begin by laying out the entire project. Then they go back and work on one section of it at a time. They work on a segment, test render it, make changes to it, render again, make more changes to it, and so on until they are pleased with the result. Then they move on to the next segment.

You also have the option of rendering the entire project or just a portion of it called the work area. The work area can be designated in the timeline window by dragging the yellow work bar at the top of the timeline over the portion of the project you wish to render.

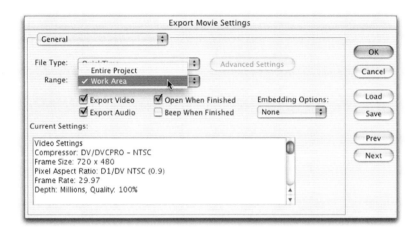

figure | 10-8 |

You can choose whether to render the entire project, or just a portion that has been designated by having the yellow work bar area stretched over it in the timeline window.

## Video Settings

After you have made your selections under General Settings, select Video Settings from the pull-down menu. These settings will vary depending upon the nature of the project.

Again, video for the Internet requires different settings than DV-NTSC video does. Likewise, CDs use different settings than DVDs do.

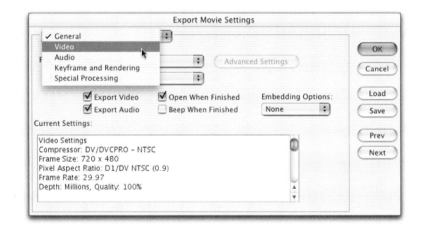

figure | 10-9 |

You can adjust your video render settings by selecting Video from the pull-down menu.

### *Frame Size*

The Video Settings dialog box allows you to specify the frame size of your video, which is measured in pixels. For DV-NTSC video, choose 720 x 480 pixels. If you were doing something for CD-ROM, 360 x 240 pixels is a common resolution. If you change the video's frame size, make sure you maintain the aspect ratio, or your video will become

The television reality show *Big Brother* on CBS offered viewers the opportunity to purchase a live Internet video feed from the Big Brother house using RealOne's streaming video player. Viewers could choose between a low-speed connection at 80 Kbps or a high-speed connection at 225 Kbps. The viewing window size appeared to be 320 x 240 pixels.

distorted. For example, 360 is one half of 720, and 240 is one half of 480. This video would maintain its aspect ratio. Video for the Internet is often 180 x 120 pixels, again exactly one half of 360 x 240. As more people continue to get high-speed Internet access, the standard frame size for video on the Internet will increase.

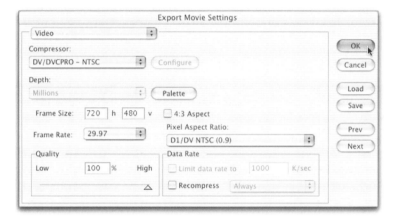

figure | 10-10 |

In the Video Settings dialog box, you can designate the video's frame size, which is measured in pixels.

### Compression

Another important video setting is the **compressor**, or video CODEC. For FireWire, the video CODEC in North America is DV-NTSC. DVDs use MPEG. CDs can use a variety of CODECs including Cinepak, Sorenson, and MPEG. Internet video can be either streaming video or downloadable QuickTime movies or AVIs. Downloadable movies are actually downloaded files saved onto your hard drive and later viewed with a player. The quality of downloadable movies is consistent; consequently, it is usually better quality than streaming video. Streaming video is temporarily displayed as you watch it via a player, but it is not actually saved to your hard drive. Streaming video can break up from time to time during transmission, and therefore the quality can be inconsistent.

For multimedia production, both for CDs and for the Internet, Discreet's Cleaner is the industry's program of choice.

figure | 10-11 |

Select the appropriate compressor, or video CODEC, to render your movie. In this example, DV-NTSC is selected because it is the required CODEC for FireWire in North America.

Some compressors will allow you to lower the color depth and even apply custom color palettes. Lowering the color depth of the video will reduce its file size. If this is not an option, the Color Depth pull-down menu will be grayed out, as it is with the selected DV-NTSC.

For additional compression, you can also lower the quality slider. This reduces the quality of the video, and likewise its file size. If the quality slider is left at 100 percent, no additional compression besides that of the CODEC is applied. Avoid lowering the quality slider if at all possible to produce the best-looking digital video.

## Pixel Aspect Ratio

In addition to selecting the appropriate frame size and compressor, you also need to select the corresponding **pixel aspect ratio**. The pixel aspect ratio for DV-NTSC is 0.9. For widescreen DV-NTSC, the pixel aspect ratio is 1.2.

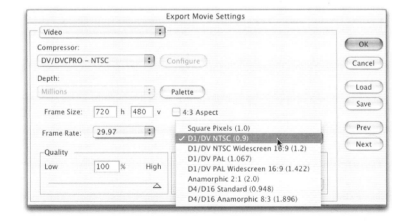

figure | 10-12 |

Select the corresponding pixel aspect ratio that is appropriate for your project. DV-NTSC 0.9 is the correct choice for standard FireWire video.

### *Frame Rate*

Frame rate is another setting that can be adjusted according to the particular project. DV-NTSC video uses drop-frame timecode, which is 29.97 frames per second. (Nondrop-frame timecode is 30 frames per second.) Motion picture film runs at 24 frames per second. PAL video is 25 frames per second. Video for CDs is typically between 15 and 30 frames per second. Video for the Internet is usually between 10 and 15 frames per second, but can be as much as 30 frames per second, depending on the window size and the speed of the connection.

figure | **10-13** |

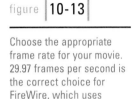

Choose the appropriate frame rate for your movie. 29.97 frames per second is the correct choice for FireWire, which uses drop-frame timecode.

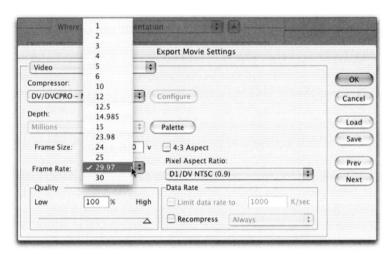

## Audio Settings

In addition to customizing your video settings, you should also check your audio settings. Again, depending on the nature of your project, these settings could change. For example, when creating digital video for the Internet, file size is the primary issue. You may lower the audio quality when rendering video for the Internet to reduce the file size. However, lowering the audio quality is almost negligible when compared to dealing with the large file sizes generated by full-screen, full-motion video. To change the audio settings, select Audio from the pull-down menu.

figure | **10-14** |

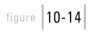

To choose your audio rendering settings, select Audio from the pull-down menu.

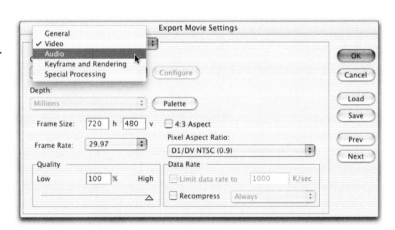

There are several options to choose from in the Audio Settings dialog box, including audio rate, format, compression, and interleave. You can also make selections as to how the audio is processed.

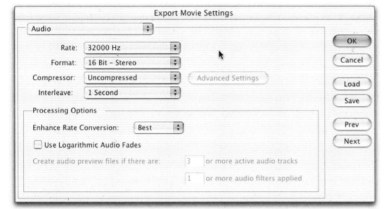

figure |10-15|

The Audio dialog box includes information on audio rate, format, compression, and interleave.

## Audio Rate

The typical audio rates for FireWire video are 32 kHz and 48 kHz. Whatever the audio rate was during capture should be used again for output. In this case, 32 kHz is selected. Typical sampling sizes for analog audio are 11 kHz, 22 kHz, and 44 kHz.

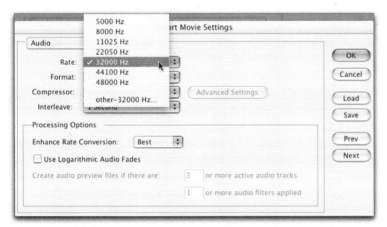

figure |10-16|

Audio for digital video via FireWire is either 32 kHz or 48 kHz. 32,000 Hz was selected here because that was the rate used during audio capture.

## Audio Format

In addition to the audio rate, the audio format is also selected. Most of the time 16-bit stereo audio is selected because it is the highest-quality option listed. It is the selection used here for DV-NTSC video.

figure | 10-17 |

The appropriate stereo audio selection for FireWire is 16 bit.

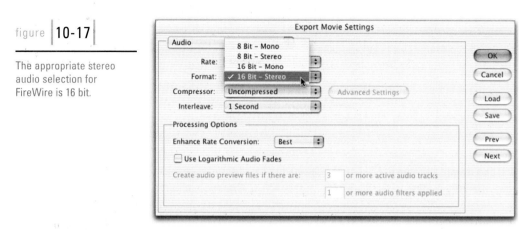

## Audio Compression

If small audio file sizes are of the utmost importance, compression can be applied. There are a variety of compressors from which to choose. Avoid compression, if at all possible, to maintain the highest-quality audio.

figure | 10-18 |

You can select a compressor to reduce the size of your audio file, or you can leave it uncompressed.

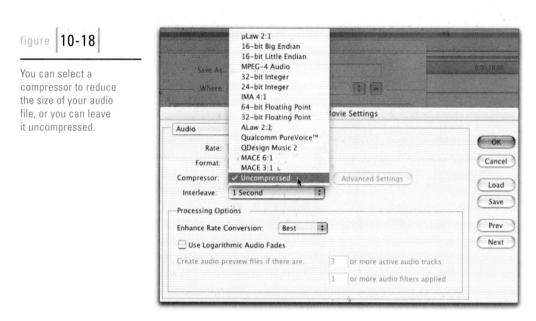

## Audio Interleave

Another selection which can affect audio playback is the audio interleave, or audio block size. If the audio appears to be dropping out during playback, the interleave size may be the problem. Different video cards prefer different audio block size settings. If you are having trouble with your audio playback, try changing this option. A one-second interleave usually works best for DV-NTSC video.

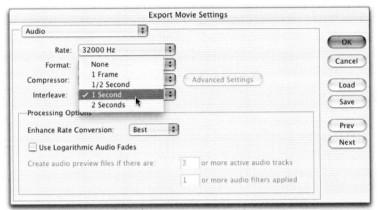

figure | 10-19 |

You can choose the audio interleave, or audio block size. A one-second setting is typically chosen for FireWire.

### Enhanced Rate Conversion

Sometimes you might work with audio from different sources. While your video may be using a rate of 32 kHz, your music may be recorded at 44 kHz. When you set your render for 32 kHz, the 44 kHz audio needs to be down-sampled to 32 kHz. Enhanced rate conversion is the process by which all of your different audio rates are converted to the rate specified in the render settings. Audio that was not converted properly may have poor sound quality. If you are using multiple sources of audio with different rates, set the enhanced rate conversion to Best.

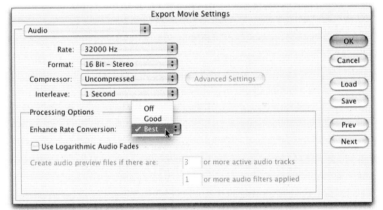

figure | 10-20 |

You can set enhanced rate conversion at Good, Best, or Off. Use Best if you are combining audio tracks that use different rates, such as 32 kHz and 44 kHz.

## Making the Movie

After you have verified or customized your render settings, you are ready to make your movie. Depending upon how fast your computer is—specifically the processor, how long your video is, and how many special effects and layers of video were used—the render could take a significant amount of time. If you don't have any real-time previewing options on your system, and you are for the most part screening your work for the first time, you may want to create a test render first.

**| TIP |**

It can save you a lot of time if you export just the audio portion of your movie to check your audio levels. Audio renders very quickly. You can eliminate any potential audio problems in advance, such as your music drowning out your dialogue. To export just the audio portion of your project, select Export Timeline | Audio from the File menu.

### Creating a Test Render

A **test render** is a render at a lower quality or with reduced settings. For example, under the Keyframe and Rendering Settings pull-down menu, you can select the option to Turn Off Filters. This will reduce the amount of time it takes to render a movie that had filters applied. You can also lower the frame rate or frame size to reduce the rendering time. Remember to maintain your aspect ratio if you change the frame size, or your video will become distorted. Test renders can save you time in the long run, especially if you are concerned with getting the timing down. Checking the timing of your cuts and transitions doesn't require seeing filters applied. Why wait ten times as long if you don't have to?

### Saving Your Movie

Earlier it was suggested to name your movie and designate a place to save it on a hard drive that has adequate file space. If you have not already done this, do it now. Once your settings have been verified or customized, your movie has been named, and you have designated a place to save it to, you are ready to click on the Save button. This will begin the rendering process.

figure | **10-21**

After you have customized your render settings and designated a hard drive to save the movie to, select Save to start the render.

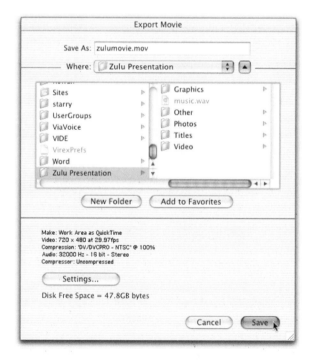

Once you have hit the Save button and the render has started, a dialog box with a progress bar will appear. This will provide a rough estimate as to how long it will take your movie to render. In the background, you will also be able to see the progress line moving through your project in the timeline window.

figure | **10-22**

After you start the render, a dialog box with a progress bar will appear, estimating the time it will take to complete.

If you want to see the particulars, such as how much time has elapsed and performance details, you can expand the window by clicking on the triangle to the left of the frame information.

figure | **10-23**

You can get more rendering details by expanding the dialog box. Click the triangle to the left of the frame information.

To get a more accurate idea of how long the render will take to complete, you can watch the progress line making its way through the project in the timeline window. You will be able to anticipate where the render will slow down and speed up. This line shows the exact frame being rendered at the time. It will move more slowly across multiple layers of video. Filters will also significantly slow it down. Transitions and motion take longer to render than unaltered video, but not as long as filters.

figure | 10-24

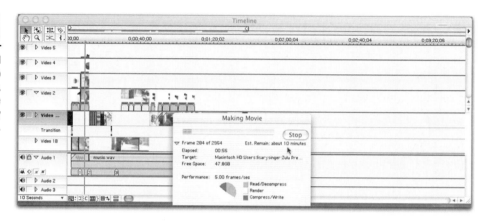

A progress line will scroll across the top of the timeline window, showing which frame of the movie is currently being rendered.

## Playing the Rendered Movie

If you chose to have your movie open when finished, it will automatically come up when the render is complete. Check it right away to see if you need to make any changes. Don't export it to tape without watching it first.

figure | 10-25

When the movie is finished rendering, it will automatically open up if you checked the Open When Finished option in the General Settings window. You can also tell it to beep when the render is finished.

figure | 10-26 |

Play the movie in the clip window to make sure you are satisfied with it before exporting it to tape.

# OUTPUTTING TO TAPE

When you are ready to output to tape, you need to turn on your digital video camera or deck. Make sure the FireWire cable is properly connected to the camera and the computer. Put your camera in VTR mode, or check with your manual to find out how to record from the FireWire port. Some cameras can be especially tricky. Don't forget to put the tape in! If it is not a blank tape, be certain you don't inadvertently record over anything important.

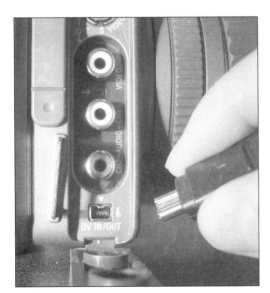

figure | 10-27 |

Make sure the FireWire cable is attached to your digital video camera or deck and that the device has been turned on. Most cameras need to be in VTR mode to record from the FireWire port.

## Playback Settings

You will also need to check the playback settings on your computer before you are ready to export. These settings specify how the software exports the video signal. Depending on your system, you may have more than one choice. On a Mac with a video card installed, you can choose to use the built-in FireWire port or the video card for export. To check your playback settings, select Project Settings | General from the Project menu.

figure | **10-28**

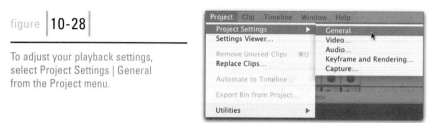

To adjust your playback settings, select Project Settings | General from the Project menu.

After the dialog box pops up, click on the Playback Settings button to the right side of the Timebase pull-down menu.

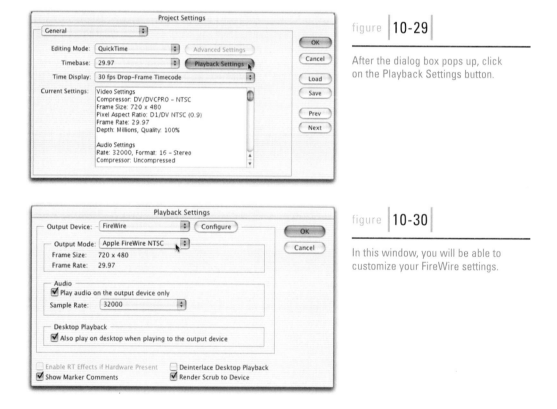

figure | **10-29**

After the dialog box pops up, click on the Playback Settings button.

figure | **10-30**

In this window, you will be able to customize your FireWire settings.

With FireWire selected for the output device in the pull-down menu, the Configure button will provide additional options if they are available. The Sony DSR-PD150 is capable of recording in either standard DV mode or the superior DVCAM format. With Video Track Pitch selected, the selection of DVCAM can be made.

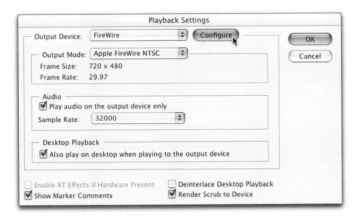

figure | 10-31 |

Prepare your output device by selecting FireWire in the pull-down menu and clicking the Configure button.

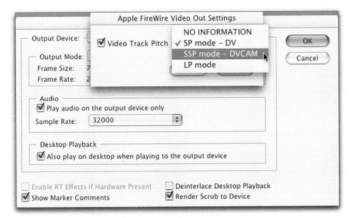

figure | 10-32 |

If applicable, you can choose the recording mode for your device by checking Video Track Pitch and making a selection. DVCAM has been chosen in this example because the video quality is higher than standard DV.

You also need to select an output mode. If you have a third-party video card installed, the option to choose it would be located here. In this example, Apple's built-in FireWire is selected.

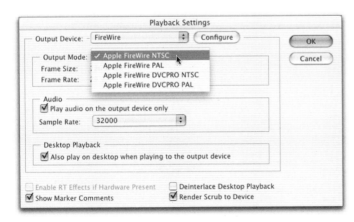

figure | 10-33 |

Select an output mode from the pull-down menu. On the Macintosh, choose Apple FireWire NTSC. On the PC, choose the manufacturer of your FireWire card.

Again, you can choose an audio sample rate for playback. This setting should match whatever audio rate you chose in the render settings. In this example, 32 kHz was selected.

figure | 10-34

Select your audio sample rate from the pull-down menu. This should be the same rate at which you rendered your movie, in this case 32 kHz.

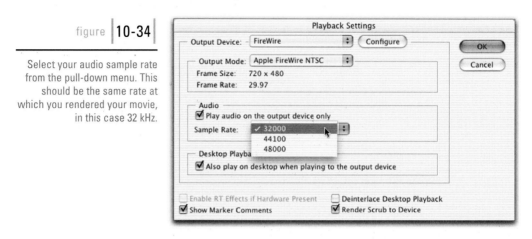

## Device Control

To verify your Device Control settings, select Preferences | Scratch Disks & Device Control in the Adobe Premiere menu. When the dialog box pops up, click the Options button under Device Control.

figure | 10-35

Customize your Device Control settings by selecting Preferences | Scratch Disks & Device Control from the Adobe Premiere menu.

figure | 10-36

Click on the Options button under Device Control.

Premiere comes with built-in device control software, or you can use third-party software. Many major manufacturers of digital video cameras and decks have their models listed here. If your model is not listed, select Generic. Check the Status to make sure your camera is online.

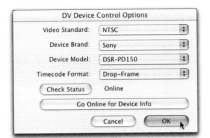

figure | **10-37** |

Select the appropriate brand and model of your device. If your brand is not listed, select Generic. Verify that the device is online.

## Recording to Tape

After you have verified your device control settings and ascertained that your video camera or deck is online, you are ready to record to tape. This can be done manually or automatically. If your system and hard drive are fast enough, you can play directly from the clip window and manually press record on your device. However, this is not the preferred method. For precise control, use the Export To Tape feature by selecting Export Clip | Export To Tape from the File menu. A dialog box will pop up for control of the record device.

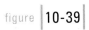

figure | **10-39** |

To export to tape, select Export Clip | Export To Tape from the File menu. A dialog box will appear, allowing you to control the recording device.

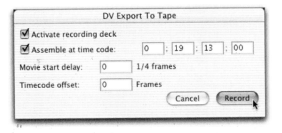

figure | **10-38** |

This Sony DSR-PD150 camera is plugged in, online, and ready to record to tape.

You can specify your movie to begin recording at an exact timecode number on the tape by checking Assemble at time code and entering the numerical values in the boxes for hours, minutes, seconds, and frames. This is a useful feature if you are exporting a lengthy project in segments and wish to put it back together on tape. Make sure you have Activate recording deck checked and then click the Record button.

The computer will activate your recording device. You should be able to both see the video and hear the audio on the recording device. Use the LCD display on a video camera or attach a monitor to the video deck to view the movie as it records. Congratulations! You are finished!

figure **10-40**

After clicking Record, your video device is activated and the movie is recording.

figure **10-41**

You can monitor your recording on a video camera by watching the LCD display.

## CHAPTER SUMMARY

It is a very rewarding feeling to take a project from concept through to completion. When you invest a significant amount of time and effort into a project, you want to make certain you back up your work. You may need to revisit your project at a later time and make changes to it. In order to do that successfully, you need to make sure that your source files and your project file are backed up.

Ideally, the best way to back up your digital video files is to copy them as data files to DVD. (A data DVD is used to store files and can only be accessed on the computer. It does not get encoded for playback on a standalone DVD player.) If you have enough room, you should also back up your rendered movie. If you are short on space, you can always re-render your project later, as long as you have backed up all of the necessary source files and the project file. Again, always protect your hard work and take the time to back up your files.

Digital video is a technical field as much as it is a creative one. The best way to produce quality digital video is to take the time to understand the principles and conventions governing the technology. Even if you do not consider yourself to be a technical person, you can *learn* digital video technology. It requires dedication and perseverance, practice and hard work, and plenty of patience. Digital video technology is still evolving, and it is important to stay aware of the current and future trends. Whether you are just interested in the technology, or plan to make a career out of it, once you get started editing digital video you'll find it hard to stop. Just remember the time and effort you devote to your craft will be a worthy investment. It is a great feeling of pride and accomplishment to sit back and watch your creative vision turn into a reality.

## in review

1. What resolution should be set for DV-NTSC video?

2. What resolution should be set for CDs and the Internet?

3. What frame rate should be set for DV-NTSC video?

4. What frame rate should be set for CDs and the Internet?

5. What are the typical CODECs used for FireWire (IEEE 1394), CDs, DVDs, and the Internet?

6. What are the audio render settings for DV-NTSC video?

7. What is a test render?

8. What things should you check before you begin to render?

9. What are the playback settings for DV-NTSC?

10. What are the steps for exporting to tape?

## exercises

1. Check your settings and render your project.

2. Play back your project, make any necessary changes, and re-render it.

3. Export your completed project to tape. (Don't forget to back up your work before deleting it from your hard drive.)

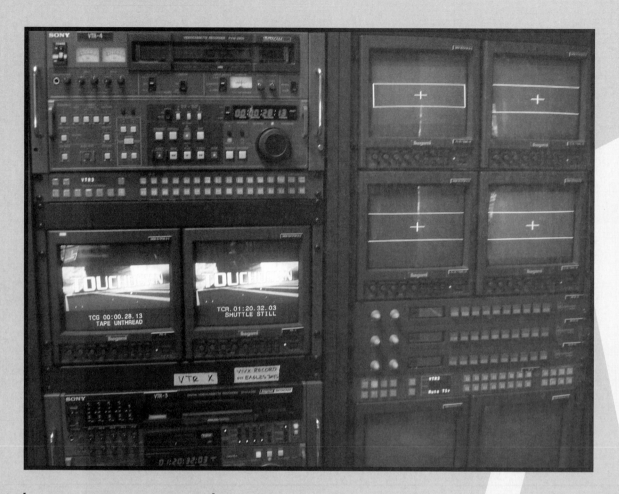

digital video resource guide

*appendix A*

## RESELLERS

B & H Photo and Video (www.bhphotovideo.com)

Markertek (www.markertek.com)

Pro Max Systems (www.promax.com)

DV Direct (www.dvdirect.com)

Apple Computer (www.apple.com)

MicroWarehouse/MacWarehouse (www.cdw.com)

PC Mall (www.pcmall.com)

Mac Mall (www.macmall.com)

## USER GROUPS, MAILING LISTS, AND FORUMS

Digital Video Professional Association (DVPA) (www.dvpa.com)

Media Communications Association (www.mca-i.org)

DV.com Forums (www.dv.com)

DV News and Views Newsletter (www.dv.com)

Digital Video Editing (www.digitalvideoediting.com)

Digital Media (www.digitalmedianet.com)

Final Cut Pro (www.apple.com)

DVD Studio Pro (www.apple.com)

iMovie & iDVD (www.apple.com)

QuickTime (www.apple.com)

Apple/Macintosh (www.apple.com)

After Effects (www.adobe.com)

Premiere (www.adobe.com)

Encore DVD (www.adobe.com)

## MAGAZINES AND BOOKS

*DV Magazine* (www.dv.com)

*Videography* (www.videography.com)

*Millimeter* (www.millimeter.com)

*Post* (www.postmagazine.com)

*PC Magazine* (www.pcmag.com)

*Macworld* (www.macworld.com)

*Mac Addict* (www.macaddict.com)

*Story* by Robert McKee

*Digital Moviemaking* by Scott Billups

*Computer Videomaker* (www.videomaker.com)

# TRAINING

DV Certification (www.dv.com)

Apple Certification (www.apple.com)

Adobe Certification (www.adobe.com)

Avid Technology (www.avid.com)

Digital Video Tutorials (www.dvpa.com)

International Film and Television Workshops (www.theworkshops.com)

New York University (www.nyu.edu)

University of California, Los Angeles (www.ucla.edu)

Art Institute (www.artinstitute.edu)

Future Media Concepts (www.FMCtraining.com)

Robert McKee's Story Seminars (www.storyseminar.com)

# TRADE SHOWS AND EVENTS

Digital Video (DV) Expo (www.dvexpo.com)

SIGGRAPH (www.siggraph.org)

National Association of Broadcasters (NAB) (www.nab.org)

Macworld (www.macworldexpo.com)

DV Film Festival (www.dv.com)

digital video troubleshooting guide

*appendix B*

# TROUBLESHOOTING CHECKLIST

Before you call for technical support, try these troubleshooting tips.

- **Is everything plugged in tightly and turned on?** These are very common mistakes and often the last things users check. Make sure that all of your cables are connected tightly to the correct ports or jacks. Also, make sure that the power is on to all of your devices.

- **Try quitting (or force quitting) all applications, turn off all peripherals, and restart the system.** Every system hangs up or crashes from time to time. If it is an isolated incident, restarting the system may fix the problem. Be sure to restart the hardware, not just the software. However, if this is a frequent occurrence, there may be a larger problem at work. Repeated crashes can damage the software and operating system over time, so make sure you resolve any recurring problems as quickly as possible.

- **Have you installed the latest versions of the software and drivers?** Because digital video is cutting edge technology, it is important to make sure you have installed all of the correct updates and drivers. Anytime there is an upgrade to one part of your digital video system, it affects the rest of your system. For instance, upgrading the operating system will probably require software and hardware updates of all your digital video components as well. Check your digital video manufacturer's Web site to verify what versions your system's configuration requires. Sometimes the software already requires an update by the time you purchase it. Also, don't be in a rush to upgrade your system with new product releases; sometimes it is better to wait until the bugs are worked out first.

- **Check out the support page on the manufacturer's Web site.** Before you call technical support (many companies do charge), try searching the support page of the manufacturer's Web site. Usually there is a list or database of common problems.

- **Search the user groups, mailing lists, and forums for your problem.** If you can't find the answer to your problem on the manufacturer's Web site, try contacting a user group, mailing list, or forum. Chances are, someone else has also had a similar problem, or knows who to ask to find the answer.

# INSTALLATION

## Video card isn't recognized

The video card isn't seated firmly in the slot.

The video card requires an updated driver.

The video card requires updated firmware.

## System hangs at start up

Drivers need to be updated.

There is a conflict with another piece of hardware.

The device is not compatible.

## Application won't launch

Insufficient memory.

Missing system files.

Software requires an update.

Incompatible version.

# DEVICE CONTROL, CAPTURE, AND OUTPUT

## Video camera or deck isn't recognized

Not plugged in correctly.

Not turned on.

Not in VTR or VCR mode, or not on-line.

Using USB cable, not FireWire cable.

Software requires an update.

Incompatible device.

Try playing a tape in the device before launching the software.

## Software loses its place searching tape

There is a break in timecode (timecode renumbers at the start of new shots).

There is snow, or blank space, in between shots.

Segment is too close to the beginning or end of the tape.

There is a tape defect, such as drop out or a glitch.

Device control software requires an update.

## Sound, but no picture

Video input is not set correctly in software (set for S-video, should be composite, etc.).

Video cables not properly connected.

## Picture, but no sound

Audio input is not set correctly in software (set for sound in instead of DV in, etc.).

Audio channels are not set correctly in software.

Audio sampling is not set correctly in software.

Audio cables are not plugged in correctly.

Audio was not recorded on tape.

## No picture or sound

Device not turned on.

Device not cabled correctly.

No tape in device.

Blank tape in device.

Video input not set correctly in software (may be set for video card, but using FireWire, etc.).

## Dropped frames

Hard drive isn't fast enough.

Video quality is set too high for your system. (Apply compression or lower quality.)

Software requires an update.

## Can't put camera in record mode

Check device's instructions for recording from a video source. (May require a combination of buttons to be pushed.)

No tape in camera.

Tape is at the end.

Tape has been "write" protected.

# EDITING, RENDERING, AND PLAYBACK

## Audio drops out

Incompatible audio block size.

Incompatible audio sampling size.

## Part of audio is missing

Audio channels are turned off.

Audio channels are not mixed correctly.

## Stuttered playback

Software requires an update.

Video card requires an update.

Video playback options not set correctly in software.

Video clip has dropped frames.

Rendering or playback frame rate is not full motion (30 or 29.97 fps).

Hard drive not fast enough.

Trying to play back video from source other than a hard drive (CD, DVD, Zip, etc.)

## Files are missing

Files are not loaded on computer.

Files have been moved to another location after project was saved.

Files have been renamed.

## Effects are not visible

Effects are turned off in editing window.

Effects are turned off in rendering settings.

Layers are turned off in editing window.

## Black flash frames

Video clips have one or more blank frames between them. (This can be difficult to see—change view in timeline.)

Transitions applied in wrong track direction.

## Photographs or graphics are distorted

Photos or graphics not sized correctly (pixels and/or dpi) for software. (Certain programs require still images to be 720 x 480 pixels at 72 dpi.)

| digital video product guide |

*appendix C*

$$$: Expensive—over $1,000

$$: Moderate—$500-$1,000

$: Inexpensive—under $500

## DIGITAL VIDEO HARDWARE

### Digital Video Cards/Editing Systems

#### *ADS Technologies (www.adstech.com)*
USB Instant DVD (PC, $)

PyroPlatinum DV (Mac & PC, $)

Pyro DV (PC, $)

#### *Aurora Video Systems (www.auroravideosys.com)*
Igniter X (Mac, $$$)

Pipe (Mac, $$)

Fuse (Mac, $)

DIGITAL VIDEO PRODUCT GUIDE

### Avid Technology (www.avid.com)

Xpress Pro (Mac & PC, $$$)

Mojo (Mac & PC, $$$)

Media Composer (Mac & PC, $$$)

Film Composer (Mac & PC, $$$)

### Canopus (www.canopuscorp.com)

DV Storm (PC, $$)

DV Storm Pro (PC, $$$)

DV Raptor (PC, $$)

RexRT Professional (PC, $$$)

### Discreet (www.discreet.com)

Inferno ($$$)

Flame ($$$)

Flint ($$$)

### Matrox (www.matrox.com)

RT 2500 (PC, $$)

RT Mac (Mac, $$)

RT.X10 Xtra (PC, $$)

RT.X100 Xtreme Pro (PC, $$$)

### Media 100 (www.media100.com)

iFinish (PC, $$$)

Media 100i (Mac, $$$)

### NewTek (www.newtek.com)

Video Toaster (PC, $$$)

### Pinnacle Systems (www.pinnaclesys.com)

CineWave (Mac, $$$)

Targa 3000 (PC, $$$)

Dazzle (Mac & PC, $)

## FireWire Cards (IEEE 1394)

### Adaptec (www.adaptec.com)

### Belkin (www.belkin.com)

## External Hard Drives

### Maxtor (www.maxtor.com)

80 GB 1394 FireWire ($)

160 GB 5000DV FireWire ($)

250 GB 5000XT FireWire ($)

200 GB OneTouch FireWire ($)

### Seagate Technology (www.seagate.com)

Barracuda 181 GB SCSI ($$$)

Cheetah 146 GB SCSI ($$)

## RAIDs

### Laird Telemedia (www.lairdtelemedia.com)

DVora Media Engine (PC, $$$)

### Medea VideoRaid (www.medea.com)

VideoRaid 160 GB SCSI ($$$)

VideoRaid 480 GB SCSI ($$$)

VideoRaid 600 GB SCSI ($$$)

### Rorke Data (www.rorke.com)

## SCSI Accelerator Cards/ Host Adapters

Adaptec (www.adaptec.com)

Atto (www.attotechnology.com)

## CDRs/DVDs

LaCie (www.lacie.com)

QPS (www.qps-inc.com)

Sony (www.sony.com)

## Keyboards/Mice

### Contour Design (www.contourdesign.com)

Shuttle Pro Multimedia Controller ($)

### Bella Corporation (www.bella-usa.com)

EZ Keyboard ($)

## Additional Hardware

### Scanners

Microtek (www.microtek.com)

Epson (www.epson.com)

Hewlett Packard (www.hp.com)

Umax (www.umax.com)

### Digital Still Cameras

Nikon (www.nikon.com)

Sony (www.sony.com)

Olympus (www.olympus.com)

Canon (www.canon.com)

### Drawing Tablets

Wacom (www.wacom.com)

# DIGITAL VIDEO SOFTWARE

## Digital Video Editing Applications

### Adobe (www.adobe.com)
After Effects (Mac & PC, $$)

After Effects Production Bundle
(Mac & PC, $$$)

Premiere Pro (PC, $$)

### Apple (www.apple.com)
Final Cut Pro (Mac, $$)

Final Cut Express (Mac, $)

iMovie (Mac, Free)

QuickTime Pro (Mac, $)

Shake (Mac, $$$)

### Discreet (www.discreet.com)
Combustion (Mac & PC, $$)

### Pinnacle (www.pinnaclesys.com)
Commotion DV ($)

Commotion Pro ($$)

### Ulead (www.ulead.com)
Media Studio Pro ($)

### Avid (www.avid.com)
Xpress DV (Mac & PC, $$)

## DV Internet Software

### Apple (www.apple.com)
QuickTime Player (Mac & PC, Free)

### Discreet (www.discreet.com)
Cleaner (Mac and PC, $$)

### Microsoft (www.microsoft.com)
Windows Media Player (Mac & PC, Free)

### Real Networks (www.real.com)
Real Player (Mac & Linux/Unix, Free)

### Sorenson (www.sorenson.com)
Sorenson Squeeze (Mac & PC, $)

Sorenson Video Pro (Mac & PC, $)

### DivX (www.divx.com)
DivX (Mac & PC, Free)

DivX Pro (Mac & PC, $)

Dr DivX (Mac & PC, $)

## Digital Video Effects/Plug-Ins

### Boris (www.borisfx.com)
Boris FX ($)

Boris Graffiti ($)

Boris Red ($$$)

**Pinnacle (www.pinnaclesys.com)**

Hollywood FX ($)

Final Effects Complete ($$)

TitleDeko Pro ($)

**Ultimatte (www.ultimatte.com)**

Ultimatte (Mac or PC, $$$)

## Device Control Software

Diaquest (www.diaquest.com)

Pipeline Digital (www.pipelinedigital.com)

## DVD Authoring Software

**Apple (www.apple.com)**

iDVD (Mac, Free)

DVD Studio Pro (Mac, $)

**Sonic Solutions (www.sonic.com)**

DVDit (PC, $)

Reel DVD (PC, $$)

**Adobe (www.adobe.com)**

Encore DVD (PC, $)

**Pinnacle (www.pinnaclesys.com)**

Impression DVD ($)

**Ulead (www.ulead.com)**

DVD Workshop ($)

## 3D Animation Software

Alias Wavefront (www.aliaswavefront.com)

Avid (www.avid.com)

Corel (www.corel.com)

Curious Labs (www.curiouslabs.com)

Discreet (www.discreet.com)

Newtek (www.newtek.com)

## Audio and Music Software

Smart Sound (www.smartsound.com)

Sound Forge
(www.mediasoftware.sonypictures.com)

Logic (www.apple.com)

## CD Authoring Software

Roxio (www.roxio.com)

Macromedia (www.macromedia.com)

**Graphic Design Software**

Adobe Illustrator (www.adobe.com)

Adobe Photoshop (www.adobe.com)

DeBabelizer (www.equilibrium.com)

Painter (www.corel.com)

**Digital Video Stock Footage**

Digital Juice (www.digitaljuice.com)

Art Beats (www.artbeats.com)

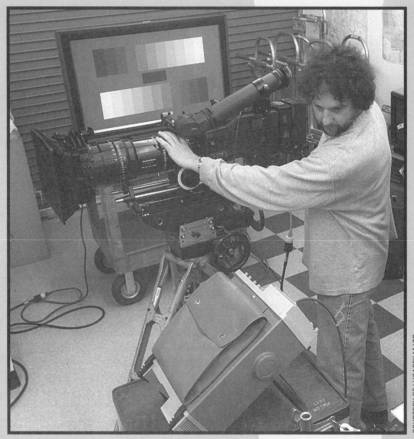

COURTESY OF LUCASFILM LTD.

fred meyers interview

.

### Fred Meyers, High-Definition
### Supervisor, Industrial Light & Magic

*A continuation of the interview from the color insert.*

**Q. You had touched upon something intriguing when you were talking about HD broadcast versus HD movie making. Do you think a new term needs to be coined to encompass the true scope of the new HD equipment you are using?**

**A.** Well, as much as we can, we do have to come up with terms that people truly understand. But we've just been looking at it as we're shooting digitally. It's digital acquisition as opposed to film acquisition.

**Q. Should the term high-definition be associated with it?**

**A.** Well, from my perspective, I stay away from using the term HD because it has broadcast and other video connotations. So it is high definition, but it's not HD as in HDTV.

**Q. Are the cameras that you used for Episode II being used in broadcast?**

**A.** Versions of the technology are. When we're working with the *Episode III* cameras in 4:4:4, RGB, 10-bit color depth per channel, it is a version not used in broadcast. It can't be transmitted. It can't be run over cable. It doesn't fit onto DV technology, that sort of thing. So even though pieces of the camera and some of the hardware are the same as a

broadcast version, there isn't any direct translation. And it isn't really a digital cinema camera. HD is a term getting kind of coined and it's what it is now in perpetuity.

**Q. So in all preference, would you prefer it to be called digital acquisition?**

**A.** Yes, I think it is digital acquisition, and there are HD technologies—HD camera technology, as well as video technology—that are implemented. But there are variants that are specific to the digital feature postproduction process, or the digital pipeline of a motion picture. An interesting term issue emerges when we refer to making movies as filmmaking. Well, you're no longer shooting on film. In the audio industry, they're not vinyl-makers anymore, are they?

**Q. What are some of the advantages of retaining control of the digital images from acquisition to the final edit? Is it more cost effective than film in the long run, taking into consideration the cost of the special production and postproduction equipment for HD?**

**A.** There's been an evolution in digital postproduction for film-originated material, and that has resulted in certain standards and formats for storing material that has been shot on film and scanned from film. Optimizing the scanning process for film at times runs at odds with optimizing the digital postproduction pipeline. During that postproduction process, the images always need to be viewed, and if in the viewing process, you continually have to convert images from the form they were in when scanned from film and optimized for that film process, into a form where you can actually view them, for example, on a workstation, or on a video projector, or on a video monitor, then that slows the process down, and sometimes it actually compromises the quality. But as we go towards digital acquisition, we can record and store the camera information in a form that isn't necessarily being compromised for the postproduction process and the display process along the way. So besides other types of manipulation that you can do when you have shot something digitally, the fact that you can be more compatible and avoid conversion steps all the way through to the final element means that it ends up, both in terms of time and quality, more effective than having to take into account the scanning stage, or going back out to film. Having to take into account conversions from or to film can certainly alter the look of the image.

One of the things that we hear quite often with digital acquisition, especially in postproduction, is, "Well, I saw this on the monitor. This is what my shot was. This is what my movie should look like. Now how come when it gets out to film, it doesn't look like the movie that I made?" Up until digital acquisition and digital release, you've almost had to compromise the material to optimize for the film process at the front end and the back end.

**Q. What hardware and software are you using to do the primary edit of the HD footage?**

**A.** Well, again, I mentioned shooting digitally. We've gone through different generations of cameras. The *Episode II* cameras were different from the *Episode III* cameras, both in the way they internally processed the image off the sensors in the camera, to the way they recorded them on the tape. What we did was develop ways to convert and optimize from the camera encoding and color space that was used into the postproduction format, so that it was optimal for the postproduction and CG work that would be done with the original material. So getting kind of specific in that area, we had to convert

from one color space to another. We had to convert from one sampling scheme to another, which had to do with how many pixels were used to make the data that actually gets recorded on the tape. And on the recording side, how to best reverse what amounts to a compression technology, what's the best way to recover the original pixel values.

So we came up with optimal software that would be as sharp as it possibly could, have the fewest amount of artifacts, and basically just be the fastest, so conversions could be done at a high quality and quickly. And this has evolved. In going from *Episode II* to *III*, because of the new design of the camera and recorder, we need fewer conversions, and we can focus more on speed. So as the quality and the amount of information we can capture with a camera and record to the tape improves, the main work of the software is to be as efficient as possible in moving data to the next stage, into CG. We're getting to the point where, for all intents, we're real-time now.

**Q. Are you using a proprietary system that's more software-based? Is it different than a traditional hardware-based video card?**

**A.** Well, it's interesting. Software and hardware right now are blurred because filtering and conversion software now can be loaded into hardware. So what's actually happening is the software that we've written is getting run in real-time in the hardware. We're at the point where software can be executed in digital signal processors, which operate in real-time. You think of it as hardware, but it is digital hardware executing software in real-time. With the latest capture card technology, conversions can happen on the fly as the image goes through the capture card, then off to the storage system. So we can convert, reformat, and write the images to the disk file system in real-time.

**Q. What computer platform are you using? Is it PC-based or UNIX?**

**A.** Well, plotting the history in *Episode II*, the input stage was all happening on SGI hardware using their version of UNIX called IRIX. As we've rolled into *Episode III*, we're running on PC hardware using the Linux operating system. So we've migrated to a version of UNIX running on nonproprietary hardware.

**Q. What are the differences in file size between 4:2:2 and 4:4:4, and how much hard drive space does it require?**

**A.** You use as much space as you have allocated at the moment in time, and you add more, and you fill it up. The file size going from 4:2:2 went from about 4.7 MB a frame in *Episode II* to around 8 MB a frame. So you could say it almost doubled.

**Q. Assuming you're working in segments, how much hard drive space are you using there? Are they set up as arrays, and how are you dealing with the throughput issues?**

**A.** It's a little bit more of a distributed system. When you have a capture card and you're working on a single workstation, everything goes onto your local hard drive. In our workflow here, individual shots and different sequences get handed off to different groups to process. Sometimes they come back to another stage to another group in the pipeline. They might move off into yet another stage where someone else will work on it. Each of those stages may have different storage associated with it. For example, one sequence might get what we'd call loaded, and X number of shots that are part of the sequence are loaded onto a fairly large server. The server wouldn't get filled up with that particular sequence or even with that particular show. It could be a server that has many different

sequences of many different shows on it. And then from there, they'll be moved off to other storage, specifically to a show or to a sequence. So what I'm describing is not one set of hard drives or one set of storage space, but a bunch of servers, each attached to different groups who are working on different portions of the project.

Usually the frames are moved at the shot level. A three- to five-second shot might have a slate at the top of it, and it might have handles at each end of the shot—in other words, extra frames that are of relevant importance if the shot itself gets extended or processing needs to take place beyond the in or out points. So, you may have five seconds of a shot and throughout its life it might move through six or more different servers as it works its way through the process.

In a first stage, for example, a shot might get handed off to a group that is trying to create what we call match move information. Say there's a person walking through a shot where the camera is panning through a scene and we need to create what basically amounts to a motion track of the camera or the person. When this group is done working with it, the shot moves on to another server where someone else may add another element to the shot. I think a way to visualize it, is that rather than one set of drive space, you might have a dozen different sets of drives on which shots bounce around. And when you add it all up, the total storage space gets really quite high.

**Q. How and when does the actual editing process of the film take place?**

**A.** Well, there's a primary editor and there are additional editors. Someone may be responsible for a specific sequence, someone else may be doing dialogue or live action, and someone else may be doing a battle or action sequence. At the production level, there could be one or more editors. For instance, on our *Episode III* project, we have two editors. However, before you get to this stage, you could have someone editing an animatic or the template—well before we even shoot anything.

So you've got an editor involved and you're shooting to and gathering elements required to fit their edit. Then there's the editing of the actual elements, typically once you get to what they call a turnover stage. This results in a list of required elements needing to be loaded for the postproduction process. You get a list of the number of frames from each take, each scene, that sort of thing. And what often happens is that another editor becomes involved who is more of an effects editor, who would then be responsible for matching the original edit to the required effects elements. And from there they're gathering the elements that have to be loaded online. They're also gathering elements that may have been entirely generated, such as CG 2D or 3D animation elements. They may also be gathering library effects. They may be creating yet another edit or template that will then be used for executing the final shot.

**Q. I understand that you have been working hand in hand with Sony to improve its 24-frame progressive cameras, based upon your experience shooting Attack of the Clones. Some issues addressed in the next generation of cameras included changing the format from 8-bit YCbCr 4:2:2 to 10-bit RGB 4:4:4 and variable frame rates to simulate undercranking film. Could you comment on these improvements, their significance, and how they are working out?**

*A.* Okay, in the camera we just go from 8-bit YCbCr, encoded as 4:2:2. In the process of working with 8-bit YCbCr in *Episode II,* we started to work with Sony on testing prototypes of 4:4:4 encoding that grew into 10-bit versions of the RGB camera. Specifically, we were looking at ways whereby we could increase color definition at the edges of the process screens—the bluescreen and green-screen shots that we were doing. If we had more bits per color and full bandwidth on all the color channels, rather than half bandwidth in the case of 4:2:2, we could get sharper edges. For example, if there was someone's hair that needed to be separated from a greenscreen or a bluescreen, the ability to extract the matte to use the element in a composite was greatly improved. So changing from the 8-bit to the 10-bit, and then the 4:2:2 to 4:4:4, gave us much better definition. Both luma and chroma transitions in the image improve, which besides giving a sharper picture in a no-effects shot, gave us improved ability to extract a process screen or even roto. It basically gave us finer detail, sharpness, and less blur in edges within a shot. So that was a big win there. And yes, on *Episode II,* we used a software process to simulate undercranking. We would record the images at basically 24 frames per second, but when we combined frames together and generated frames that were an average of those frames, we could simulate a longer exposure and/or the undercranking capability of a film camera.

That process was effective on *Episode II* in some ways and was a little lacking in others. It certainly allowed us to simulate the undercranking. It didn't allow us to really build an exposure and get the effect which comes along with undercranking of a longer exposure, which means you can work with less light, and means you could stop the lens down, and

increase your depth of field. This is advantageous when shooting a miniature. For a miniature to look like the full-scale thing, you simulate the depth of field, and that requires you to stop the camera down. So by working with Sony in *Episode III*, we were able to come up with a way to let the camera accumulate multiple frames. And when that happened in the camera, not only did it give you the ability to simulate the undercranking, but it also gave you the ability to build an exposure so you could get an effective higher sensitivity of the camera. This meant you could work at a lower stop on the camera and, therefore, work with a smaller model and less light. So in the newer cameras, we can do even more than we were able to do in software alone.

*Q. How have the camera lenses been improved? How have these improvements impacted principle photography in* Episode III?

*A.* In *Episode II*, the cameras were based on video and HD technology for broadcast-designed lenses. Panavision came and built motion picture lenses that would work with the new cameras. It was their first generation. The lenses were fairly large and, while the quality was improved both over broadcast and video lenses, we realized that there was room for second- and third-generation improvements. So in postproduction photography on *Episode II*, we had a second generation of lenses from Panavision. Other manufacturers also started to show us lenses, including Fujinon, which were specifically designed for digital acquisition for the motion picture style of shooting. This included everything from the gearing on the lenses for motors, to the markings on the lens for focus pullers.

There are a lot of differences between video and broadcast lenses and motion picture lenses.

Especially because many new accessories needed to be available for the motion picture style lenses. When we started on *Episode III,* we got a second generation from Fujinon. I look at it as really the third generation, because they had the benefit of seeing what the original lenses were like. The lenses got lighter, and they got smaller. The quality got better, the sharpness got better, and the contrast got better. And that gave us a good edge. The new lenses, combined with the new cameras, make pictures that look very good now.

### Q. What factors should other filmmakers take into consideration when trying to decide whether to shoot on HD or on film?

*A.* There are a lot of different things involved. A lot of them have to do with shooting style—what the look is that they're trying to achieve. Probably to frame that question, I would say that shooting on film in some ways has devolved over the years, not evolved. While not true for all projects, if you stand back and look at what you get in the film process, you get a negative. But you can never view a negative. You must view a print, a positive print. To get that positive print, the negative has to be printed, and there are stages of processing and timing involved to get the exposure of the print. The exposure of the print can never capture everything that the negative had captured. So typically what happens is that the negative is exposed—and hopefully the exposure is optimal. And hopefully the print is from the optimal point of the negative, and you get a pleasing result. Often though, because the negative captures more than the print, the exposures are less than optimal or have kind of, like I said, devolved into results that are less than pleasing. It may or may not have anything

to do with the talent of a cameraman. It could have to do with many different things. You can have things all over the place with film, and you've got some unpredictability going into the printing process. Some decision has to be made to optimize that print, or in the case of a digital postproduction process, optimize the scan and time it so that you get what you want the picture to look like.

So there are these printing lights which have to be changed to try to put the picture back into what the original intent was. And that involves people in the lab. It involves color timers and, therefore, you've got several people who have touched the process. It's not just the cameraman. You maybe have three people who have impacted what a shot actually ended up looking like.

Shooting digitally, you have new tools right there when you're shooting. You basically have your lab right there. You can see what you shot. Therefore, you can actually get what you want. You can set your exposure, set your camera, to capture exactly what you want to shoot. So what happens is, instead of just a cameraman going out there and throwing some lights on a scene—I'm obviously simplifying this to a certain extent—you light a scene and you say, "Okay, 5.6, roll camera." You may find out later that a 5.6 wasn't the best stop for that shot, and someone retimes it back so it actually looks like it had been shot with a more open exposure, 4 or something like that. They fixed it, and that's the way it should look. You see this right there when you're shooting, and you can dial it in right then and there. So it puts the creativity and the onus of responsibility for how the image looks right back into the cameraman's hands. And that's an important factor. If you approach

it this way, you've got the tools right then and there, and you can decide if that's the look that you want. But you have to make the decisions right then and there—it forces you to make the decisions immediately.

I suppose you could say that it can be an aesthetic decision, whether to shoot on HD or film. Maybe the decision is based on depth of field. Maybe it's based on characteristics such as film grain, or that you want that look. Maybe it's based on muted highlights that you might associate with something that's shot on film. I don't really think there's anything that specifically says you need to shoot on HD or film. I think that with the malleability of HD and the ability to make those immediate on-site decisions, you could get a look that would be pretty much anything you wanted, within a few limitations.

*Q. What about more practical considerations in terms of the cost effectiveness? How much money are you actually saving with the digital acquisition?*

*A.* I'm the engineer. The producer needs to be on the line for that! My perspective on that is one that there's an expectation of what a camera package costs. There's an expectation of what lab and film costs, what tape stock costs. And there's really probably a comparable dollar amount, whether it's film cameras or digital cameras. But it's other factors that come into consideration—lab costs, telecine, scanning— that's where the big differences come into play. And, again, I'd leave it to the producers to make the case for that. In terms of the camera package, they're probably very similar.

*Q. Do you think shooting HD will one day replace shooting traditional film? If so, how do*

*you foresee such a transition happening? How quickly are other filmmakers adopting this technology?*

*A.* I think if you look at what's happening with still photography, while there's still a fair amount of film still photography, there's no stopping shooting digital stills now. And the same really applies. Clearly shooting digitally is going to replace shooting on film. It will happen. I would almost think that it would happen sooner than later. But some things have to play out their own timeline. It seems like on the professional side, as opposed to on the consumer side, there's a little bit more reluctance to change. It may be generational, a new breed of filmmakers. I hear stories, I think Elizabeth Dailey was telling me once that at USC, one professor wanted to send—I may not have this quote exactly right—but wanted to send a class out with Eclairs or some 16 mm cameras, and the professor was basically shot down by the students. They said, "No, we're not going to go out with film. That's not what we're going to be using when we're out there working, so forget it!"

*Q. What are some of the biggest challenges you faced pioneering this technology and how did you overcome them?*

*A.* I don't know what the biggest challenge was, but the way obstacles were overcome was with a "We can do it" and "Just do it" attitude. Not "Why we can't do it," or "Why should we do it?" There was a commitment by George, and that dropped a lot of the barriers. That being said, probably many of the barriers and the biggest challenges were things that were still barriers within our own infrastructure and needing to grease the wheels, so to speak. You

know, "Get over it. We're doing it, now let's do it the best possible way we can." So I think probably that's how things were solved and the challenges were just getting everybody to work at the goal. A lot of the technical challenges were difficult, but at the same time, there are a lot of creative and talented technical people here at the company. I guess what I'm trying to convey is that once you get people on board, you're over the biggest hurdle.

**Q. For you personally, how does it feel to be pioneering this new technology and advancing the field of digital video? Was it ever something you thought you would be doing or dreamed of doing?**

**A.** It's been an incredible opportunity. I've enjoyed it thoroughly. I don't always step back and look at it and say, "Was this what I thought I would be doing?" It's working with this type of technology—from the video, the computer, and the sound and production background that I have—it just felt like something that was just natural to happen. And in that sense, components of what I felt was going to be needed to make it actually all fit together are things that I've been toying around with for many years. In my mind, it took the vehicle and the commitment from George to basically give me the opportunity to say, "Well, okay, yes, I do know how we can do this. And thanks, and here's how we'll do it."

COURTESY OF LUCASFILM LTD.

| ben snow interview |

### Ben Snow, Visual Effects
### Supervisor, Industrial Light & Magic

*A continuation of the interview from the color insert.*

**Q. What does your role as visual effects supervisor actually entail, and who do you interact with on a day-to-day basis? Also, how is the effects team at ILM structured?**

**A.** The main team depends on the type of show that is being done, or the type of movie project that's being done. Usually you have one or more visual effects supervisors and an effects producer who keep track of things and help make it happen. In a creature animation show, you also have an animation supervisor. Working with them are computer graphics supervisors who help determine some of the computer graphics needs of the effect. Also, a compositing supervisor helps oversee the compositing, which is where you combine all the different elements that are created to make a particular shot. You also have model shop supervisors whom you work with in the model shop and directors of photography who shoot miniatures, if you're doing that. There are also practical effects people who devise any practical explosions or dust elements that you need to create.

There are various subdepartments involved in creating and painting computer graphics models and art directors working on concept art pieces. Rotoscope artists help us isolate or "cut out" different elements and do hand painted work on elements. The match moving team helps us re-create the set

and any real photography in the computer so we can match our computer graphics elements. This gives you a sense of the team that is involved. The visual effects supervisor is usually the leader of that team, or one of the leaders of the team. We are basically responsible for working with a director, to help work out how he's going to get the image that is in the script created on the screen.

**Q. Is the director of photography involved at this point?**

**A.** Not always. Increasingly, as the films become much more visual effects oriented, we sometimes get called in at the very start when there's just a script existing. Sometimes that's even before the director or the DP is involved. However, it depends on the movie. In the case of the film I'm currently working on, *Van Hesling*, the DP's fairly heavily involved early on. In the case of *Star Wars:* Episode II, the DP was also active, but we didn't see a whole lot of him early in the process. On *Star Wars,* George Lucas, the director, works with an art department team, often even before he starts talking to ILM about the visual effects. They start creating some concept art and rough animations and so forth, which help work out the scope of the project. This is increasingly happening with other movies, too. The director will work with some sort of animatics team that creates rough animations, using off-the-shelf software to get a sense of how some of the big action and effect sequences will work.

**Q. And that's fairly recent with the advances in digital technology? Weren't visual effects mostly relegated to postproduction?**

**A.** Yes, although usually there'd be clever directors who used effects well and would involve people earlier on, and they'd storyboard their most elaborate effect sequences. There was always some level of this, usually through storyboarding. Because effects are quite an expensive part of the process, it was vital to have something that everyone agreed was what we were trying to achieve. The animatics process gives you a moving storyboard, which is a lot more useful in terms of planning, particularly when there's character motions involved and particularly when you want to shoot some elaborate camera moves on set.

**Q. Do you find with the animatics that you actually can judge better whether or not things will work out as you had intended and maybe modify an original plan?**

**A.** Yes, that's exactly true. It also gives you a good sense as to whether the director is going to like it. You might have an idea for a camera move, but you want to show it to him and get a buy-off on what you think the camera move should be. The director will look at it and say, "Yeah, I like that" or he'll change it. If you have an animatics team working very closely with the director, they get feedback instantly from him and can make modifications right away.

**Q. And that's headed up by the animation producer, or by a separate team?**

**A.** It depends. On some films it is the animation producer; on other films they hire an animatic artist or a small team that works on computers in the director's office. There are other times when they'll ask us to do animatics, and the visual effects supervisor will work with a small

team, or one or two people here at ILM, to do animatics creation.

**Q. At ILM, how many people work on an average film? How do films like Episodes I, II, and III compare?**

**A.** Well, the films are getting larger and larger, but I think in an average film you have maybe 100 to 200 people at ILM. Films are getting increasingly larger and more complex, so you can have crews of around 350. *Episodes I* and *II* were probably more like 600-odd people. There are probably even more when you imagine everyone who doesn't get a credit because there's limited space—the credits are long enough as it is. Most productions have maybe 100 or 150. But as I say, it's increasingly the norm to get these really big, big movies.

With *Star Wars* particularly, they used animatics a lot. And there was a massive art department effort. The animatics and art people are often consulted when the movie is being shot on set, but they also sort of make things up as they go along. What happened with *Episode II* is that after photography, George Lucas came back and started assembling the film. He told us what sort of effects he thought he would need so we could start working on whatever R&D we needed to get those effects, whether it was computer R&D or practical effects R&D. For any creatures that we knew we were going to have to build, or any places we knew we were going to have to make, we started making and painting the computer models. Again, the art department sometimes helps in this process by making little clay maquettes of these creatures and machines.

So at this point in the process, we have a bunch of art and we have these little maquettes. Usually we start making the creatures on the computer with a modeler, and someone called a view painter starts painting those creatures. We also have someone who controls the "look" of those creatures. The "look" of the creatures refers to the surface properties; making skin look like skin, or metal look shiny like metal, and that sort of thing. That team gets together and gets going on things.

Meanwhile, the visual effects supervisor is often shooting the film with the director. They're on set consulting on how we should do this and how we should do that. We've had meetings up front with the director of photography, the practical effects team, and the art director on the film and have decided, "Okay, this can be a set. This will be a set extension. We're only going to build part of a set. What can VFX do here?" We negotiate who's going to do what, and then they go and shoot the film. Sometimes, they make it up on the spot and don't shoot exactly what you're expecting even from the animatics and storyboards. Usually we're there on set to consult as to what sort of bluescreen level we want. What happens with *Star Wars* is then George will start editing the film together using the bluescreen footage and using animatics where animatics exist. Sometimes he has the animatics team continue and start putting animatics in behind the bluescreen. When it gets to ILM and me as the visual effects supervisor, I start looking at it. I get an idea of what's going to happen. I have some artwork, I have some animatics, and I have the original photography. From that, I plan. I ask, "Okay, how do we make this look completely

real and how do we bring it to the screen final? What is going to be computer graphics? What are we going to build as miniature? What can we shoot elements for? And what can we just do using compositing to combine different elements that are shot on location?"

I sit down and just plan that out, and I plan it out with the help of some of the people I mentioned before, computer graphics people and so forth, and come up with a scheme for each shot. At that point, we sit down and work out how much it is going to cost us to do each of these shots, and what sort of resources we are going to need in terms of animators and technical directors, who are the people who do the lighting, and so forth.

**Q. So you start off, I would assume, with a preliminary budget, guessing how much the visual effects are going to cost; and then since you've already got some principle photography that's done bluescreen, does that often change?**

**A.** Yes, absolutely. What we do to start is take the script, and I, or a producer, or both of us, go through and do a rough breakdown of what we think are VFX shots, just based on the script. Based on that, we do a ballpark, which is where we just try to judge how complex this film is going to be. Sometimes people do that by just saying, "Okay, we know there's X number of shots with this creature," and we'll say on average, "That's going to take this amount of time." Sometimes if you can, and I prefer to work this way, you can go through and do a slightly more detailed analysis and say, "Okay, this is going to need this, this is going to need that," and try and work out resources and techniques for each shot in the breakdown.

When we shoot the film, sometimes things don't go as expected, or the director has a new idea. After the film is shot, and the visual effects work is turned over to us at ILM, we'll go through the budget again and re-evaluate what it will take to do the work.

In the case of a big film like *Star Wars,* though, we can make certain assumptions. We know what it took to make the other *Star Wars* films, and we know that one of the big driving things on the *Star Wars* film is they want to be efficient and they're expecting certain optimizations and economies of scale. Because there is such a huge number of shots, we know we can expect maybe hundreds of shots of a given type. We then ask: "How can we make it easy enough that we can do those shots without each one being a complete challenge to do?" Probably in the first phase after filming we ask, "Okay, how do we do this effect? How do we actually even get it to the screen? How are we going to make this work?" Secondly, "How are we going to do it in a really efficient way so that we maximize the bang for the buck?"

**Q. And these are primarily your decisions?**

**A.** I'm definitely making the decisions, along with the producer; but I'm also making them with the involvement of these different departments. I'll say to a computer modeler, "How long is it going to take you to build this?" We ask the same question to the miniature unit. And sometimes it's also, "Where have you got resources right now? Do you have more people available to work on miniatures, or do you have more computer graphics people available?" This makes a difference as well. "How are we going to do this, and what's the most efficient way of doing this? What's going to get the best result?"

**Q.** *In a film like* **Episode II,** *so much of the principle photography was shot against a keyable background. What criteria do you use to determine whether bluescreen or greenscreen should be used for a particular shot?*

**A.** Back when we used optical technology for film effects, we really favored bluescreen work. There are a few reasons for this. I think the big one was that with film, the blue channel tends to be one of the grainier channels. Bluescreen was favored by ILM at least partly because traditional optical photochemistry used the blue channel as a matte, essentially getting rid of the blue channel and using that as a matte channel and replacing it with the green channel. We would put up with grainier matte edges because we had ways of making that better through our different optical techniques, rather than sacrificing the quality of the color image because we wanted to keep the least grainy image possible. This was one of the simpler reasons for it.

Now that we've got a lot more sophisticated digital keying tools, the screen color is less of an issue than it used to be; but the facts still apply. Ironically, in HD technology, we still found the blue channel was grainier. ILM definitely had a rich heritage in doing bluescreen, and a lot of our tools were developed around that. Now we can use green or blue with equal facility. We still have a preference for blue because of the reasons I mentioned, but really it's the color that we're going to put in front of it that most dictates this. And also, the lighting equipment. There's different lighting equipment available. A well lit blue or greenscreen is probably the most important thing, rather than the color of the screen. It's really what you do and how you approach it.

In video technology, greenscreen has sometimes been more widely favored. Really the response of a normal video camera may be a little bit different from the film cameras and HD cameras that I'm using. The way we key stuff now anyway, it's not like we completely throw away the blue channel data. It's much more sophisticated now.

**Q.** *In order to be successful as a visual effects artist, what kinds of commercial software programs should students be proficient in? What programs do you use at ILM? Are they mostly proprietary?*

**A.** Well, interestingly, the thing that we really like is knowledge of the techniques and the practice of different things and their eye. Do they have a good eye? You know, are they a talented artist? That's probably one of the most important things. I've always found that if you know the techniques of compositing or lighting or animation, then you can reasonably and quickly be retrained on a new tool. If you don't have that ability and don't know what's going on in the composite and that sort of thing, then that's a bigger disadvantage. If you're proficient in a compositing package and you do good-looking work, then that's probably the most important thing that we'd be looking for.

We do use a lot of proprietary software, but we also use a lot that is off-the-shelf; and we generally try and use more and more off-the-shelf because it costs a lot to maintain proprietary stuff. The off-the-shelf stuff is increasingly getting to the point where you can write your own plug-ins and supplements and do the stuff that no one else can do, which is what our bread and butter is in a way.

**Q. What off-the-shelf software do you use?**

**A.** We use Maya and Softimage for animation. We had proprietary compositing software, but we've started increasingly looking at Shake and After Effects. We also have Inferno and Discreet Logic software, although we've got a special version of it that we've plussed out to do our own things. We actually are using a variety of software now, and our own proprietary software still does things that the vendor packages don't. The vendor packages, as I've said, have opened themselves up a bit more and allowed us to write our own scripts and plug-ins. This has meant that it's easier for us to do our own special stuff in those programs.

**Q. Now, in terms of cutting the actual shots together, are you using anything proprietary for that? Are you using anything like Avid or Final Cut Pro or any of those programs?**

**A.** In terms of cutting stuff together, we have a lovely little proprietary tool that we use for cutting stuff at our desktops. Our editors use Avid because most film editors use Avid or a similar system. This enables us to exchange data with clients and get updates to the cut because these things are quite dynamic. The director will be changing the cut sometimes daily; and you'll want that information if you're doing animation, timing, and so forth.

**Q. You've had a tremendously successful career at ILM; what advice could you share with a student who dreams of having a career like yours in visual effects?**

**A.** Don't give up is the first thing. If you really believe in it, you can really do it. I always wanted to work in films, and I wanted to work in visual effects, but I never really drew at school. I wasn't a fine artist. I always thought I wouldn't

be able to get into this. I couldn't be a visual effects person, but I was a huge fan. I used to read *Cinefex* magazine and *American Cinematographer* about all the effects movies used, and I was really interested in that and made little Super 8 movies myself. When I went to study, I actually did a computing degree. I did a major in film, which I was lucky to be able to do, but I never really did a lot of direct-to-computer graphics stuff. I kept my interest up in film, as I did computing. Then at the point when computer graphics took off, I said, "Well, actually, I want to get in movies." Then I said, "Okay, you know what, I've done the computing thing. I've made a bit of money in this." I was able to travel a little bit, and I decided, "Look, I really want to try and break into the industry, and I'm just going to do it, and I'll take any sort of job."

Initially, I tried to get an editing job. I just went around and knocked on the doors of all these editing houses. I was actually traveling, I'm Australian, but I was living in London at the time. I sent off about 30 or 40 letters and just went and knocked on doors, and a few people would talk to me. A couple of people said, "You know, we don't have any work right now; but, boy, you've got these computing skills. You should really look at computer graphics." At that stage, computer graphics was sort of at the level of *Tron*, but I really was more interested in the stuff ILM was doing—the more photo real work—which is mostly done with miniatures and optical photography. Anyway, I did say, "Okay, I'll go to a computer graphics house," and I ended up getting work as a runner, which is like starting at the low end. You make cups of tea, deliver parcels, and that sort of thing. I learned a lot by doing so and actually was able, because I did have computer skills, to pick up the business pretty

fast and move up fairly quickly once I got into the industry. It was very fortunate for me that computer graphics was taking off at the time, and I was able to do what I'd always wanted to do, just maybe not exactly via the route I expected. My parents had said computers will get you any sort of job. They turned out to be right. Really it was, I think, just saying, "Okay, you know what, I'm willing to start small. I'm not necessarily going right to ILM for my first job and then because they don't accept me, give up. There's a post house nearby. I'll try and go there." Go there and just say, "Can I do anything here?" and then maybe even just work for very little money initially. If you like it and if you take to it, then you'll progress quickly. I think it's really a case of not giving up if you really love the thing that you want to do. I think this will be evident and your enthusiasm will make it possible for you to succeed.

**Q. We touched upon this earlier, but could you comment more on how the recent advances in technology have changed your job or the way that you approach it?**

**A.** Animatics and previsualization have made a big difference. *Episode II* was interesting because some of the HD technology was new. We  instantly saw the benefits, even though sometimes we had to work around limitations in the new technology. Before, we'd have to shoot film and then scan the film to bring it online. It's quite an expensive process. Shooting on HD allowed instant feedback because you could see right away what it looked like on the monitor. Sometimes you could even patch it through to a projector in one of the screening rooms and see the results instantly. You'd then be able to correct mistakes straight away. You wouldn't be waiting for the film to be printed and look at it the next day to find out that

something was out of focus. This made a huge difference. It also made it possible for me to say, "You know what, I'd like to shoot this thing a little bit differently," and I'd shoot a different pass and maybe turn one of the lights off on this pass. I knew then that I would have this video available to me if I needed it later and not have to worry about it. I was able to protect myself a little more affordably.

The other thing is that because I know compositing is now an option—and the filmmakers know compositing is an option— even when we're filming live-action photography, we can make different decisions. It can be a little confusing for a traditional filmmaking crew because you can say, "You know what, I can just shoot this thing in two halves and combine those later in the computer and no one will ever know." It'll be actually a much easier way of getting the shot. People will look at you. They're so used to getting things on camera, but they'll say, "Oh, gee, okay, I guess we'll just have to go with you on this one." This sort of tool just gives filmmakers tremendous freedom.

**Q. Do you feel that people are finally starting to catch on in the film industry, and that with the success of Episode II more filmmakers are going to be pursuing this avenue of trying to shoot on HD?**

**A.** I think so, but I think also the tools that you can use in post are affecting it. You know, it's funny, I think that one thing that has happened—and one thing that's doing this sort of stuff and pushing ahead as George Lucas did on *Episode II*—is that the equipment gets better and better. It's like we're at the birth of HD here almost. And so the stuff that we shot *Episode II* on is the most primitive the HD

equipment will ever be. Already on *Episode III* the equipment's better. There is higher dynamic range. There's higher resolution. There's all this stuff that means that the image is getting better and better. And it's not going to stop there because, really, in theory, this technology will eventually be able to capture light wavelengths that film cannot.

**Q. So high-definition video will actually surpass film eventually?**

*A.* Eventually it will. And so it's kind of exciting to be there in the infancy. I think that already you're seeing some of that. Because film and television are getting closer in terms of TVs doing stuff with HD, there are tools that make things a lot faster because there's obviously a huge volume of stuff associated with television. But because we have to achieve a higher quality in film, we have different demands on us than television has on it. And so, for example, with a film like *Episode II*, they said, "You know what, we want to use one of the great DPs that's done a lot of film work." We want him and his camera crew to be able to think of this more like they've thought of their film cameras. And at ILM, we want to use our directors of miniature photography, who've got all the expertise in lighting these miniatures so they look like full-size sets and full-size machines.

And so we made sure that the HD technology, the language of it, works in a way that we can understand in film. So it's funny because in a way you say, "Oh, boy. To start with, we're making the new technology sound like the old technology and work a bit like the old technology." But then gradually you can start using and exploiting the new things that it gives you as well. And so you're learning the new

language that the HD and the video options give you, and the whole different range of color correction approaches from what we would have done when we were doing optical and photochemical type adjustments. So, it goes both ways. Some of the ways that we try and bring quality to the film images gets passed into the HD technology, and some of the incredible power of the HD technology starts expanding the tools that we use for making films.

**Q. What's it like for you, as a visual effects supervisor, to work with directors that have different levels of expertise regarding the technology?**

*A.* It's definitely part of the job to try and make the director as comfortable with the technology as possible, as comfortable with what we're going to do as possible, because they have to put a lot of trust in us. And particularly to understand where they need to make certain decisions and commitments to things, because changing things later on is going to be a nightmare. So it's vital that you explain this to them and work with them and tell them. Because sometimes when we're shooting the stuff, we have to make certain demands on how things need to be shot so that they can now be effectively integrated with the visual effects. And I think if the director's also producing it and has some sense of the money involved with visual effects, they are really open to, "Yeah, okay, if we spend a little bit of extra time now, we're going to save time later on." But it's probably one of the hardest things.

I've been somewhat fortunate that, at least in the last couple of projects, the directors have been very effects savvy and interested in effects. But still you're always developing new

technologies, and there are always times when the director will say, "Well, I want to change this." And you say, "Well, if you change that, we have to then do this and this and this and this and this all over again." And I have to explain that in this case, it's going to be hard to do it and we won't be able to do this or that. If the director is really effects savvy, they know how they can make the trade-offs and ask themselves, "Is this really important? Yeah, but then maybe we can do this differently. And if I stop to shoot an extra element, then later on it's not going to be as hard to get this effect in post."

So that education thing is vital. As long as the director's open-minded enough and happy to work through it with you, and the same with the DP and the art director and the practical effects guy, then you're okay. But it's absolutely the case that it can make a big difference, and it's really vital that you can get their cooperation and trust in the way you shoot this stuff and in the way you work with them in the postproduction process.

**Q. With the current pace at which digital technology is advancing, how do you think your job will change five years from now?**

**A.** Number one, we're seeing a lot more of this sort of work. So we constantly have to be faster and better at it. At the same time, people are able to do some of this stuff on their home computers. And so what you see is some incredibly interesting and fun stuff that people do at home, and some of it is incredibly realistic looking. It is a real exciting time now when people can afford to buy stuff that can do really high-quality work. This changes the whole way we have to think about running

things. As the commercial software gets a lot better and a lot more powerful, we want to try and exploit that, because then we don't have to train our people as much using proprietary software. We can have a more fluid workforce. We can exploit some of this talent that's coming out of people working on lower-end systems, and get them in here and working.

I think we're already seeing a lot of exciting flowering of the language. I mean even just the way video clips and video technology changed the look of movies. I think that the lower-end and lower-tech stuff, and the fact that people are shooting stuff on Mini-DV and compositing stuff on Mini-DV, now has directors saying, "Oh, you know what, we're going to do all this ourselves. We're just going to buy this computer, and we're going to composite our own effects. We're making a low budget film, and we'll do it." That's really going to change the whole approach to things. We have to be faster and looser. We have to be, you know, able to really react and be a little bit dirtier.

On the other hand, directors, particularly through the example set by George Lucas with his films, are starting to cotton onto how much they can get away with and manipulate their live-action photography later. So they're increasingly asking for more demanding things and more demanding solutions. We still haven't reached the point where we have to stop developing newer and higher-end equipment and technology and tools to be able to do the tricks that they increasingly are coming to expect as a matter of course. Again, the legacy of video and the fact that directors are coming out through telecine and video suites and are accustomed to just being able to do this and that at the turn of a dial, is that they expect the

same sort of result when they get into film effects. And so with this sort of stuff, if some guy can do it in his garage, then you have to be able to do it here and then you have to be able to do that plus all this other stuff that really hasn't been done before. The envelope gets pushed and the lower end gets more ramped up. So it's a fast and furious pace for sure.

In five years' time, I'm sure we'll be using more and more of this stuff that the students are using in the colleges. And the differences increasingly come down to not who has the best technology, but who has the best artists, who has the more experienced and talented people to work with. It's great. It's kind of a leavening thing. I think with film, the appetite of directors is going to be more and more; and films are going to get more and more spectacular and maybe cheaper because they'll go in there and say, "I'm going to shoot this all bluescreen." In the last film I worked on, *Episode II*, every single shot, except for one in my sequences, had either just a bluescreen element or nothing at all in the original footage. And in the film I'm working on now, *Van Hesling*, more than half of my shots are that way. They built some beautiful sets, but there's also a huge bluescreen that we have to create the whole environment.

And so as directors gain trust and confidence that they can use synthetic environments, they're going to demand more and more spectacular stuff. But I think the clever directors are still going to make good assumptions, as I think George Lucas does and I think Peter Jackson does also, as to what makes sense to build as a set and do for real and what makes sense to do synthetically.

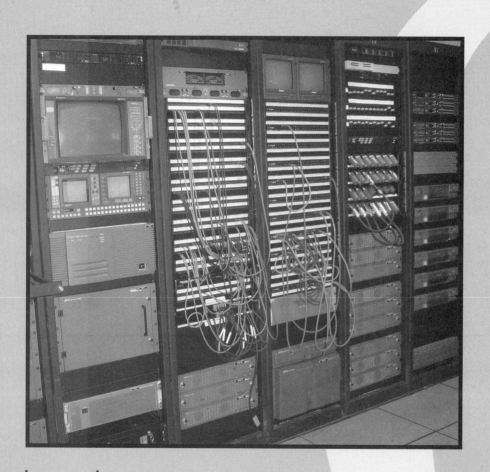

glossary

# *glossary*

**8 mm**—A consumer analog videotape format that uses a small videocassette with a tape that is eight millimeters wide.

**action safe area**—The outermost line of the video frame within which any action will be safely displayed in its entirety.

**alpha channel**—An extra piece of information that is written with the file, designating a portion of the image, with the option of becoming transparent if later activated in another software program.

**analog**—The traditional video signal, which is an electrical signal that fluctuates exactly like the original signal it is mimicking.

**antagonist**—The "bad guy" or the adversary of the protagonist.

**aperture**—The part of the camera that controls the amount of light that is let in by adjusting an opening called the iris. The aperture changes sizes, which are measured in increments called f-stops, to let in more or less light.

**aspect ratio**—The width to height proportion of the video frame. The current NTSC video standard has a 4:3 aspect ratio.

**ATA (Advanced Technology Attachment)**—A type of hard drive.

**back light**—Typically a spotlight used to provide definition between the subject and the background. It is usually placed above and behind the subject, opposite the camera.

**barndoors**—A lighting accessory consisting of metal doors, which can be attached onto a light fixture and positioned to adjust the beam of light.

**batch capture**—A style of video capture in which all of the in and out points of the video clips are designated first, then the computer goes back and captures the entire list.

**battery memory**—A type of battery, like a NiCad, that should be fully discharged before it is recharged, or the battery's life will be greatly shortened.

**Betacam SP**—A professional analog videotape format developed by Sony that uses half-inch-wide videotape.

**Betacam SX**—A professional digital videotape format that records 8-bit 4:2:2 component digital video signals and up to four channels of 16-bit 48 kHz audio.

**bluescreen**—A video technique used to isolate a subject by filming the subject against a blue background which will later be replaced with other footage.

**BNC**—A type of connector used professionally to transmit the component video signal.

**boom**—A long pole that supports a microphone, allowing the microphone to be positioned closer to the subject.

**broadlight**—Also called a floodlight; a type of fixture that spreads the light evenly over a large, broad area.

**cache**—An electronic storage area that temporarily holds frequently used data for the CPU.

**camera notes**—A form used during video production to record the starting and ending timecodes for each shot and to make notes regarding the quality of each shot.

**camera setup**—Part of the production schedule that designates which shots can be filmed from the same angle and relative placement of the camera.

**CCD (charge-coupled devices)**—Computer chips in the video camera that convert optical images into electrical impulses.

**CD-R**—Inexpensive recordable compact disc that holds between 650 MB and 700 MB of information.

**chroma keying**—A postproduction technique during which a specified color is selected to be keyed out, or made transparent.

**chrominance**—The color portion of the video signal.

**CU (close-up)**—A head shot of a person that cuts off at the top of the subject's shoulders.

**CMYK (cyan, magenta, yellow, black)**— The colors used in print media to reproduce an image.

**CODEC (Compression/Decompression)**— A mathematical algorithm used to decrease the file size of a video image.

**color depth**—The number of colors represented in a video image measured in bits. 1 bit represents two colors, black and white. 8 bits is 256 colors. 16 bits is 4,000 colors. 24 bits is 16.7 million colors. 32 bits is 16.7 million colors with 256 levels of transparency.

**color graduated filter**—Also called a color grad; a video filter used to add a color to a specific area of an image.

**color temperature**—A distinction which measures visible light in degrees Kelvin, K. Daylight is 5,600 K, while artificial tungsten light is 3,200 K.

**component**—A professional video signal, in which the red, green, blue, and luminance portions are kept separate.

**composite**—A consumer video signal, in which the chrominance and luminance portions are blended together.

**compressor**—A type of video CODEC, or mathematical algorithm used to decrease the file size of a video image.

**confrontation**—The second act of a screenplay during which most of the story's conflict takes place.

**contrast filter**—A type of video filter that adjusts the contrast of an image, or its brightness and darkness values.

**CPU (central processing unit)**—Also called a processor; the chip that performs most of the information processing in the computer.

**credits**—A list of names attributing who worked on a project and what their roles were.

**cyc light**—A type of fixture used to evenly light large studio backgrounds called cycloramas.

**DAT (digital audio tape)**—A digital tape format that records information onto a small, 4 mm tape, which can be erased and rewritten.

**DDR (digital disc recorder)**—A type of video recording device created in the mid-1980s, which could both play back and record images at the same time.

**depth of field**—The range of the distance in which the image remains in focus in front of and behind its focus point.

**desktop video**—A term used in the 1990s to refer to consumer digital video editing on the computer.

**diffusion filter**—1. A type of video filter used to hide wrinkles and facial blemishes; 2. A lighting accessory used to decrease the amount of light on a subject without altering its color.

**Digital-8**—A consumer digital videotape format that records up to 500 horizontal lines of resolution and either 12-bit or 16-bit PCM stereo audio.

**digital filmmaking**—A cost-effective way for independent filmmakers to make movies by shooting digital video, editing it, and having it transferred from the computer to film.

**Digital-S**—A professional digital videotape format that uses 4:2:2 processing and offers two or four channels of 16-bit 48 kHz audio.

**digital zoom**—A video camera feature, which artificially extends the zoom capability of a lens.

**dolly**—A wheeled platform that attaches to the tripod's legs, enabling the tripod to be easily wheeled around.

**downloadable movie**—A method of transmitting video over the Internet in which the user would receive a copy of the digital video movie on his or her computer.

**dpi (dots per inch)**—An increment used to measure resolution.

**drop-frame timecode**—A format for timecode using 29.97 frames per second; the hours, minutes, seconds, and frames are separated with semicolons (00;00;00;00).

**drop out**—White streaks that occur when video information is missing due to a defect in the videotape.

**DSS (digital still store device)**—A video recording device created in the early 1980s, which was capable of storing and recalling individual video frames.

**DTV (digital television)**—The digital video broadcast standard set forth by the FCC.

**DV (digital video)**—An analog signal converted into binary form, which is represented by a series of zeros and ones. In a broader sense, the term can encompass all digital video technology, including digital video recorders (DVRs), digital video discs (DVDs), digital cable and satellite service, as well as digital video cameras and digital video editing.

**DVCAM**—A prosumer digital videotape format that uses 4:1:1 sampling and records two channels of audio at 16-bit 48 kHz, or four channels of audio at 12-bit 32 kHz.

**DVCPRO**—A prosumer digital videotape format that records at 4:1:1, but will accept and maintain a 4:2:2 signal because it does not resample it, but rather passes it through; it uses 16-bit 48 kHz audio.

**DVCPRO 50**—A professional digital videotape format that uses 4:2:2 sampling by using two compression chip sets that work in parallel, each using 2:1:1 compression; it uses 16-bit 48 kHz, two channel PCM audio.

**DVD (digital video disc)**—Also called digital versatile disc; a new storage medium that will hold gigabytes of information on a single disc.

**DVE (digital video effects system)**—A video recording device created in the 1970s that converted frames of analog video into digital form to create special effects. These were pass-through devices and the frames were not actually stored in memory.

**DV-NTSC**—The type of video compression used by FireWire (IEEE 1394).

**DVR (digital video recorder)**—A video receiver and hard drive that can record hours of programming digitally.

**ECU (extreme close-up)**—A type of video shot during which the subject's chin remains in frame. The shot typically cuts off at the actor's hairline or forehead.

**electromagnetic spectrum**—The range of visible light (blue, green, yellow, orange, and red) and invisible light (ultraviolet light and infra-red).

**ellipsoidal light**—Also called a spotlight; a fixture which produces a narrow beam of light with a defined edge.

**FCC (Federal Communications Commission)**—The government body responsible for making the laws regarding television broadcasts.

**field**—One of two passes during which horizontal lines of resolution are scanned to reproduce a video image on the television screen. The odd lines are scanned first, forming the first field, and the even lines are scanned second, forming the second field.

**fill light**—A spotlight used to reduce the shadows caused by the key light. It is placed in front and to the side of the subject, but opposite the key light.

**filter**—1. A video accessory used to adjust the color or contrast of the image; 2. A type of postproduction effect that alters an image's chrominance, luminance, or its look by manipulating its pixels.

**FireWire**—Also called IEEE 1394; a communications protocol invented by Apple Computer that allows digital video cameras and computers to transmit a digital video signal back and forth.

**f-stops**—Measured increments of light, controlled by the iris, that pass through the aperture of a lens.

**fluorescent lights**—A type of cool lights that generate less heat and have a longer lamp life. They can be color balanced for either daylight or tungsten.

**focus lens light**—A fixture whose light beam can be adjusted to either the spotlight or floodlight position.

**fog filter**—A video accessory that simulates fog and creates a soft glow.

**fps (frames per second)**—The number of frames, or still images, generated in one second to produce motion. Video is 30 (29.97) fps; film is 24 fps.

**fragmentation**—A hard drive state that occurs over time when the drive no longer writes files in one continuous space, but rather breaks them up into multiple parts, slowing down the drive's overall performance.

**fresnel light**—A lighting fixture that uses a glass lens with concentric circles.

**full-motion video**—Video that runs at the 30 (29.97) fps standard.

**full-screen video**—The standard video resolution measured in pixels filling the

entire television screen. (Analog video is 640 x 480 pixels. Digital video is 720 x 480 pixels.)

**gel**—Also called a color filter; a piece of colored flexible plastic that is used to alter the hue of light.

**generation loss**—The degradation of image quality caused by the duplication of an analog videotape.

**gobo**—Metal disks that attach to a light fixture, producing a design or pattern and creating atmosphere.

**gobo rotator**—A motorized device that rotates the gobo and creates a moving pattern.

**graphic**—Computer-generated imagery that may or may not include type.

**graphics card**—A computer card that supports the video display of a computer monitor.

**greenscreen**—A video technique used to isolate a subject by filming the subject against a green background which will later be replaced with other footage.

**HDTV (high-definition television)**—A new television standard which uses a high resolution of either 1280 x 720 pixels (progressive) or 1920 x 1080 pixels (interlaced) and a 16:9 aspect ratio.

**headroom**—Space provided above a subject's head at the top of the video frame.

**Hi-8**—A prosumer analog videotape format that uses 400 horizontal lines of resolution and high fidelity (Hi-Fi) PCM stereo audio.

**high-level formatting**—Also called initializing the disk; a procedure that installs a Mac or PC file and directory structure on a hard drive that has already been low-level formatted at least one time.

**HMI lights**—A type of hot lights that are expensive and have the same color temperature of daylight (5500 K).

**hot audio**—Audio that was recorded too loudly and is distorted.

**hot swappable**—A feature that allows FireWire devices to be attached and turned on and off without having to restart the computer.

**hue**—The actual shade of the color being displayed.

**IDE (Integrated Drive Electronics)**—A type of hard drive.

**IEEE (Institute of Electrical and Electronics Engineers)**—FireWire is Apple Computer's trade name for the interface IEEE 1394. It is an international standard that allows high-speed connections and transfer rates between a computer and peripherals.

**interlaced**—The method of combining two fields to form a frame. The television set is interlaced.

**iris**—The mechanism of a camera that opens and closes the aperture of the lens.

**keyframe**—A frame that marks the place in time where a particular change occurs. Keyframes are used in digital video and 3D animation.

**key light**—A spotlight which is the principle light used to illuminate the subject. It is positioned to the front and side of the subject, on an angle.

**lamp**—A light bulb in professional lighting equipment.

**lavalier microphone**—A small microphone that is clipped onto the clothing of a person.

**leadroom**—Space provided so that the subject never "bumps" into the edge of the video frame. Usually the subject takes up one third of the screen, and two thirds of the screen is devoted to leadroom.

**lighting kits**—Two or more lights and/or accessories sold with a carrying case at a reduced rate.

**linear editing**—A traditional style of video editing where the program is edited consecutively from beginning to end.

**low-level formatting**—A method of preparing a hard drive for recording data by numerically marking all its sectors and tracks.

**LS (long shot)**—A head to toe shot of a person, with the entire body being in frame.

**luminance**—The black-and-white portion of the video signal, or its lightness and darkness values.

**lux**—An increment for measuring light's intensity or brightness. The amount of light that falls on a surface area of one square meter when a candle is placed one meter away.

**MCU (medium close-up)**—A shot that cuts off at the subject's bustline.

**Mini-DV**—A consumer digital videotape format that uses 4:1:1 sampling, records up to 500 horizontal lines of resolution, and records audio in either two channels at 16-bit 48 kHz, or four channels at 12-bit 32 kHz.

**mist filter**—A video accessory used to create a mood by lightening the shadows in an image.

**MLS (medium long shot)**—A shot that cuts off at the subject's knees.

**motion**—A postproduction effect that can make a video clip zoom in or out, move across the screen, rotate, or pause in place for a specified period of time.

**MS (medium shot)**—A shot that cuts off at the waistline.

**ND (neutral density) filter**—A camera feature that decreases the amount of light used to reproduce an image without altering the image's color.

**nondrop-frame timecode**—A format for timecode using 30 frames per second; the hours, minutes, seconds, and frames are separated with colons (00:00:00:00).

**noninterlaced**—Also called progressive; the method of forming a video frame by drawing all the lines of resolution in a single pass, going blank for a fraction of a second, and drawing the next frame. The computer monitor is noninterlaced.

**nonlinear editing**—A style of video editing which is nonconsecutive in nature; nonlinear editing is often used synonymously with professional quality digital video.

**NTSC (National Television Standards Committee)**—1. The organization responsible for the video standard used in North America and other countries; 2. The video standard at which the signal is broadcast at 525 horizontal lines of resolution and 30 (29.97) frames per second, with a 4:3 aspect ratio.

**omnidirectional microphone**—A type of microphone optimized to pick up sound from all directions.

**optical zoom**—The built-in capability of the lens to magnify, which is determined by the construction of the lens itself.

**OTS (over the shoulder)**—A shot showing part of the back of one person's head while another person or subject is the focus of the frame.

**overscan**—A process that increases a video image's size, typically by five percent.

**PAL (Phase Alternate Line)**—PAL is the video standard used in the United Kingdom, Western Europe, and Africa.

**paradigm**—The standard three-act formula for a dramatic structure. Act 1 is the Setup, Act 2 is the Confrontation, and Act 3 is the Resolution.

**partitioning**—The process of dividing the hard drive into sections called volumes.

**pass through**—The ability to pass an analog video signal through a digital video camera and automatically convert it to FireWire.

**pixels**—A series of small blocks used to draw a video image.

**pixel aspect ratio**—A method used to represent different types of pixels. DV-NTSC uses a 0.9 pixel aspect ratio; widescreen DV-NTSC uses a 1.2 pixel aspect ratio.

**plot point**—An event that swings the story into another direction.

**polarizing filter**—A video accessory used to eliminate glare from reflected surfaces, such as water and glass.

**POV (point of view)**—A type of shot during which the lens of the camera acts as the subject's eyes.

**premise**—The idea of a screenplay, summarized in a single sentence.

**premultiplied alpha channel**—Also called a matted alpha channel; the transparency information is kept in a separate channel, but it is also kept with the color information in the red, green, and blue channels. It is premultiplied with a color, usually white or black.

**preproduction**—The phase of the video process that precedes the actual video shoot. It includes script writing, creating storyboards, and the production schedule.

**prime lenses**—One of three types of high-quality lenses: a normal lens, which has a

medium field of view; a wide-angle lens, which has a broader field of view, but distorts the image; or a telephoto lens, which covers a limited field of view, but has the ability to magnify.

**production schedule**—The schedule for shooting a video production dictated by the shot sheets, camera setups, and location and actor availability.

**project file**—A document that records which files are used, the order and duration the clips appear on the timeline, and what effects are used during editing.

**proposal**—A written idea for a film or video project that can be anywhere from one page to well over a dozen.

**prosumer**—A cross between professional and consumer.

**protagonist**—The "hero" of the story, or the person around whom the conflict takes place.

**QuickTime**—A type of software compression created by Apple Computer that shrinks the size of digital video files.

**rack focus**—A camera technique where the focus shifts from a sharp foreground image with a blurry background, to a blurry foreground with a sharp image in the background, or vice versa.

**RAID (redundant array of inexpensive disks)**—Also called arrays; two or more hard drives working together simultaneously.

**random access**—The founding principle of digital video technology stating that it takes the same amount of time to access any file.

**RAM (random-access memory)**—An integrated circuit memory chip that allows data to be stored, accessed, and retrieved in any order.

**rasterize**—To convert path-based art into pixel-based art.

**RCA**—The type of connectors typically used by composite audio and video.

**real-time**—Special effects, such as basic transitions, motion, and transparency, that don't require rendering to be viewed.

**redundant**—The duplication of hard drive data (RAID levels 2 through 5).

**reflector boards**—Also called bounce boards; a lighting accessory that reflects light and redirects it.

**render**—The process the CPU takes to carry out a particular set of instructions or tasks. The term render is commonly used to refer to the high-end calculations required to edit digital video or create 3D animation.

**resolution**—1. The size of the video frame measured in pixels; 2. The final act of a screenplay during which the conflict is resolved and the loose ends are tied up.

**RGB (red, green, blue)**—The three additive primary colors used to construct a video image.

**RPM (revolutions per minute)**—The speed at which the hard drive spins.

**sans-serif fonts**—Fonts without thin lines around the edges which reproduce well on video.

**saturation**—The intensity or strength of the color.

**screenplay**—A story written in a particular style and format intended for the movies.

**scrim**—A lighting accessory that attaches to a metal frame and hangs in front of a light to diffuse it, reflect it, or project a pattern.

**SCSI (small computer system interface)**—A type of hard drive and a communications protocol for the computer.

**SCSI accelerator card**—A card that is added to the computer to provide additional throughput on the SCSI bus so that large amounts of data can be moved quickly.

**SDI (serial digital interface)**—A high-end video connection that provides lossless digital video quality.

**SECAM (Systeme Electronique Pour Couleur Avec Memoire)**—A video standard used in France, Russia, and Eastern Europe.

**seek time**—The speed at which the hard drive accesses the information on the disk.

**serif fonts**—Fonts with thin lines on the points of the letters which usually do not reproduce well on video.

**setup**—The first act of a screenplay during which the characters are introduced, the place and time is set, and the main idea of the story is identified.

**shotgun microphone**—A type of directional microphone used to capture audio from a distance.

**shot sheet**—A list briefly describing all of the individual shots that need to be filmed during a shoot.

**shutter speed**—The part of the camera that controls the rate of exposure of light. It typically ranges from 1/4 of a second to 1/10,000 of a second.

**site release**—Written permission from the property owner granting the right to shoot a film or video production at a specified location.

**softbox**—A lighting accessory that mounts to a metal frame forming an enclosed box around the light to soften it.

**softlight**—A fixture that redirects or bounces the light to diffuse it.

**spectral energy distribution curve**—The percentage of light that is transmitted through a particular filter and its wavelength in chart form.

**stereo mini**—The typical connector used for plugging headsets into portable CD players.

**storyboards**—Drawings of each shot in a production for television, film, video, or 3D animation.

**straight alpha channel**—Also called unmatted alpha channel; transparency information is kept in a separate channel, not with the color information in the red, green, and blue channels.

**striping**—RAID level 0, which is non-redundant, or not repeating, and designed specifically for speed.

**S-VHS (Super-VHS)**—A prosumer analog videotape format that has 400 horizontal lines of resolution and stereo-quality audio.

**S-video**—A video signal in which the chrominance and luminance portions of the video signal are kept separate.

**test render**—A render at a lower quality or with reduced settings, used to preview a project.

**three-dimensional graphics**—Computer-generated imagery that is created on three axes: the vertical, or Y-axis; the horizontal, or X-axis; and the depth, or Z-axis.

**three-point lighting**—Also called triangle lighting; a basic lighting setup using a key light, a fill light, and a back light in conjunction with one another to light a subject.

**timecode**—An electrical signal that assigns a numerical address to every frame of the videotape. Timecode is measured in, and displayed as, Hours: Minutes: Seconds: Frames.

**titles**—Text files made up of a single word, multiple words, or phrases to provide supplementary information, to reinforce important concepts, or to clarify unusual terminology.

**title safe area**—The innermost line of the video frame within which any title will be safely displayed in its entirety.

**transfer rate**—The speed at which the hard drive sends and receives data.

**transition**—A postproduction effect that acts as a bridge between two layers of video.

**transparency**—A postproduction effect that allows you to see several layers at the same time.

**treatment**—A formal, detailed proposal that tells a story and describes the characters, but uses little or no dialogue; it can be as long as sixty pages.

**tungsten lights**—A type of hot light that reaches extremely high temperatures (3200 K).

**two-dimensional graphics**—Computer-generated images that are created along two axes: the vertical, or Y-axis, and the horizontal, or X-axis.

**ultraviolet filter**—A video accessory that helps reduce atmospheric haze.

**umbrella**—A lighting accessory that attaches to a fixture to soften the light and diffuse it.

**underscan**—A process that shrinks the video image, showing it in its entirety including the edges of the picture.

**unidirectional microphone**—A microphone optimized to pick up audio from one particular direction.

**vector graphics**—Two-dimensional graphics that are path based as opposed to pixel based.

**vectorscope**—A professional testing device used to measure the quality of a video signal by measuring the chrominance.

**VHS (video home system)**—A consumer analog videotape format that is one half-inch wide and has only 240 horizontal lines of resolution.

**VHS-C**—A consumer analog videotape format that adheres to the VHS standard, but is a smaller size, requiring an adapter in order to be played in a VHS deck.

**video card**—A card for a computer that converts analog video signals into digital video signals.

**video release**—Written permission from a subject granting the right to use the subject's likeness in a film or video production.

**video streaming**—A method of transmitting video over the Internet in which the video is temporarily loaded in the system as it plays, but is not actually saved on the computer.

**voice-over script**—A written script that is provided to a narrator or narrators, who will record a voice-over to convey additional information not conveyed in on-camera dialogue.

**V-RAM (video RAM)**—An integrated circuit chip used for graphic display functions, such as supporting the colors on a computer monitor.

**waveform monitor**—A professional testing device used to measure the quality of a video signal by measuring the luminance.

**white balance**—A video camera feature that adjusts to differences in color temperature by calibrating the image for daylight or artificial light.

**widescreen**—The simulation of a movie theater perspective by creating an elongated rectangle; some camera models will also create the letterbox effect by striping black bars across the top and bottom of the video image.

**WS (wide shot)**—Also called an establishing shot; an interior or exterior shot used to establish or set the scene, by putting the location into some kind of overall context.

**XLR**—A type of connector used with professional audio equipment.

**Y splitter**—An adapter that splits a mono audio signal and distributes it to both stereo channels.

**zebra display**—A feature available in high-end digital video cameras that stripes zebra-like lines in the viewfinder across any part of an image that exceeds the camera's ability to record its brightness.

**zoom lens**—A lens that combines a normal lens, a wide-angle lens, and a telephoto lens into a single lens.

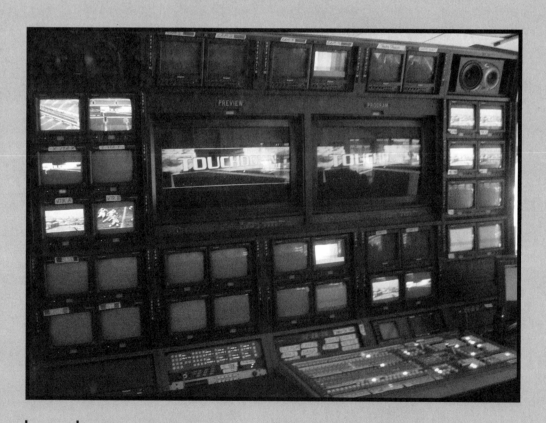

index

*index*

4:1:1 and 4:2:2 digital component, 26
8 mm tape, 23

## A

action safe area, 138
Adobe After Effects, 139, 143–145
Adobe Illustrator, 138, 143
Adobe Photoshop
    alpha channels, 147–151
    color correction, 119–120
    compression, 118–119
    cropping and resizing, 122–131
    Image Size command, 122–132
    matting, 129–131
Adobe Premiere
    alpha channels, 159–151
    audio interleave, 153, 210–211
    audio levels, 152, 174
    audio and music, 193–195
    audio settings, 208–211
    capturing audio, 170–171
    capturing video, 168–174
    device control, 166–167
    editing, 178
    exporting video, 202–205, 215–220
    filters, 189
    Image Pan command, 132–134
    importing files, 181
    motion, 187–188
    photographs, 131–134
    project file, 178–180
    project settings, 164–165
    rendering video, 211–215
    scratch disk, 165–166

**INDEX**

source files, 179–180
timeline, 181–182, 201–202
transitions, 183–185
transparency, 150–151, 185–187
video settings, 205–208
Alberino, Robert, 53
alpha channels
creating, 147–151
general use, 145–146
premultiplied, or matted, 147
straight, or unmatted, 147
analog video, *see also* video
consumer tape formats, 23
vs. digital video, 3, 22
linear editing, 4–5
professional tape formats, 25
prosumer tape formats, 24
antagonist, 65
aperture, 32, 100
Apple Computer
Final Cut Pro, 10, 178
FireWire, 6–7, 54
QuickTime, 4, 55, 204
aspect ratio, 9, 121, 205–207
ATA (Advanced Technology Attachment), 46
audio
cables, 97
capture settings, 170–171
compression, 153–154
editing, 193–195
enhanced rate conversion, 211
inputs and outputs, 31
interleave, or audio block size, 153, 210–211
levels, 152, 174
microphones, 31, 95
music, 154, 193–195
render settings, 208–211
sample rate, 152–153
scoring, or marking, 193–195
standards for video, 15–17, 24, 27–29
synch (synchronization), 152

**B**

back light, 106
barndoors, 92
batch capture, 173
battery memory, 87
Betacam SP, 25
Betacam SX, 29
bits, 14
bluescreen, 73, 107–110
BNC connectors, 96
booms, 95
breakout box, 162–163
broadcast digital video, 15

**C**

cables, 96–97
cache, 45
camera notes, 103
camera setups, 78–79
cameras, *see also* digital video cameras
digital photography, 115–116
traditional photography, 114
CCD (charge-coupled device), 3, 27–30
CD (compact disc), 4–5
CD-R (recordable compact disc), 56
chroma keying, 107–110
chrominance, 7
CMYK (cyan, magenta, yellow, black), 7, 116
CODEC (Compression/Decompression)
still photographs, 114, 119
video, 55, 64, 203–207
color
bits, 14, 114
broadcast, 139
color depth, 14, 117
correction, 119, 171–172
electromagnetic spectrum, 106–107
filters, 86–87
gels, 92–93
monitoring, 15, 35, 88, 171–172
RGB and CMYK, 116
spectral energy distribution curve, 92
temperature, 33, 91, 92
techniques, 94, 141

compact disc (CD), 4–5

component video, 7–8, 22

composite video, 7–8, 22

composition and framing, 98–99

compression

    audio files, 153–154

    photographs, 114, 119

    video files, 206–207

consumer tape formats 23, 27

continuous rasterization, 143–145

cool lights, 91

CPU (central processing unit), 44

creativity, 69, 142

credits, 138

cropping photographs

    aspect ratio, 121

    horizontal method, 122–125

    matting, 129–131

    panning, 131–134

    shape differences, 120

    vertical method, 126–129

**D**

DAT (digital audio tape), 56

data, backing up, 56–57

depth of field, 100

desktop video, 4

digital disc recorder (DDR), 3

digital filmmaking, 10, 35

digital still store device (DSS), 3

digital television (DTV), 10

digital video cameras

    accessories, 36

    batteries, 87

    connecting to a computer via FireWire, 159

    digital filmmaking, 10, 35

    exposure modes, 32

    filters, 86–87

    LCD displays, 88

    lenses, 31–32, 86

    lighting, 33

    purchasing equipment online, 37

    special features, 29–31, 34–35

    still photograph feature, 115–116

digital video computer editing systems

    backing up, 56–57

    cache, 45

    determining a budget, 42–44

    entry-level systems, 42–44

    FireWire and videocards, 54–55

    hard drives, 46–49

    high-end systems, 42–44

    memory (RAM), 45–46

    processors and rendering, 44–46

    researching and purchasing, 42

    upgrading , 42–44

digital video disc (DVD), 2

digital video (DV), 3

    4:1:1 digital component, 26

    4:2:2 digital component, 26

    advantages, 5–6

    vs. analog video, 22

    file size, 14–17

    history, 3–7

    nonlinear, 4–5

    product guide, 231–234

    standards

        broadcast, 15

        DV, 25–26

        Internet, 16–17

        multimedia, 16

    resources, 223–225

    sampling, 26

    tape formats

        consumer, 27

        professional, 28–29

        prosumer, 27–28

    troubleshooting guide, 227–229

digital video effects system (DVE), 3

Digital Video Professionals Association (DVPA), 190–193

digital video recorder (DVR), 3

Digital-8, 27

Digital-S, 29

dollies, 90

downloadable movie, 16

dpi (dots per inch), 15, 117–118

drop out, 6

drop-frame timecode, 165
dropped frames, 166, 169
DV Profiles
    Digital Video Professionals Association (DVPA)
        Rod Harlan, 190–193
    Eagles Television Network, ETN, 50–53
        Dana Heberling, 51
        Robert Alberino, 53
        Ron Schindlinger, 52
    Greater Philadelphia Film Office
        Sharon Pinkenson, 11–13
    Rowan University
        Ned Eckhardt, 74–77
    Tommy Productions
        Tommy Rosa, 104–105
DVCAM, 28
DVCPRO, 28
DVCPRO-50, 29
DVD (digital video disc), 2
DV-NTSC, 55

## E

Eagles Television Network, ETN, 50–53
Eckhardt, Ned, 74–77
editing, *see also* Adobe Premiere and Final Cut Pro
capturing audio, 170–171
    capturing video, 168–174
    device control, 166–167
    exporting video, 202–205, 215–220
    linear versus nonlinear, 4–5
    real-time, 55
    rendering video, 211–215
    scratch disk, 165–166
    special effects, 183–189
    electromagnetic spectrum, 106–107
    exposure modes, 32, 100–101

## F

FCC (Federal Communications Commission), 10
field, 9
file formats, 151
fill light, 106
filmmaking, digital, 10, 35

filters
    camera, 86–87
    gels, 92–93
    special effects, 45, 189
Final Cut Pro (Apple) 172–173
    color correction, 171–172
    digital filmmaking, 10
    in and out points, 173
    switching from Adobe Premiere, 178
FireWire (IEEE 1394)
    cables, 6, 97
    capturing video, 157–160
    exporting video, 215–220
    technology, 6–7, 54
fluorescent lights, 91
focus, 99–100
fonts, 140
formatting hard drives, 48–49
fps (frames per second)
    digital filmmaking, 10
    drop-frame timecode, 165
    dropped frames, 166, 169
    field, 9
    frame rate, 14–17, 208
    nondrop-frame timecode, 165
    NTSC standard, 9
fragmentation, 48
f-stops, 32, 100
full-motion video, 15
full-screen video, 15

## G

gels (filters), 92–93
generation loss, 6
gobos and rotators, 93
graphics
    three-dimensional graphics, 145
    two-dimensional graphics, 143
    vector-based graphics, 143–145
graphics cards, 3
Greater Philadelphia Film Office, 11–13
greenscreen, 73, 107–110

# H

hard drives
    formatting, 48–49
    fragmentation, 48
    optimizing performance, 46–47
    partitioning, 49
    RPMs, 46
    RAIDs, 47
    SCSI accelerator card, 47
    seek time, 46
    transfer rate, 46
    types of, 46
Harlan, Rod, 190–193
HDTV (high-definition television), 9–10
headroom, 73
Heberling, Dana, 51
Hi-8, 24
high-definition television (HDTV), 9–10
HMI lights, 91
hot audio, 152, 174
hot lights, 91
hot swappable, 159
hue, 7

# I

IDE (Integrated Drive Electronics), 46
IEEE (Institute of Electrical and Electronics
  Engineers), 54
IEEE 1394, *see* FireWire (IEEE 1394)
i.LINK (Sony), 54
ILM (Industrial Light & Magic), *color insert*, 236–253
interlaced video, 9
interleave (audio block size), 153, 210–211
Internet, 16–17
iris, 32

# K

keyframes, 189
key light, 106
keying, chroma, 107–110

# L

lamps, 91
Landa, Robin, 69
leadroom, 73
lenses
    depth of field, 100
    interchangeable, 86
    types of, 31–32
lights and lighting
    accessories, 93
    bluescreen or greenscreen, 108
    color temperature, 91
    gels, or color filters, 92–93
    kits, 92
    three-point, or triangle, 106–107
    tips, 107
    types of, 90–92
linear editing, 4–5
lines of resolution, 9, 22
lpi (lines per inch), 15
Lucasfilm, *color insert*, 236–253
luminance, 7
lux, 33

# M

matted alpha channel, 147
matting photographs, 129–131
memory
    hard drives, 46–49
    RAM, 45–46
Meyers, Fred, *color insert*, 236–243
microphones, 95
Mini-DV, 27
monitors
    connecting, 103
    types of, 88, 159–161
    waveform monitor, 15
motion, 45, 187–188
multimedia, 16
music, 154, 193–195

## N

neutral density (ND) filter, 33
nondrop-frame timecode, 165
noninterlaced (progressive) video, 9
nonlinear editing, 4
NTSC (National Television Standards Committee), 8–9, 138–139

## O

over the shoulder (OTS) shot, 72
overscan, 88

## P

PAL (Phase Alternate Line), 8
Palatini, Richard, 94
paradigm of a drama, 66–67
partitioning, 49
pass-through option, 35
Philadelphia Eagles, 50–53
photographs
    acquiring, 114–116
    color correction, 119–120
    compression of (CODEC), 118–119
    cropping and resizing
        aspect ratio, 120–121
        horizontal, 122–125
        matting, 129–131
        panning, 131–134
        vertical, 126–129
    image quality, 114
    scanning and importing, 116–120
Pinkenson, Sharon, 11–13
pixel aspect ratio, 207
pixels, 9, 14
point of view (POV) shot, 72
ppi (pixels per inch), 15
premultiplied alpha channel, 147
preproduction, 61
principle of random access, 5
production schedules, 78–80
professional tape formats, 25, 28–29
project file, 178–180

proposals, 62
prosumer, 8
prosumer tape formats, 24, 27–28
protagonist, 65

## Q

QuickTime, 4, 55, 204

## R

rack focus, 99
RAID (redundant array of inexpensive disks), 47
RAM (random-access memory), 5, 45–46
random access, principle, 5
rasterization, 143–145
RCA connectors, 97
real-time video editing, 55
release forms, 80–81
render, 14, 44–45
rendering video, 200, 211–215
resolution
    photograph, 117
    screenplay, 67
    video frame, 14–17
RGB (red, green, blue), 7, 116
Rosa, Tommy, 104–105
Rowan University, 74–77
RPM (revolutions per minute), 46

## S

sampling
    audio, 152–153
    video, 26
sans-serif fonts, 140
saturation, 7
Schindlinger, Ron, 52
scratch disk, 165–166
screenplays
    paradigm of a drama, 66–67
    premise, 65
    sample format, 63–64
    types of conflict, 65
scrim, 93

script writing
    proposals, 62
    screenplays, 63–67
    television scripts, 67
    treatments, 62
    voice-over scripts, 67–68
SCSI (Small Computer System Interface), 46
SCSI accelerator card, 47
SDI (serial digital interface), 159
SECAM (Systeme Electronique Pour Couleur Avec Memoire), 8
seek time, 46
serif fonts, 140
shot sheets, 78
shots, types of, 70–73
shutter speed, 32
Sickinger, Michael, 142
Snow, Ben, *color insert*, 244–253
softbox, 93
special effects, 45
spectral energy distribution curve, 92
Star Wars, *color insert*, 236–253
stereo mini, 97
storyboards, 70
straight alpha channel, 147
S-VHS (Super-VHS), 24
S-video, 7–8, 22
synch (synchronization), 152

**T**

tape formats
    consumer, 23, 27
    professional, 25, 28–29
    prosumer, 24, 27–28
television scripts, 67
test render, 212
three-dimensional graphics, 145
three-point, or triangle lighting, 107
timecode
    breaking, 167
    camera notes, 103
    drop-frame timecode, 165
    in and out points, 173
    nondrop-frame timecode, 165
    voice-over script, 68
    writing, 31

title safe area, 138
titles
    adding motion, 187–188
    broadcast colors, 139
    safe areas, 138
    serif and sans-serif fonts, 140–141
Tommy Productions, 272
transfer rate, 46
transitions, 45, 183–185
transparency, 45, 185–187
treatments, 62
tripods, 89–90, 101
tungsten lights, 91
two-dimensional graphics, 143

**U**

ultraviolet filter, 87
underscan, 88
unmatted alpha channel, 147
USB cable/port, 158

**V**

vector-based graphics, 143–145
vectorscope, 15
VHS videotape, 2, 6, 23
VHS-C, 23
video
    accessories, 36
    analog, *see* analog video
    broadcast, or professional, 15, 25, 28–29
    component, 7–8, 22, 96
    composite, 7–8, 22, 97
    consumer, 23, 27
    digital, *see* digital video
    equipment, 37
    high-definition, 9–10
    prosumer, 24, 27–28
    sampling, 26
    shooting, 99–102
    signal, 7–8
    standards
        NTSC, 8–9
        PAL, 8
        SECAM, 8
    streaming, 16
    S-video, 7–8, 22, 96

video cards, 3, 54–55, 157
visual effects, *color insert*, 236–253
voice-over scripts, 67–68
V-RAM (video RAM), 46

## W

waveform monitor, 15
white balance, 33, 102
widescreen mode, 34

## X

XLR connector, 95

## Y

Y splitter, 97

## Z

zebra display, 35
zoom lens, 31–32